The Jupiter/Saturn Conference Lectures

Liz Greene
Stephen Arroyo

CRCS Publications
Post Office Box 20850
Reno, Nevada 89515
U.S.A.

Library of Congress Cataloging in Publication Data
Greene, Liz.
 The Jupiter/Saturn Conference lectures.

 (Lectures on modern astrology ; v. 1)
 Comprises lectures excerpted from a 7-day conference held in Berkeley, Calif., July 1981.
 Contents: Informal comments on the Jupiter-Saturn conjunction / Stephen Arroyo -- Chart comparison & the dynamics of relationship ; The myth of the individual journey / Liz Greene -- Key issues in astrology today ; Person-to-person astrology / Stephen Arroyo -- [etc.]
 1. Astrology--Congresses. 2. Jupiter (Planet)--Miscellanea--Congresses. 3. Saturn (Planet)--Miscellanea--Congresses. I. Arroyo, Stephen.
II. Jupiter/Saturn Conference (1981 : Berkeley, Calif.)
III. Title. IV. Series.
BF1651.3.G73 1983 133.5 82-45632
ISBN 0-916360-16-4

© 1984 by Liz Greene & Stephen Arroyo

All rights reserved under International and Pan-American Copyright Conventions. Printed in the United States of America. No part of this book may be used or reproduced in any manner whatsoever (including photocopying) without written permission from the publisher, except in the case of brief quotations embodied in critical or scholarly articles and reviews.

FIRST EDITION
INTERNATIONAL STANDARD BOOK NUMBER: 0-916360-16-4
LIBRARY OF CONGRESS CATALOG CARD NUMBER: 82-045632
Published simultaneously in the United States and Canada by:
CRCS Publications
Distributed in the United States and internationally by
CRCS Publications
(Write for current list of worldwide distributors.)
Cover Design: Image & lettering both by Rebecca Wilson

Contents

Introduction

1. Informal Comments on the Jupiter–Saturn Conjunction 1
 ... *Stephen Arroyo*
2. Chart Comparison & the Dynamics of Relationship 16
 ... *Liz Greene*
3. The Myth of the Individual Journey 46
 ... *Liz Greene*
4. Key Issues in Astrology Today 81
 ... *Stephen Arroyo*
5. Person-to-Person Astrology: Summary of Results 97
 of On-going Relationship Research
 ... *Stephen Arroyo*
6. Light & Shadow 129
 ... *Liz Greene*
7. Methods of Chart Synthesis 162
 ... *Stephen Arroyo*
8. Jupiter & Saturn 190
 ... *Liz Greene*

Publisher's Note

This volume is one of a planned series of books compiled from the lectures and workshops of some of the most innovative and articulate contributors to modern astrology's development. We call the series *Lectures on Modern Astrology* to stress the fact that the material included in this series will have to meet most or all of the following criteria:

- the use of clear, modern language
- a particularly sharp vision of astrology's unique value and potential
- *a person-centered focus* rather than the traditional event-oriented preoccupation with predictions (although an intelligent, *integrated* use of event potentialities and trends lies within this definition)
- providing some new contribution to the on-going development of a broad-based astrological psychology that does not merely speculate about but which actually *illuminates* human experience and behavior.

It is our belief that today much of the best material and most of the new ideas of real value are being presented—not in formal, book-length volumes—but in lectures and workshops (as well as in an occasional journal article). By providing this medium of edited transcripts in book form, we feel that some of the most vital and incisive of today's astrological thought—which heretofore has been communicated only to small groups in person and then passes into oblivion—can now be given a permanent form and a wider availability. In this way, we hope to contribute to the building of a new tradition of intelligent, in-depth astrology and to the evolving formulation of a language for *person-centered* astrology that is both accurate and appropriate for growth-oriented people.

Those who want to be notified of future volumes in this series should write us and ask to be on our mailing list.

Introduction

The Jupiter/Saturn 7-Day Astrology Conference in Berkeley, California was a unique event. Instead of the carnival atmosphere that pervades most astrology conventions and conferences, there was a precise focus for participants at all times. Only one talk was scheduled for each time period, and the attendance was limited to 137 people. It was extremely fortunate that most of the people attending were unusually intelligent and courteous toward other participants, for this permitted an especially harmonious and unified experience for most of us. In fact, upon reflection, that this conference was felt by many to be a magical and even for some a *peak* experience (as attested to by the enthusiastic letters from over one third of the participants after the event) cannot be accounted for by analyzing the individual talks and events that made up the conference. The conference was something more than the sum of its parts; it was one, *whole* experience, in which many of us were fully immersed for an entire week. The conference was the embodiment of a vision of an astrological gathering of an entirely new order, more serious, more purposeful, and more professional than most.

Since the event occurred during the July, 1981 Jupiter/Saturn conjunction in Libra, many of those attending were simultaneously having Jupiter and Saturn aspect some natal planet or significant point in their charts. The conference therefore marked for many a turning point in their lives and, in many cases, in their professional or vocational attitudes and plans. And I suppose the conjunction's placement in Libra must be taken into account when questioning how so many people could be so sensitive to each other and get along so harmoniously for 7 days!

Naturally, much of this experience cannot be conveyed through a book of transcribed lectures, and no doubt the magic of the conference which was personal to each participant cannot be communicated in this introduction. But I did simply want to provide the reader with some background on how this book came to be.

The eight talks included herein are excerpted from a total of sixteen talks given at the conference by Liz Greene, Alan Oken, Conference Coordinator Jim Feil, and myself. The original plan for this book was for it to include most of these talks, but Jim Feil's talks proved too difficult to transcribe and Alan Oken declined to participate in this project when presented with the initial proposal. However, Liz Greene and I decided to go

ahead with it anyhow, once we saw how much material we had merely from our own talks. We have taken full freedom to edit the transcripts, adding or deleting as we saw fit, yet trying to retain the basic flow of the original lectures.

I myself have occasionally included some material that I did not have time to present or to expand upon in the alotted time periods, but which I had prepared for inclusion in the talks. I have also broken up one very long talk into two for added clarity. In her editing, Liz Greene—because of professional ethics common to all therapists—has occasionally altered the case history material to preserve the client's anonymity and confidences. Otherwise, she has endeavored to retain the tone and sequence of the original talks.

<div style="text-align: right;">Stephen Arroyo</div>

1—Informal Comments on the Jupiter-Saturn Conjunction

Stephen Arroyo

This conference was conceived during the first of three Jupiter-Saturn conjunctions, and the conference is finally happening during the last of the three conjunctions in Libra. The primary point of this informal evening meeting is to establish the overall themes of this conjunction and therefore of this conference. We will be comparing theory with specific observations from myself and from many of you. And of course some historical trends will also be explored in order to expand our understanding of this conjunction's meaning over the years, as it sets up a rhythm of approximately twenty years. Later in the conference, Liz Greene will also be presenting further information on the Jupiter-Saturn conjunction, especially from the viewpoint of mythology and psychological and historical trends.

I have never specialized in mundane astrology and have in fact never had much interest in trying to predict world events. However, I *am* interested in historical cycles and trends and in the *mass psychology* that accompanies them. There has been a lot of speculation in the past few months among astrologers and in the various astrological journals along the lines of world event predictions, but tonight we might focus on some more personal things, the psychological impact of this conjunction on each of us, as well as on various thoughts, observations, and facts related to mundane occurrences. And since the conjunction is in the sign Libra, one of the main themes of this conference is *relationships,* and that subject must be seen to include relationships between all sorts of people, groups, nations, and races—not just one-to-one relationships.

One could speculate that a Jupiter-Saturn conjunction in the sign of Libra, the sign of harmony, balance, mutual consideration, and fairness, would be wonderful on many levels and would bring about many forces of equalization and cooperation. One particularly hopeful, optimistic person, astrologer Philip Lucas, recently wrote:

> The next twenty years will witness the end of many current groupings, parochial viewpoints that have led to polarization, alienation between men and women, rich and poor, Christian and Moslem, Arab and Israeli, communist and capitalist, owners and workers, conservatives and liberals, etc., etc.

I hope this is right, but note the word "polarization." Historically, Libra has been known as much for war as for peace. Libra does tend to polarize; people with strong Libra influence tend to be *exclusive,* to see others as "with me or against me." President Carter's political problems were partly due to his exclusive, polarizing attitudes of this type; and of course Carter was defeated in his re-election bid as the first Jupiter-Saturn conjunction occurred. One might also point out that the gigantic conflagration of World War II continued for three years *after* Neptune entered the sign Libra. By no means did this idealistic symbol of universal peace bring about instant world harmony! Hence, although there are great opportunities for establishing world harmony on an increasing scale based on justice and sharing during the next twenty years, there is also a great danger of war based on polarization, exclusivicity, and a "we or them" attitude. Note that Libra has been called the "iron hand in the velvet glove," so don't underestimate the rigidity or willfulness of Libra. It *is* Saturn's exhaltation sign! I sometimes call Libra "a polite Aries."

If you read the astrology magazines of the 1930s, you'll see that many astrologers were predicting a great era of world peace. They couldn't have been more inaccurate. But, as early as 1922, Marc Edmund Jones (a Libra Sun person) recorded a prediction that Neptune's entrance into Libra in the fall of 1942 would bring about an event that would drastically change the course of world history. In the fall of 1942, the first controlled nuclear chain reaction took place in Chicago, and the atomic age began.

The following statement by Philip Lucas, whom I quoted earlier, outlines his vision of the new Jupiter-Saturn conjunction:

> The Principle of Expansion, Growth, Opening, and Trust in Providence combines with the Principle of Contraction, Limitation, Inhibition, Concentration, Structure and Crystallization. Jupiter again overtakes His Father, Chronos, or Saturn, and pours into the rigidified, crystallized forms of the last two decades a new inspiration for growth and change. The restraints and limitations of the old order are burst through, and a time of rapid expansion ensues at all levels of existence. ... Many of the old structures in Society (from economics to religion, from politics and diplomacy to education and law) must give way to "new Wine", new ideas, and a Clearer Vision of human social organization based on Justice, Compassion, Tolerance and Respect for the innate rights of each individual.
>
> This conjunction signifies a cleansing of the Earth's mental atmosphere that is today so polluted with hatred, anger, despair, deception and greed. The next 20 years will see this happen on a scale unimaginable to us now in our present limited mode of perception and awareness. The World is truly on the Scales and the Grim Reaper, the "Lord of Karma", is demanding payment for past offenses. Forgiveness and protection (a function of Jupiter) from the swift, exact Justice of Saturn is still available to those willing to repent, and to live in accord

with the Law of Love and Compassion. But time is running out. In Libra Saturn ensures that all debts are paid to the last cent. There is no stricter justice.

During Pluto's transit of Libra, the Air Signs have matured and become adept at leadership and the balanced exercise of Power and Authority. More Air Sign Leaders, (leaders who rule through Principle and Ideals, rather than through Manipulation, Coercion and Suppression) will come to the fore. Already we find their prototypes in such people as Trudeau of Canada (Libra), Carter of the U.S. (Libra), D'Estaing of France (Aquarius), Thatcher of Gr. Britain (Libra), Suarez of Spain (Libra), Ayala of Colombia (Gemini), Van Agt of Holland (Aquarius), and Eanes of Portugal (Aquarius). Other current Air Sign Leaders whose reputations are not as pure include: Mobuto of Zaire (Libra), Ceaucescu of Romania (Aquarius), Reagan of the U.S. (Aquarius), and Bush of the U.S. (Gemini). The two Popes before John Paul II, Paul VI and John Paul I, were both Libras. This is a Royal Conjunction, and marks a major turning point in this century.

It's rather amazing how many world leaders are air signs, and this certainly validates the astrological tradition of the air element's association with social and political concerns. We might also remember that Uranus spent seven years in the air element (Libra) a few years ago, which seems to have speeded up the development of many air-sign people.

The cycles of the Jupiter-Saturn conjunctions traditionally have comprised the so-called "Great Mutation," specifically the "mutation" happening when the conjunction changes elements. The great traditional religions are almost all associated with a particular Jupiter-Saturn conjunction that marked the birth of their "incarnation": Moses, Buddha, Mohammed, Jesus, etc.. Although the conjunction itself occurs every twenty years, marking specific social and mass psychological rhythms that we'll talk about shortly, a broader cycle is the repetition of the conjunctions in the same element for approximately 200 years. The last Great Mutation started in the *earth* sign Capricorn in 1842. The current conjunction in an *air* sign represents a new trend since it is the first Jupiter-Saturn conjunction since 1842 that is not in an earth sign. However, we better take advantage of this brief respite, because the Jupiter-Saturn conjunction twenty years from now in the year 2000 will again take place in the earth sign Taurus. It is only after that that the Great Mutation will begin completely in the air element, when the Jupiter-Saturn conjunction of 2020 takes place in 0 degrees and 31 minutes of Aquarius.

Since the current Jupiter-Saturn conjunction is in the air element for the first time in hundreds of years, and especially since it occurs in the *Cardinal air sign* of Libra, the sign of Saturn's exhaltation, we simply have to expect significant and long-lasting social changes. The next twenty years should witness widespread changes, redefinitions, realizations, and energetic

developments in the spheres of social structures, relationships, marriage, and all other forms of interpersonal interaction. Already, I have been seeing almost everyone I know focusing on relationships, dependency, needs for people, the authenticity of current relationships, loneliness, and—in general—all sorts of self-vs.-other issues and problems.

The various social contracts and obligations that hold a society together (or rip it apart) will also undergo vast changes. Already, we see in the United States and in England a complete reversal of social and economic policy trends that have dominated political life since the last Jupiter-Saturn conjunction of 1961. Not only was Carter's defeat the last gasp of the last cycle's approach to social problems, but the scope of his defeat was an obvious repudiation of many old, failed policies by an increasingly conservative electorate. Note that Libra is a much more conservative sign than is generally realized! Hence, Reagan was elected in November, 1980, just prior to the first of the three Jupiter-Saturn conjunctions in Libra.

And what is Reagan's first significant action? To push through a huge change in the tax laws that will reestablish old-style capitalism and make more secure the wealth of the ruling classes.* I am not saying that changes in the tax laws aren't desperately needed; I mainly want to point out that this conjunction is the beginning of a radically new cycle on every level of human activity and accomplishment. And it has huge implications for the trend of social changes for the next twenty years. Just a few years ago, it was inconceivable to the great majority of Americans that a man so old-fashioned and uncompromising as Reagan would be even reasonably considered a serious presidential candidate. However, such is the tremendous tide of change in the mass psychology that accompanies a new Jupiter-Saturn conjunction: overnight tens of millions of Americans found themselves *feeling* what Reagan had long been saying. And this new seed of mass psychological change is only *beginning* to sprout at this time. The next ten years, until the Jupiter-Saturn opposition, will witness the release of this energy and potential, for good or ill.

Within the twenty-year cycle defined by the conjunctions of Jupiter and Saturn, one can recognize two semi-cycles. The first ten years of a cycle are more intense, and there is a sort of *winding up* leading to the peak of the Jupiter-Saturn opposition. The last ten years of the cycle often seem to be a

*It turned out that the complete Reagan tax package was passed into law on July 29th, 1981, only 5 days after the third Jupiter-Saturn conjunction. Curiously enough, July 29th, 1981 was also the day of the widely-publicized marriage of Prince Charles and Lady Diana Spencer, who were first publicly rumored to be involved as the first of the three Jupiter-Saturn conjunctions was forming in late 1980. One might speculate that this future King and couple may play a greater role in world affairs than their "figurehead" status might seem to imply.

winding down of the intensity, pace, and overall direction that was present in the earlier stages of the full cycle. During the first ten years, people tend more to initiate, project, experiment, and many rapid changes happen, as well as most of the biggest crises. Then, during the second ten years, people often seem to be exhausted, needing a period of reflection and assimilation since the pace of change has been too rapid to sustain.

If you take the American Civil War period, you'll find that the Jupiter-Saturn conjunction was in Virgo in 1861: Lincoln being elected (quite by surprise to most contemporary political observers), the Civil War breaking out, the explosive issue of slavery, the mass slaughter, the destruction of the South's entire way of life, the mass migration of blacks to the industrial North, and annexing additional states to the Union for political advantage during the war. Reconstruction after the War aborted since Lincoln was the only one with the vision, determination, morality, and political capacity to carry it out. By the 1870s, the waning semi-cycle, the USA retreated almost totally from the real issues of the Civil War.

If you talk to Black people in this country, most will tell you that the same thing happened during the last cycle: in 1961 there was a Jupiter-Saturn conjunction in Capricorn, and of course we all know that there was a tremendous burst of humanitarian and governmental activism in Civil Rights—a great many protests, a great many new laws, and new governmental structures (Capricorn!) established to enforce them. Then of course the Viet Nam war culminated around the Jupiter-Saturn opposition, and a period of national and individual introversion began in the second half of the cycle. One sees this often: the first ten years mark a decided extroversion, optimism in many cases, or at least striving for an ideal cr fighting for a cause. As the opposition approaches, the intensity of extroversion and the level of outward-directed confidence begins to wane, both nationally, socially, and in many cases individually.

So, the 1960s did parallel the 1860s in many ways, as has been pointed out in the mass media quite effectively. After the Jupiter-Saturn opposition, however, all the activists seem to have become totally exhausted, and the government also, under Nixon, who presided over the opposition period, began to back off from certain commitments and directions that had been started in the 1960s. Many people I know, who were extremely active in many extroverted areas of activity—including a decided activism and group commitment centering around astrology—activities such as politics, civil rights, and anti-war protests, feel that many of the ideals of the '60s were totally dissipated in the '70s, often by unethical commercialization.

Another interesting period is the 1920s. In 1921, the Jupiter-Saturn conjunction occurred in 27° Virgo. Right up until the Wall Street crash,

a huge segment of American society, especially in the big cities, went hysterically nuts! People from Victorian backgrounds were suddenly doing all sorts of things—it's interesting that a conjunction in *Virgo* could bring a *rebellion* from puritanism as well as simultaneously the puritanical forces that produced Prohibition. Many of the things people were doing then make current activities look almost tame. So, during the first ten years of that cycle, there was a huge burst of new freedom, both in behavior and in literature and art (Virgo!). The Virgo influence, however, made itself felt even when its traditional puritanical limits were being tested. If you look at the fashions of that period, they were very *tight,* like Virgo. There were tight little hats, tight little dresses, tight shoes, tight bodices. Everything was tight and stylish—look at the cars designed then! And of course people were getting tight also, illegally.

Then in the 1930s, as Jupiter and Saturn approached their opposition, the hysteria peaked, Wall Street crashed, and the entire *world* economy took a nose dive for the next ten years. The '30s were a winding down reaction to the frenetic activity of the '20s. There was a certain degree of inflation during the 1920s, which is hardly mentioned anymore, and credit was extended to anyone with excessive liberality. The 1930s, in sharp contrast, were a period of a complete lack of credit and a real *deflation* wherein the currency bought more month after month as prices dropped. The extroversion of the '20s was rapidly replaced by the introversion, depression, desperation, and fearfulness of the '30s.

In 1941, as Jupiter conjuncted Saturn in Taurus, the already hot wars around the world exploded into a total world war, as the USA got overtly involved after Pearl Harbor. Throughout the '40s, there was a tremendous amplification of production in this country that really fits the symbolism of Taurus. The productive capacities of this country astounded the world. Huge transfers of wealth and massive destruction of wealth and property also accompanied this first semi-cycle, and the pleasures of everyday life (Taurus) were violently altered for millions of people worldwide. The *rebuilding* of much of the world's economy and hundreds of cities also took place during this period, the Marshall Plan being part of the constructive side of this Taurus conjunction.

Then of course in the 1950s a distinct introversion took hold of the Western world. Entire populations were exhausted from war, suffering, fear, worry, and horror; and Americans in large numbers sought escape, pleasure, luxury, and security (Taurus!). A retreat from activism and a need for rest characterized the period, although the USA did show its appreciation to the soldiers of World War II by generously providing government help with housing, education, VA hospitals, etc. Strong reactions against war, extroverted

ambition, and social conformity also began to surface in the USA and in Western Europe. The 1950s were years of disillusionment also, however. The "glory" of war for some, and the excitement of war and its clear goals for others, proved to be peak experiences that were impossible to duplicate or equal during peacetime. As the '50s wore on, therefore, more and more cynicism and dissatisfaction began to surface... until the 1960s ushered in a new era.

THE 1960s & 1970s

The most recent complete cycle, which is now ending, began as Jupiter and Saturn conjoined in 25° Capricorn 12' in February of 1961. You might look it up to see what factors in your chart were activated by that conjunction—what house the conjunction fell in, what planets were aspected, etc. See if those factors and that house were forcefully energized not only at the time of the conjunction but throughout the last twenty years. We can talk about this later in the discussion session after you've had time to think about it. Of course, John F. Kennedy was inaugurated very close to the time of the exact conjunction, and during his administration and the one that followed under Johnson, the governmental power symbolized by Capricorn increased tremendously. There was likewise a great growth of governmental paternalism (Capricorn!) wherein the government tried to be all things to all people and to provide all sorts of services and guarantees that had previously been provided by the private sector or not at all. As with all Jupiter-Saturn conjunctions, there was a release of a tremendous new spirit in the country and in fact worldwide, reflected both in the Kennedy era "Camelot" glamor and in the new cultural and musical developments.

It seems significant that the Beatles musical group began their rise to international fame almost exactly at the time of the 1961 conjunction. They were booked into the Liverpool nightclub "The Cavern" in March of 1961. John Lennon, who contributed the intellectual force and sharpness to the group and thus was more than the other three responsible for the enormity of the group's *social* impact, was born with an almost *exact* Jupiter-Saturn conjunction at 13° Taurus. And it must be seen as a sad commentary on the end of an era that he was murdered as Jupiter and Saturn formed the first of their three new conjunctions in his Sun sign Libra.

By the time of the Jupiter-Saturn opposition, the up-beat spirit of the cycle, as reflected in the politics, the music, and in world events, dwindled rapidly and gave way to more pessimism and resignation. By the time the Viet Nam war was seen in its full horror and Robert F. Kennedy was assassinated in 1968, the last remains of the positive spirit that started in 1961 were

devastated. I don't want to reiterate all the dismal events of the 1970s, but I should give a few examples of this "winding up" and then "winding down" that accompany the two semi-cycles of the Jupiter-Saturn 20-year complete cycle.

1. The "liberalism" and paternalistic approach to government in the USA begun by Kennedy and Johnson almost completely dissipated during Carter's term as the new Jupiter-Saturn conjunction approached. Carter had the misfortune to preside over a radical shift in national mood that made him out of step with the country's unpredictable obsession with projecting its problems onto its president.

2. The creative, innovative, humanizing aspects of the "hippie"/flower child movement in the 1960s devolved into the mechanical, inhuman, technocratic "cultural" developments of the 1970s, symbolized most dramatically by the disco and punk music styles.

3. The American projection of strength *and idealism* in world involvement (the extroversion of the first semi-cycle!) shown in such actions as the Peace Corps, large amounts of foreign aid, and many types of foreign intervention peaked with the Viet Nam fiasco, and the last Jupiter-Saturn cycle ended with America thoroughly humiliated and drained of confidence by the Iranian hostage situation and by the national impotence to deal with the repression in Poland and the slaughter in Afghanistan.

4. The economic policies of the 1960s, especially the inflationary forces linked to rapidly expanding government, resulted in the cycle ending with a severely sick economy *worldwide,* inflation in the USA over 20%, increasingly worthless money, and an international debt burden that would never be paid.

5. The "know yourself and express yourself" spirit of the early and mid-1960s that was at that time ideally combined with communal sensitivity and group identification degenerated into the profound selfishness of the 1970s that was often characterized by extraordinary egocentricity, ruthless assertiveness toward other people, an insistence on the right to "do one's own thing," a rejection of marriage and having children, and a complete lack of interest in contributing anything to society.

THE JUPITER-SATURN CYCLE OF THE 1980s & 1990s

We mentioned earlier what sorts of things this new conjunction in Libra might symbolize. There certainly will be renewed interest in and commitment to marriage, long-term relationships, and more traditional living styles which will also include having children! The conjunction happening in Libra should bring a rebirth of social conscience and—*one would hope*—an increased reliance on humane and aesthetic standards rather than purely financial or

technological ones. Libra is a conservative sign, but yet the technological revolution in electronics and computers will no doubt continue—Libra *is* a mental and communicative sign. And I should also give you the views of Malcolm Dean, a Canadian writer whom I'll quote from his most interesting book, *The Astrology Game*:

> On the basis of previous decades, it may be suggested that the eighties will be an extroverted decade which will really commence in earnest in 1981. There will likely be a resurgence of some aspects of the sixties, especially counter-culture movements, open confrontations with authorities over military and ecological concerns, and (long-overdue) the return of popular music with a message. Disco, it is to be fervently hoped, will die. In many ways, the confrontations will be more substantive, since many of those who protested in the sixties have now worked their way into the social system. They may now sport pin-stripe suits rather than hip-long haircuts, but they have not entirely forgotten their vision for a new society. Whereas the seventies were concerned with maintaining an increasingly outdated status quo and with a retreat into fantasy and personal indulgence, the eighties will be concerned with the very real need for concrete action on a world scale, in order to avert military and ecological disasters. In the sixties, authorities denied that such actions were necessary. By the seventies, ecology, consumerism, and occupational hazards became accepted concerns, but ones which always received a low priority. The eighties will probably not have such luxuries as the large margins of error which allowed the seventies to muddle about. The issues will be global and immediate, demanding global and immediate solutions. Whereas the seventies placed an emphasis upon refinement and improvement of old technologies such as the automobile, the eighties will place a much stronger emphasis upon new technologies. There will also be a resurgence of new religious movements in response to the social tensions of the decade, as well as renewed interest in the established Oriental teachings (Page 315).

THE JUPITER-SATURN CONJUNCTION ON THE PERSONAL LEVEL

We all know that Saturn brings experience into a specific focus for each of us. This Jupiter-Saturn conjunction is not just in the sky; it's a powerful transit for each of us. Jupiter expanding Saturn, while they both are simultaneously activating each of our charts, cannot be ignored. I would wager that at least half of you here tonight can *already* strongly identify with a lot of new, important activity in the area of experience shown by this conjunction's house position for you. Right now, it might only be in mental form, in seed form; you might not have started *acting* yet because it is only the beginning of a twenty-year development period.

And of course, wherever Jupiter is by house position as it transits, you have the opportunity and the urge to expand your understanding beyond current boundaries, to improve your situation through understanding and then through positive action. It may seem that Saturn and Jupiter together are saying to you something like this: "You've *got* to learn this, you've *got* to learn this!" But at the same time as the heaviness of Saturn is being felt, telling you that you have *no choice*, Jupiter is also telling you, "Isn't this great that you're finally learning this and understanding this?!!" So, Saturn brings certain dimensions of your life into focus and often reveals the results of previous activity and attitudes, while heightening objectivity and—ideally—giving you the determination and commitment to make things happen and the discipline to do them right! Jupiter simultaneously expands your understanding and gives you the faith and strength to *act* on that new understanding, based on a new vision of the future. Your vision of the future, one would hope, will be a more realistic one now, thanks to the Saturnian assimilation of past experience in that area of life.

So, Jupiter conjunct Saturn in Libra now could mean a new vision of your future work. Saturn always has to do with *work* of some kind. I don't mean just a job or a career, though, since it can mean clarification of a new direction in your *life's work*. Many people I know are, however, starting to think about entirely new directions in career-related work. This conjunction could bring into focus a new vision of your future work along the lines of a new commitment, a higher standard, or a new level of understanding. See what planets in your natal chart are being aspected by this conjunction, and see what house or houses are involved. We can hope that the conjunction in *any* area of your life will indicate a new level of objectivity and a broader sense of perspective.

I'd have to say that this new objectivity and perspective will also have to deal with close relationships for most people, whether or not other areas of life are simultaneously involved, mainly because the conjunction is in Libra— and you have to remember that Libra is the *only* sign of the zodiac that deals so immediately and almost exclusively with one-to-one relationships and all forms of partnership. For many, many people this conjunction could mean a new perception of the practical reality of *specific* relationships and of *human relationship in general*. It could show you who is *really* a loyal friend whom you can count on and who is not. It can show you people's motives for being in any kind of relationship with you, and it can show you your own motives in ways that may surprise you. In many people today, it could mean the rebirth of awareness of the importance of relationships, sharing with others, and the traditional values of commitment and responsibility in relationships. The media seems to be confirming that already there is a great increase in traditional marriages and in childbirth too among the baby-boom generation that has postponed such commitments for so long.

I have a theory about the Pluto in Leo generation, which I'll discuss further in a moment. For now I'll just mention that the Pluto in Leo generation is a very creative group, but also a very self-centered one, and it is possible that they are beginning to get a little tired of just living for their own short-sighted objectives alone. Many of them are starting to make new commitments, and I think this Jupiter-Saturn conjunction in Libra is going to bring a whole new wave of re-evaluations of all the experimental things they've been doing, all their self-indulgences. They're seriously thinking of what kind of life they want to live and what kind of relationships they want.

I have a quote here from Liz Greene's *Relating* book, which I think is very good:

> Today the slights, insults, and buried anger of centuries are pouring from the collective level into personal relationships.

This is so true. Many people these days are angry about their relationships, but it is saying more about *them* that they *are* so angry than about the people with whom they are involved. Very often you can see that they are not just reacting to a specific person or to an immediate personal experience; they seem to be reacting *from* some kind of collective, generalized, impersonal experience of their sex or group. It's some kind of collective release of collective, pent-up emotional force and pressure, like a volcano.

After reading this quote in Liz Greene's book, I jotted down the following thought:

> Surely this social trend correlates with Uranus having recently gone through Libra and then through Scorpio, and then Pluto going through Libra also. These planets break up the old patterns, and hopefully Pluto will cleanse the collective levels of the psyche, dirty job though it may be.

So, you have Uranus in Libra totally revamping and revitalizing your awareness of relationships, revolutionizing them on many levels; and then you have Uranus going through Scorpio, an *eruptive* sign. It is a sign that tends to be very repressed and then suddenly totally explosive. And of course Pluto going through Libra will bring to the surface *everything* that is represented in the individual and collective psyche that could be symbolized by Libra, and some of it may be eliminated during this time, although it may not always be pretty to watch! But like it or not, we are all participating in this transformative phase in human relationships. In Western countries, we seem to have more freedom in relationships and therefore seem to be dealing with such challenges more immediately and obviously. However, even in countries like India, a great many women are rebelling against traditional patterns. They are going off to the cities, building careers, and getting educated. Even some

of the rural women are being active in protest over economic difficulties and ecological threats. And when it starts happening in India, you know it's a worldwide phenomenon.

After the vast changes, especially in the area of relationships, brought about by Uranus and Pluto both going through Libra, we now see the Jupiter-Saturn conjunction in Libra beginning to build new structures. Wherever this conjunction is will be an area of life where new structures are initiated and invigorated. But this particular conjunction happens while Pluto is also still in Libra. This renewed focus on relationship, as I mentioned before, will confront most of us with such questions as: dependency, how much we need or don't need people, self vs. others . . . that is, how much to live for oneself, loneliness, and so on. Almost everyone I know has had some sort of major relationship problem since December, when the first conjunction happened. How many people here can relate to that idea? [Many hands are raised.] How many are Libras here, someone just asked?* [Many hands are again raised.] Well, both Liz Greene and I are going to do a talk specifically on relationships during this conference, so those talks should be relevant to many of you.

To get back to the subject of the Pluto in Leo generation, I think that perhaps half the people here have Pluto in Leo. You know, there are two sides to everything. The Pluto in Leo generation is an extremely creative generation of people, and they are just beginning to get into positions of power in the world. We have yet to see how well this generation will meet the challenges of life, especially—for them—the challenge and choice between a power-hungry self-aggrandizement and the creative ideals that many of them deeply believe in. While being creative and idealistic on one hand, this group is also so self-centered and ruthless that they will often insist on doing whatever they want simply because, "I just want to!" My speculation is that this generation will have to confront a great deal of loneliness resulting from this over-emphasis on the self and from the self-indulgence resulting from focusing so much on one's own "self-expression." The Jupiter-Saturn conjunction in Libra, I feel, is already beginning to draw the attention of this generation in particular to questions of loneliness, the limitations of self-centered living, the need to contribute something to society, and so forth. You might say that Pluto in Leo in *compulsive selfishness,* often accompanied by delusions of grandeur! And, Leo being the sign most known for having children, this group has had extraordinarily violent feelings about childhood, methods of child-rearing, resentment about their own upbringing, and the

*A survey of those attending this conference later revealed that a vast number of participants were having significantly close aspects from the Jupiter-Saturn conjunction to important points or planets in their charts.

pros and cons of having their own children. For those of this generation who reject parenthood completely, a rather strange old age may be awaiting them, in which they have no link to the future through children or—more importantly—grandchildren. They may find themselves living in a fragmented society in which our culture's schools, neighborhoods, and morals have been allowed to disintegrate due in large part to the lack of sense of community felt by those who lack that bridge into the society's future—children.

Another thing that might be said about the Jupiter-Saturn conjunction is that it will inevitably mean, at least temporarily, a tremendous amount of new work for everyone, as Jupiter *expands* Saturn. Is that true for a lot of people here? Have you been working extra hard since December when the first conjunction happened? [A great many hands are raised, and many vocal acknowledgements of agreement are heard.] Wow! That is more than fifty percent of you! This weight of increased work also increases overall stress on people, and if this conjunction is strongly activating a natal planet or one of the angles, especially by conjunction, square, opposition, semi-sextile, or quincunx, the increased weight and stress could cause you to *radically* alter whatever dimension of experience is being pressured. You could even feel like you were cracking, as the old shell is being broken to make room for the new structure and the new understanding. Whatever is going on, one of the challenges of Jupiter and Saturn being experienced together is to optimistically plan and work toward the future (Jupiter) while assimilating the lessons of past experience (Saturn), even if you thereby have to deal with fear, resentment, hurt, disillusionment, and pain. This conjunction represents a curious mixture of positive and negative, optimism and pessimism, faith in the future and yet a realistic acknowledgement of the limitations of life that you've learned from the past.

Speaking of realism and disillusionment, we have to discuss one other group of people. Many of you here were born with Neptune in Libra. For many of you, natal Neptune will therefore be in the house where the Jupiter-Saturn conjunction is falling. In other words, this conjunction is going to activate the very house where so many of you have natal Neptune. And, in fact, since the Jupiter-Saturn conjunction is repeating three times over the entire first half of the sign Libra, many of you will have your natal Neptune being closely conjuncted by the Jupiter-Saturn conjunction! Whatever Neptune and Neptune's house mean for you will be actively brought to your attention, and in need of improvement, greater understanding, and probably a new discipline or commitment or structure. In many cases, what heretofore may have been idealized or what you may have been trying *to escape from* or what you've been using *to escape through,* shown by Neptune's house and perhaps aspects, could be brought to your attention by Jupiter-Saturn in an

inescapable way. Jupiter-Saturn activating this Neptunian area of your life could force you to see that area realistically and to expand your understanding of that area of life *beyond* previous illusory or self-deceptive attitudes. Areas of chronic confusion can be clarified during this time; in fact, such previously confusing dimensions of experience may become clarified even though you may not *want* to see them more clearly and realistically. So, whatever house the Jupiter-Saturn conjunction activates, *especially* if Neptune is in that house natally, reveals a real need for developing practicality and for facing things with unflinching honesty and authenticity.

This Neptune in Libra generation seems extraordinarily fixated on *relationships,* compared to my parents' or grandparents' generation. For many people of this group, their whole lives seem centered upon relationship, and their emotional state goes up and down along with the current state of their main relationship. Relationship has become perhaps the main issue that obsesses them. Previous generations had so many other things to occupy them: work, family obligations, etc. But this generation with Neptune in Libra *idealizes* relationships, and thus they're all confused by them all the time. Or they're disappointed in relationships, or they want to try all kinds of new arrangements because they've been disillusioned in some way. And I think it's quite significant that Neptune in Libra constitutes an extremely passive combination of symbols. Neptune is the most passive planet; it's totally yielding. It will yield to infinity and will become nothing eventually. And Libra, especially for a cardinal positive sign, is often remarkably passive or at least *dependent* on others. It is a Venus sign, after all. Libra in many cases is much better at *being loved* than at *giving love*. It's a passive sign that wants sharing, wants to be appreciated; they want to *be loved,* but they don't easily go out and give it.

I think it's significant that this generation with Neptune in Libra is so *oversensitive* about being loved or about being hurt in love. This group so idealized relationship and so much wanted some kind of extraordinarily satisfying idealistic relationship that many of them have become totally disappointed and disillusioned with various types of relationships. Maybe that whole group has expected too much *to come to them,* too much of other people. Maybe they've expected that they should be loved by everyone or by the world; and it takes time, they're slowly learning, to realize how to work at relationship and how to accept what is. As one mystic has said, "What is love without responsibility?" Well, I think that this is perhaps one of the lessons of Jupiter and Saturn in Libra, especially for the Neptune in Libra group.

All right, we've established that the Jupiter-Saturn conjunction will release a great deal of energy in those areas and activities shown by its place-

ment in relation to your natal chart. And earlier I mentioned that it might be useful to see what natal planets and factors were activated by the last Jupiter-Saturn conjunction in 25° Capricorn in 1961. If you want to take this further, you can look up the Jupiter-Saturn conjunction that occurred before your birth, because you were after all born during a certain historical period that embodied certain social values and cultural developments and ideals. A particular energy release was under way when you were born, based on the previous conjunction, and you were part of it—perhaps more actively a part of the society's specific thrust if you were born in the first semi-cycle than in the second semi-cycle.

This may be simply an idealistic fantasy on my part, but the Jupiter-Saturn conjunction in Libra at a very positive level could signify an increased consciousness of the need to *share* with other human beings on an international level. I would certainly hope this develops, because one of the biggest dangers in the world is the horrible imbalance of wealth, food, clean water, investment capital, and health care. Libra *should* have some sense of fairness in social and humane concerns. During this period, we may have to decide to what extent our individual lives have to be related to and integrated with a larger social purpose. Do we *need* to do something in the world? Do we have to contribute something? It will depend on each person's own individual nature, on his or her dharma or destiny. Some of us do and some of us don't need to be involved with the world at large. Some people are more inward and private by nature. But I would expect that this current conjunction would signal to those who *are* destined to play a greater role in the public world that the time has come to begin such activity or at least to prepare for it. Certainly some new sense of community cooperation seems called for by this conjunction, and perhaps the Neptune in Libra group needs to revivify this ideal more than most people.

[At this point, a spontaneous question/answer and discussion session began, which lasted for about an hour, and during which dozens of conference participants shared their current experience of the Jupiter-Saturn conjunction as it activated their own charts. Extremely interesting and decisive events and realizations were occurring for these people. However, most of the discussion proved to be inaudible on the tape recording, so it is omitted here.]

2 – Chart Comparison & the Dynamics of Relationship

Liz Greene

This session is meant to be on the subject of relationship. I know that there has already been some material on this given at the conference. And I wanted first to state that there is an enormous proliferation of techniques in the astrological assessment of relationships and that they are all very useful. They are all in one way or another insightful about different aspects of human exchange. But I am always left with the feeling that if you only approach the issue of relationship in a technical way, by just comparing two charts or drawing up a composite chart, or any of the other range of techniques that we have, then some very fundamental, very important points get lost.

To me, the thing that gets lost is the fact that every relationship contains an element of mystery that ultimately can't be defined, can't be explained. The essence of human interchange is like the essence of the person, and the essence of the person is not in the horoscope. I don't think we will ever find it in the horoscope. Bear in mind the fact that the chart you have in front of you could easily be that of a chicken, or of an opera society, for there is nothing in that chart that demonstrates that it's human. But something works through it which is uniquely the individual soul or individuality of the person. I believe this applies also to interchange between two people. Plato called Eros a great *daimon*. He believed it to be the desire and pursuit of the whole, the One. The acknowledgment of some kind of mystery, some god at work, I believe is terribly important, because without that, all your techniques leave you, in the end, with unanswered questions.

So I would like to begin by stating that, however sophisticated they may be, they can't answer fundamental questions like what the meaning is of a relationship, or how long a relationship will last. I don't think that anything we do as astrologers can answer these questions. No technique can tell you whether you should or shouldn't be in a particular relationship, or whether it's right or wrong to be in it. So if we are willing to acknowledge the limitations of the astrological perspective, then I think we can really begin to use it creatively.

Before I would assess any chart comparison, I would always look at the individual chart before anything else. The reason for this is that you can't put anything into a relationship except yourself. There is no interchart aspect or harmonic chart or converse progression that can reflect any dynamic that isn't in both people. Nothing can go on between two people which they have not brought into the relationship. This sounds perfectly obvious, except that

one tends to miss the obvious. The destiny in a relationship cannot be anything other than something which is encompassed by the destinies of both people. It isn't a third thing that comes out of nowhere. So I would begin with the individual chart. One of the ways I have found most helpful with this is to approach it through images, rather than working to intellectually analyse the chart or define it with keywords. It is rather like a theatre. There are certain actors who have been given certain roles. This raises the issue of fate, because the characters and the costumes they wear, and the particular relationships they have with each other, are given at birth. There isn't a lot one can do about it. One simply is fated to work with those characters.

Whatever you want to call them—gods or archetypal figures or characters in a play—there is a myth or story being told in the horoscope. And if any person comes into my life and plays an important part, he is there because in some way he is connected with my myth. Otherwise he would not be in my life. And he will be carrying the part, the projection, of one of my inner characters. What we seem to do with our horoscopes and with all these different characters is that we elect to identify with some of them and disown others. The ones that we disown become our exteriorised fate, and we meet them outside ourselves. Sometimes another person will carry one of these inner characters for a lifetime. This happens with lifelong marriages. That isn't necessarily a bad thing. It can work very well. The thing is to know what is really happening. Otherwise you are impossibly dependent on that other person in a very compulsive way.

If my myth touches the other person's in a dynamic way, when there is any kind of change or transformation that happens in the relationship, then it's alive, which is as much as one can say about it. Whether it will last, or whether it will turn good or bad, is really irrelevant. At least it's alive. If myths or stories touch, then one has an experience of a relationship containing vitality and life, even if it's difficult. Then it becomes like alchemy. Jung refers to alchemical symbolism frequently to describe the dynamics of relationship. Something happens between two substances that produces what the alchemists called the Stone. The Stone is exceedingly mysterious, and Jung thought it reflected something psychological rather than physical, something to do with the sense of one's own inner centre. If this kind of experience happens in a relationship, then this is rare and wonderful. But I don't think a chart comparison can tell you whether a relationship is capable of this kind of transformation of both people.

Now I would like to go through some of the areas that I would focus on in the individual chart. You can get a sense of the forces that are at work in the relationship because they take the form of images or figures, and you can see them in the space between two people. If you are doing marital

counselling, or working with two people who have come for a chart comparison—whether it's parent and child, or lovers, or husband and wife, or any other pairing—they come in bringing these figures with them. The room is full of them. And the characters that stand in the space between the two people are usually the ones who are not being lived out in the horoscope.

I would begin by looking at the elements. This is something I don't want to spend too much time talking about today, because I've already spent a lot of time writing about it. But my eye would go there first—what is empty or missing in the horoscope? When something is empty we are going to try to fill it, because there does seem to be a basic movement in the psyche toward completeness. Perhaps this is why a human chart acts differently from a chicken's. If a person is lopsided it seems the unconscious will attempt to round him out. If an element is missing, one is usually fairly comfortable about missing it in the first part of life. Often it doesn't seem relevant, it isn't something that one concerns oneself with. You can get by well enough on what has been well-developed. But usually at mid-life this begins to change. Sometimes it starts earlier, and one can be aware of a lack, aware that there is some area of life which is very difficult to handle. Usually we begin by finding a lover who can fill the empty space, but then later on the lover becomes difficult to handle. That is when the figures appear, first in the guise of the other person, then within oneself.

These images may be very earthy, heavy, or airy and sublime, or fiery, or watery. You can find close relatives and cousins of these images in fairy tales and myths. If earth is missing or minimal in a chart, then the actor or actress appears on stage in an earthy costume. This can be an earth mother type, or strong, stable father, the one who in some way represents uncomplicated nature. For the person without earth, this kind of personality is difficult to live with, but he will also idealise it. Earth can also be the doer, the person who is heroic in the world, the one who can go out and make money, the one who can achieve something in society. This is the person with status, a capacity for coping and making things work. It is as though this thing that one is trying to find inside oneself formulates as a figure between two people, and one looks through that figure at the other person and finds him both fascinating and repulsive. The other person who is carrying this image will react to it in a whole variety of different ways. Sometimes he will unconsciously elect to carry the image for reasons of his own. Or he may fight against it, or be indifferent. If he is indifferent, then nothing happens; no relationship occurs. If he elects to carry it, it will usually be because he identifies himself with it. It makes him feel good to be seen in that way.

This is one of the qualities that you notice immediately at the beginning of a relationship. When you are involved with someone who is projecting

this kind of image on you and it is one you secretly like to identify with, then you feel more attractive and more radiant, more confident. You feel as if at last you are truly understood. It is as though the figure not only represents something missing and longed for on the part of the projector, but it also invokes something from your own psyche as well. So stuff gets added to this image in the middle, and it can become the main dynamic in the relationship.

On the other hand, you can fight that figure, and say, "No, I'm not like that. Stop trying to change me, I'm not the earth mother of your dreams, why do you keep trying to put me in that pigeonhole?" This kind of fighting can also be immensely creative and dynamic in a relationship, because it forces you in the end to ask why this theme keeps coming up. It may be a projection from your partner, but why does it keep landing on you? But either way, whether you identify with it or loathe the sight of it, if it is loose in your life, then it belongs to your own myth.

The figure in the middle can also be watery, if water is missing in the chart. This can be the image of the enchantress, or the sympathetic mother or tender father, the one who understands everything and has compassion and can forgive you when you can't forgive yourself. It can be the good father who is nurturing and caring and near, because in the element of water there is so much capacity for intimacy. So if that magical figure that is missing in the chart appears between two people as a watery image, then it comes clothed in the garb of tenderness and intimacy. It can also come as a manipulator, because water also manipulates, devours, disintegrates.

The image can also be fiery. It can be the artist or the actor or the deeply creative person. This is a very common pattern when fire is missing in the chart. One falls in love with the artist, and there is an idealisation of the creative personality. What you love about that person is that he's so creative. But that is a figure in your own myth. If you have no fire in your chart, then this is one of your characters.

If the figure is airy, then he may be brilliant and intellectual, articulate and sociable, and possess all the gifts of detached, amusing interchange. He or she may be erudite, or someone who has an important intellectual contribution to make to society—someone who is politically influential, an accomplished woman, a man of ideas.

All these figures which I have sketched emerge out of the individual chart, either because they are unconscious when an element is missing, or because we identify with them when an element is heavily tenanted. We bring them with us into relationships and experience them through the other person. I always like to know first, when I look at charts in a comparison, what cast of characters the two individuals have brought with them.

There is another area where these characters appear, and that is in aspect configurations. An aspect is not only a dynamic energy or relationship between two basic drives. It is also an image, a figure. To be more precise, it's a quarrel or a love affair between two figures. If there is an aspect in the birth chart where one end or the other has not been integrated or accepted, which seems to be the case particularly with the square and opposition, then one of the planets cuts loose and goes off and appears as your lover, husband, wife, child, or parent. So if I have an aspect such as sun in square to Pluto, I might be quite comfortable about the sun. I may like that face of myself a lot, identify with it. But Pluto is a different issue. If I unload Pluto and don't recognise that this figure has anything to do with me, then I'm going to start seeing Pluto everywhere around me. I will bring that character into my relationships, and then I will constantly have to confront issues of darkness and possessiveness, bitchiness and destruction and devouring. I may also experience deep transformation, but of a particularly painful kind. Pluto's brand of transformation is that you go into the fire and then have a choice of either losing your left arm or your right leg in order to get out again.

If I project this dark figure, then I will meet it constantly in my relationships. I will unconsciously demand that it appear through any person I get involved with. Or if I have something like Venus conjunct Uranus, and I'm not happy with that conjunction because it doesn't agree with the values present in the rest of my horoscope, then I will keep meeting it outside. You can have a very conventional person who believes in a socially acceptable, traditional format for his relationship life, yet who has a Venus-Uranus conjunction sitting in the horoscope. If he doesn't own that and won't live it on some level and pretends that it doesn't belong to him, then he will invoke it in every relationship and choose people who can act it out for him.

Audience: Did you know that's the case with Anita Bryant? She has an exact Venus-Uranus conjunction on the midheaven.

Liz: I'm not surprised. When you carry these things to an extreme, then you have to find a scapegoat to hunt. She's done it on a grand scale.

So any aspect in the horoscope that cannot be met within is going to people the cast of characters met without. And they are gods. I think it's a great mistake to try to reduce a planet to a psychological concept or a metaphor. There is something about these images which has the power to fascinate you and move your life, whether you meet them in other people or in yourself. They change you, which no actual flesh-and-blood person has the

power to do independently. If you meet these images in dreams, it's in a much purer form, because you recognise that the character belongs to you. It's in your dream. You can often see the planetary images very clearly in dreams sometimes. Pluto is often a black man or woman, or comes shrouded in black. He comes out of caves, subways, sewers and basements, out from under the cellar stairs. He lives in boxes which people don't open, or creeps out of dark woods. He often attempts to pursue or rape. He comes out of dark landscapes and fog. Pluto, when he appears in dream imagery, male or female, seems always to come out of a womb of some kind and to carry this flavour of something unknown, dark and haunting.

Planets in particular houses also seem to be part of the cast of the play. This is especially true of the houses that deal traditionally with other people, which is to say the fourth and tenth, the seventh and the fifth. I think we overlook the fifth very easily, when it comes to chart comparison, because we say the fifth is the house of children, so what does it have to do with a husband or wife? But the fifth house is also the house of one's own inner child. This means that the part of me which is a child, which will always be childlike, is going to be coloured by whatever is in the fifth house. If I have an actual flesh-and-blood child, then I will perceive that child through the image of my inner child, which is reflected by my fifth house. So if I have Uranus in my fifth house, what I experience in my children will be the image of Uranus. And they will very obligingly carry it because they're not old enough to fight me. If I have Neptune in my fifth house, then I will experience the image of the victim or the redeemer of victims in my children. But unless I can recognise that the Neptunian victim and the Uranian rebel are part of my own childlike side, then I condemn my children to having to live them out whether they are suited to or not.

We also see these images in the childlike part of another adult. I think one of the most basic psychological dynamics in relationship circles around the child in both people. The way that James Hillman puts it is very nice— that a marriage or any relationship of a binding kind is a place where the child in both people can come out safely. This is one of the expectations we have of our intimate relationships. There is an infant, who may be divine and beautifully childlike to its owner but who is also exceedingly obnoxious, infantile, self-indulgent and demanding. This infant will seek to find acceptance through the protectiveness or the containment of the partner. And the infant reflects the qualities of the fifth house. How it is received by the partner also depends upon the state of the partner's fifth house, his relationship with his own childishness. If you don't want that child in yourself, then you will see it in somebody else. Then we say, "Oh, he's so childish, I can't bear it when he behaves like that."

I think the seventh house is obvious. We all know that the seventh is the house of the other, and the other, ultimately, is internal and not external. It is the most overt place where the characters in our drama materialise in concrete form. The fourth and tenth houses are more subtle, because we say that these are mother and father. I don't really want to get into an argument about which is mother and which is father at this point. I'll argue later if anybody wants to. But these houses represent the parents, and this is another obvious and basic psychological dynamic. Not only do we bring our inner children into relationships, but we also bring mother and father. It's the commonest place from which complaints arise in relationships. It's become part of our modern jargon: mother complex and father complex. The issue of what is in the tenth house is the issue of what you perceive as mother, what mothering means to you. The fourth represents what you perceive as father, what fathering means to you. Your image of the creature that you call mother is in fact an image of the mother in you. These characters are not really the parents; they are images of the parents, actors in your play. Obviously they get projected, especially in the first half of life, because we look for mother and father in our partners. Whenever I have had to assess difficult marriages which have been contracted before the age of about thirty or thirty-one, I have noticed that the tenth and fourth houses represent the figures that are operating in the marriage, much more than the seventh house. In the beginning the first woman that you meet is mother, whom you see through the lens of your tenth house, and the first man is your father. It takes a long time to get over thinking that there might be any facet of femininity other than this image of mother, or any facet of masculinity other than the image of father. That is why we analysts are in business, because it takes half a lifetime or longer to discover that all women are not your mother and all men are not your father. So the planets in these two houses seem to be most active in relationships in the first half of life.

I feel it is a big mistake to assume that we always project mother on women and father on men. It doesn't seem to be that simple. Mother and father, as they appear in the fourth and tenth, are mythic figures, and mythic figures have a remarkable propensity for changing sex. They carry qualities or patterns which are not necessarily defined by bodily sexuality. If there is an enormous issue around mother for a woman, she will often find herself confronting this issue in a relationship with a man. It's actually mother she's grappling with, both in the man and in herself.

Planets in these houses form part of the cast of characters. With all these issues I don't think it's a question of something being good or bad, pathological or healthy. It seems that the situation of projecting psychic contents or figures is something that simply happens. Perhaps it happens because there is

a need on the part of the image itself to find its way into being born in form or in consciousness. If there is a potential in me that is still locked in the image and has not yet developed as part of my life, then it is going to want to be concretised. Sooner or later it will want to live in the world. There is an urge toward incarnation, toward being realised, which seems to be inherent in these images. So they project themselves. It is not that I am doing something pathological or neurotic by projecting. I don't project something in the unconscious; it projects itself. These figures need me, my consciousness, as a midwife. That is the herald for the beginning of some kind of relationship between me and them. When an inner image projects itself, it is as though it is saying, "It's time." And eventually maybe I will begin to get a feeling that this image has something to do with me, and that it doesn't just belong totally to you.

There are two figures that I want to spend some time talking about. They are not limited to particular horoscopes, but seem to be universal. They lie beneath all the personal material in the individual horoscope. I am not sure what they are. It seems as though they are images of two extreme archetypal poles of masculine and feminine. I have yet to see a relationship of any importance where they don't surface in some form.

The feminine pole of this pair has a very curious iconography. Much of the time she appears as the figure of the gorgon. I don't know if any of you have seen *Clash of the Titans*, but there is a wonderful gorgon in the film. There are a number of gorgon legends in folklore. The commonest is that the gorgon was once a very beautiful woman. Some goddess is jealous of her, or some injury is done to her. Sometimes this is a rape. The rape and violation of this woman spawn a sense of terrible outrage and a need to avenge the violation. If you study the iconography of the gorgon right across the Mediterranean cultures and ancient Middle East, you see that she has certain universal characteristics that cross cultural boundaries. She is a universal image. She always has her tongue stuck out in a very phallic way, and there are generally snakes around. Sometimes her hair is made of snakes, as in the case of the Greek Medusa. Sometimes she has two snakes wrapped around each arm. She has very large, staring eyes, and her gaze paralyses. She is an image of outraged, violated nature. I think it is very difficult for a woman to actually recognise when the gorgon appears, because one simply falls into her, becomes her. Men spot it instantaneously. She has a characteristic voice, which is one of injured dignity and outrage. Her surface complaint may be typical, "How could you have hurt me?" or, "If you really loved me you wouldn't have done that." Underneath there is a deep, ancient bitterness. It is the ancient bitterness of women feeling used, humiliated, trodden upon. This is a collective image, a very old experience, but a small personal hurt

can plunge you into this voice that speaks with the pain of millions of years. And the moral side of this is a difficult problem, because from the gorgon's point of view she has a right to be outraged and vindictive. She believes it's all the fault of men. I feel it is questionable whether the gorgon's suffering is anybody's fault. The story is that the gorgon's face freezes into a hideous grimace, because she cannot let go of her outrage.

This figure has a way of inviting herself into relationships with extraordinary regularity. This is the thing so many men fear in women, and it is the thing women do not wish to recognise about themselves. All of the themes of the castrator and devourer are related to this figure. She is a sort of shadow of the feminine principle. I think that astrologically she has a great deal to do with Pluto. She is also connected with the eighth house and with the sign of Scorpio. How this works out in terms of an individual's chart and life seems to vary. I feel that if there is a dominant Plutonian influence in a chart, whether it is that of a man or a woman, then the gorgon is going to be perhaps a little bit bigger and with a few more snakes, and more readily able to be invoked. Because she is a feminine image, she has a tendency, when part of a man's psyche, to project herself on his women.

The gorgon has a polar opposite, and whenever she surfaces within a relationship she has a remarkable capacity to bring her opposite up with her. The name I have chosen to give this opposite comes from Eugene O'Neill's play, *The Iceman Cometh*. Psychiatry knows him as the psychopath, and considers his condition untreatable and incurable. We tend to use the label of psychopath about people who appear to have no feelings. Psychiatry defines the condition as one of inherent moral inferiority, which means that there is no sense of guilt in inflicting pain on others. One cannot be touched on an emotional level. One can commit an action which is antisocial or cruel and feel no remorse, no empathy. I prefer to call him the iceman, and he is a mythic figure. I think he is in some way the shadow of the masculine principle, the extreme limit of it. I suspect that he is the inner burden men must carry, just as the gorgon is the burden of women.

You can see immediately when the dialogue begins between these two figures, when they are carrying on in somebody else's life. It's a lot harder to hear that dialogue when it is your own. The man and woman seem to disappear, and the gorgon and the iceman enter the scene. The gorgon begins to rage, and the iceman withdraws. He says icy things like, "I don't wish to discuss this any further." He tells the gorgon that she is being irrational and overemotional, and makes clear his revulsion toward her. He says, "When you've quieted down and can behave like a civilised human being, then we'll discuss it." But usually he won't discuss it at all, because he gives her outrage

no value. He cannot be made to feel guilty, because he is incapable of guilt. The only thing that happens is that he becomes cruel or leaves.

The dynamic between these two is terrifying, not least because these two figures can emerge in two people who actually love each other and don't want to feel like that. However well two charts go together, the individuals can be trapped in this dynamic. It's like a possession. These figures are not personal, they are archetypal. They are common themes in literature and art, and have been around for millenia. Although they are not personal, they feed on personal grievances. When they come out, if one is gripped by them too much, they can destroy any relationship, no matter how astrologically well-matched the participants.

The issue here seems to be about trying to work with figures such as these from the inside. I feel the gorgon is connected with Pluto, and the iceman with Uranus. In a chart where there is a dominant Uranian or Aquarian emphasis, male or female, then I think the iceman is a little bit more refrigerated than usual. It's easy to see him in this kind of temperament, just as it's easy to see the gorgon in the Scorpionic temperament. But I think they also come rushing in when you find issues of missing air and water in two horoscopes. If you find Uranus or Pluto in the seventh house, you can work out for yourself how quickly both figures will emerge as the motivating energy in relationships. This is also the case when Uranus or Pluto appear in the tenth or fourth or fifth, or if you find aspects such as moon-Pluto, sun-Uranus, Venus-Pluto, moon-Uranus. With all these aspects, particularly the squares and oppositions, the iceman comes down readily from his mountain and the gorgon crawls out of her cave, and suddenly they have taken over the relationship.

Audience: Do they cross over? Say that a woman has a sun-Uranus aspect. Does the iceman come out of her?

Liz: I think that the iceman becomes part of what Jung calls the animus. Yes, he is part of her. But he comes out in a particular way which is very dissociated. It's as though the coldness comes out in her voice, which says all those things. But there's a sense of dissociation, because it's a male figure. He's actually cutting the woman herself down, at the same time that he's saying cold things to the partner. In the end he's an inner tormentor. He punishes a woman's femininity and cripples her feeling. Usually he's projected on a man, but you can catch him inside, criticising and cutting down. With many women he is a terrible problem. But he doesn't destroy the man on whom he's projected, so much as he destroys her.

Audience: Could you give an example?

Liz: Do you mean a chart example, or in practise? In practise it's a particular voice which I've heard from a lot of Aquarian women. It says, "I don't believe in possessiveness, relationships ought to be free from emotional scenes and demands, no one can own anyone. I don't feel jealousy, I find emotion weak and disgusting." That's the voice. Unfortunately it doesn't sit very well in the feminine psyche. There's an incredible touchiness about it, a real defensiveness. When I've worked with this kind of voice in analysis, it often takes months and months and months before that woman will actually acknowledge that she hurts, or feels fear, or is lonely or vulnerable. It may take a very long time. The iceman is inside and constantly tells her that her feelings are silly and worthless and that she has no right to feel them. On the other hand, because it isn't so much a part of the feminine, a woman trapped by the iceman can really get free of him once she breaks her identification with him. That doesn't mean he goes away, but she can challenge him from inside. With a man, it seems so much a part of the masculine psyche that it's a very different process working with it.

I don't think these archetypal figures really change in the way we commonly think of change. Perhaps they alter slowly over centuries. This is a very difficult issue, especially if you work in the psychological field. One of the fantasies that drives us to want to help people is the belief that everything can be changed. The hope of transformation and of curing the sick and the destructive makes up the skeleton of our ethical codes. If we didn't believe we could change, then we would not be involved in this sort of work. And there is a problem with this because on the one hand a lot of inner figures do indeed transform. They undergo permutations, they show a more positive face, they stop frightening us. We become more conscious of them and change our attitudes toward them and they, in turn, become more civilised. The image of the rapist or sadistic man in a dream may gradually change, and although he still retains his Plutonian character, he's approachable. You can talk to him, he isn't intent on killing you anymore, he contributes vitality and sensuality to your conscious personality.

But although these figures may transform in some ways, they also remain capable of reverting back to the extreme negative poles. In some sense it means carrying a burden all of one's life, of the possibility of these figures erupting over and over again in any relationship. I don't think they ever wholly go away. I suspect this is part of the reason why people tend to avoid any really deep work on themselves. We want to believe that sooner or later

we will get the formula right once and for all. But the gorgon is a universal, collective figure. If she is transforming, then she is doing it over a stretch of thousands of years. One individual's efforts with her do count for something, but it's hard to see what this does for the collective. Perhaps it's an act of faith. You can at least learn to confront her yourself, and if she starts erupting in a situation with another person, you can learn to recognise her voice and go into another room and close the door and try to help her pain yourself, instead of expecting your partner to redeem her for you. You can take responsibility for containing her, even if it's inappropriate to take responsibility for her in herself. Or you can take your psychopath, your iceman, away and have a dialogue with him yourself, rather than unleashing him at somebody else. I have a lot of questions about just how much things like this really change. I know that the ego, consciousness, can grow stronger and more flexible, and can contain and understand them better. We are capable of making a relationship with them, which seems to make all the difference. And if you can make a relationship with the gorgon and the iceman, then you're capable of making one with someone else.

Now these two extreme mythic figures have all kinds of male and female images overlaying them which are highly individual and belong to the placements in an individual horoscope. It looks as though all these different feminine figures, both dark and light, extend in a line the end of which is the most primordial one, the Terrible Mother in the shape of the gorgon. All of the different masculine images likewise stretch out in a line until the ultimate primordial Terrible Father, the iceman. You also meet the essence of the Good Mother, the giver of life, and the Good Father, the giver of immortality and meaning. Perhaps all these different figures aren't really separable, but various faces of one. In practise, they wear different costumes and sound very individual notes, with the same bass note underneath. The underlying theme is that they seem to want consciousness. That is why they emerge. They want embodiment. Perhaps they want transformation.

This seems to be the point where the artificial division of what you consider to be your outer and what you consider to be your inner life breaks down. Jung once said that the anima is not only an inner figure, she is also a living woman. Likewise, the animus is not only a dream image, or the masculine pole of a woman's psyche, but a living man. I think it's very difficult to know where these two begin and end. If you're in a close relationship with someone, you may dream about him a lot of the time. You can look at your chart and see perfectly clearly how that person fits something in your tenth or seventh or fourth house, and know on a rational level why he is in your life. But he's both inside and outside. There is no way that you can really separate them. If you find that something changes inwardly, then the outer

person often changes too in his or her attitude toward you. There aren't any answers to this. But you can't really tamper with another person, while you can go a long way toward looking into yourself.

Audience: How does leaving a character out of your life which is in your chart relate to fate?

Liz: I fear this will fill another talk. Fate means what has been written. In myth and fairy tales, all the representations of the fates are always women. They seem to be symbols of the unconscious, the mother out of which the individual personality emerges. I would suggest that there is a connection between the orderly pattern of the unconscious psyche, which unfolds in a person's life story, and fate. I think that an astrological chart describes inner substance. It's the stuff you are made of, the basic matter that forms the psyche. It is certainly what has been written, but it's unformed when you are born. It exists in potential. It hasn't been lived yet. And sooner or later it will seek to actualise itself. We know very little about what the unconscious is. We only know it by its effects, its intrusion into our field of awareness. But one thing is becoming increasingly apparent both to psychology and to physics, and that is that in the realm of the unconscious, mind and body aren't separate things, they're all mixed up. A psychic image and an event coincide. They are part of the same stuff. Jung calls this synchronicity. It seems to lie behind what we call parapsychological phenomena. Whatever the unconscious is, it isn't only psychic. It's also material. The most obvious place to see this is in the issue of physical illness—the link between a psychic state and a bodily illness. So if there is something psychic in me which I am not in any way allowing to actualise in my own life—or if I am too young or undeveloped to provide it with a container—then somehow or other it draws other substance to itself because I'm not giving it any substance. If I don't permit it any substance, then it must get that substance someplace. So I will attract, or it will attract, those situations in life which I may call chance or somebody else's fault or accident or whatever. That image, that psychic stuff, will eventually materialise with or without my consent. If I don't realise that it has anything to do with me, then I feel as though something outside me made it happen.

I realise that it's asking a lot to present this viewpoint of things. The reason I am saying it is not that I have worked out a theory, but that I have seen this happening all the time in my analytic work. When you work very deeply with the unconscious, you can spy on that process of materialisation.

Of course it also involves the analyst, so it isn't really proper spying. You can watch figures first emerge in dreams in a very nascent way. You talk about them and give them time and energy and value, and gradually they begin to manifest in the person's life; they become part of him. There is something intensely awesome about it. You become aware that there is a process going on which the ego is not controlling, but with which the ego can cooperate. So it isn't my pet theory of reality; it's actually something I see living and happening all the time. And I feel that things in the horoscope very literally leap up off that map and materialise before us as our life circumstances. But they begin inwardly. It's inner stuff that the chart describes, not outer circumstance. The issue of giving value or recognition to these images is also very critical, because giving value doesn't necessarily mean acting it out. When I was talking about the gorgon and the iceman, giving importance and recognition to them doesn't mean that I have to become them or identify with them. But it does mean I must give them some kind of substance through which they can live. I can perhaps paint them, or write a poem about them or, better yet, let them write their own poems. I can photograph them when I see them in life or act them in a play. Or I can meet them and recognise them in my clients and analysands, which is what we do as astrologers and analysts and counsellors. We act out our own planets through our clients and then we attempt to understand them and give them advice. This is particularly true if you are a psychotherapist and see people on an ongoing basis. You keep meeting yourself. This may be very creative, if you are conscious of it. If not, you're in trouble. And your client of course meets himself in you. We call this negative and positive transference. Then you can ask that lovely and delicate question that the analyst prizes above all other questions: Do you think perhaps this might have something to do with you?

Any cross-aspect—which means any planet in my chart aspecting any planet in your chart—is an activation of an image. I have a nascent set of possibilities, a bundle of raw psychic stuff which is my own myth, my own story, my own fairytale. What brings it alive is somebody else sidling up to it and giving it a kiss or a kick, which constellates that image in me. So if you are looking at the dynamics of interchart aspects, I think there is a very basic formula that you can work with, which is that the planet in my chart which is aspected is the way I experience the relationship. For the time being, you can put aside whatever it is in your chart which is aspecting mine. Whatever the planet aspected in my chart represents in me, it is activated in the relationship. That part of me is constellated. Now whether it's a good or a bad constellation is a very dubious issue, because it depends very much on how I react to this thing in myself being stimulated. I don't think the results depend so much on the nature of the aspect. So I would not be inclined to

place much value on whether your Venus is in square or in trine to my Mars. But I would look much more carefully at how I'm getting on with my Mars, because if I'm uncomfortable with my own passions and aggressive urges and you come along and stir them up, even if it's a wonderfully benign aspect that looks like a match made in heaven, what I will experience is the darker side of Mars. I might accuse you of trying to make me angry, or of bringing out the worst in me. The actual nature of the aspect is much less relevant than whether I can relate to my own planet.

I have found that relationships in which the charts have a lot of difficult cross-aspects are no less productive and exciting than relationships with a lot of harmonious aspects. The ones which seem to be the hardest are those where there are very few cross-aspects. This is especially the case if my sun, moon and ascendant are not being aspected by your chart. Then I will have the feeling that although you might spend a lot of time with me, you haven't a clue about who I am. There isn't any pickup point; there is nothing in you tuned in to receive me. I don't register on you as an individual if your chart doesn't aspect those fundamental points in mine. So in some way we would keep missing each other. There is a feeling of emptiness and frustration which grows in these kinds of relationships. I would much rather have a relationship where everything in your chart squared and opposed everything in mine, rather than have one where you missed me altogether.

The issue of the sun seems to be very interesting because the sun represents the basic identity. It's my need to be myself, to be different from other people, to be unique, to experience myself as somebody special. It's debatable whether a person is going to be conscious of that in himself to begin with. Very many people aren't, especially when you meet them in private rather than in public. There isn't anybody individual at home. The sun as a reflection of defined ego consciousness is not something that one can take for granted. This seems to be the case especially when the sun in the birth chart is taking difficult aspects. Very often what this means is that the ego's development has been interfered with. In some way the sense of self has been distorted or damaged or has simply not developed very much. There are a lot of childhood situations which are conducive to that kind of damage, where the ego is not yet properly formed and one identifies all the time with other people and with collective values. So expressing the sun is difficult right from the outset, because the person may not yet have his own values and sense of identity. If someone else comes along with a planet aspecting my sun, then that relationship is going to start forcing me to become very conscious of myself. I may not like this very much if I am the sort of person who prefers not to have to be a person in my own right. It's a mistake to assume that because your Venus is on my sun I am going to love being around you and

get on beautifully with you. I may not like it at all, particularly if I don't like my own sun-sign and what it demands of me. All you can say about cross-aspects to the sun is that the other person's presence always reminds you that you are an individual. He may be doing this in a variety of different ways. If the aspect is a square or an opposition, he may be trying to change you, which is an excellent way of discovering who you are. If there is somebody trying all the time to make you into what he thinks you ought to be, you very rapidly discover something about yourself through the sheer effort of fighting him. At least you find out what you're not. This is one of the reasons why difficult aspects are not to be sneered at when you see them at work in a relationship. They may generate the very thing you need the most, by stimulating your awareness of your own nature and needs.

If something in your chart aspects my moon, then what it will constellate in me is more a sense of belonging. One of the moon's meanings seems to be that it relates a person to the collective family, to the instincts and to nature. The moon is not a very individualised thing. It doesn't have much to do with my aspirations as an individual. It is much more concerned with my ordinariness, where I am just like everyone else in the human family, where I feel secure and comfortable being just like everyone else. Because this is my sense of safety, my sense of security, I depend on it. It embeds me in the common lot, and takes away my feeling of isolation. So if your chart aspects my moon, it will stir up this side of me. Again, I may or may not like it, because I am pushed into having to respond to you all the time. If someone touches your moon, you go out to that person; you get mixed up with him. You blend with him, and you can't just cut yourself off and walk away because you feel safe around him. You identify with him; it's an emotional attachment and identification. Even if it's your Saturn on my moon, I will still get attached and identify with your depression.

So if I am someone who finds it very uncomfortable experiencing your feelings and moods as though they were my own, then I am not going to be happy with this contact at all, even if your sun conjuncts my moon—which is supposed to be one of the traditionally wonderful aspects between two people. The moon may not like this at all, because this kind of contact pushes a person into his feelings and needs. The moon needs to belong; it needs other people and needs to be needed. If a person is very unconscious of his own emotional needs, and likes to think of himself as very aloof and independent, then something hitting his moon may horrify him because it constellates dependency.

On the other hand, something aspecting my moon may be immensely satisfying. I may enjoy having this side of my nature stimulated. It can make a woman feel very feminine and maternal when the moon is triggered. She

feels needed. It isn't so easy for a man, because if the moon in a man's chart is strongly cross-aspected he is aware of his emotions all the time. The woman who aspects his chart in this way—or the man, for that matter—constantly pushes him into his feeling needs.

Difficult aspects to the moon can be very valuable because they force you to become aware of what you feel. Even something as potentially ghastly as Saturn opposing your moon from someone else's chart can be valuable, because the other person is always trying to withhold from you the very things you need and value.

I think the issue of the moon's needs is a very interesting one because you find that a good many of the problems you meet in psychotherapy have to do with a person not giving value to his ordinary needs. For a whole host of different reasons he may denigrate or ignore his own feelings. Perhaps he is too spiritual, or has a whole set of strictures about what is appropriate or inappropriate in the matter of needs, or his upbringing has taught him that he should not need anything. He may be very frightened of being merely human and vulnerable and longs to be one of the immortals, or the hero in a mythological drama who doesn't need anybody or anything and can never be hurt or lonely. So it's a very great problem for many people to acknowledge the moon, women as well as men. I find this increasingly with women because as the issue of the sun and independence and individuality preoccupies women more, the moon gets put upon. It's as though there is a prevalent belief that you can't allow them both.

I don't want to go through every planet because I would like some time for discussion. Some planets are more interesting than others, and some are also more complex. I would particularly like to mention the outer planets because these don't receive very much coverage. In terms of synastry they are not usually considered important because they affect whole generations and are considered more or less irrelevant to the individual. I have not found this to be the case. If one of your outer planets is aspected by someone else's chart, what is evoked in you is something beyond the ego's boundaries. Because it transcends these boundaries it can be very, very disturbing. Saturn seems to mark the perimeter of the ego. It's like a skin around the organism. It defines where I end and where you begin. It's the aspect of the ego which is connected with defenses and separateness. The planets that lie beyond Saturn are all felt as enemies of the ego because they threaten its sense of permanence and differentness. The outer planets connect us up with the collective unconscious and with those currents in the collective that belong to our racial heritage. Generations experience these movements at work; they stimulate entire masses of people, entire countries. When these similarities in the deep psychic background are felt by the ego, then it is very threatening

to the individual. He doesn't like feeling that he is just like every other American or Englishman or every other woman or man and that he cannot control his reactions on this deep level. He fears being affected by mass currents that are a part of the time he lives in and to which he is subject, *zeitgeists* that move through particular historical periods and influence entire generations. The fear isn't unreal, either; you have only to look at Nazi Germany to see how the decent individual disintegrates beneath a collective flood.

So the outer planets are threatening. It seems that the only people who don't mind are people who don't wish to affirm any individuality but who want to be part of a mass movement. But generally the outer planets are felt as disturbing. So if one of your planets lands on Uranus in my chart, it's going to stimulate something in me which belongs to the whole ideological fabric of my generation. Generations do have ideologies and are motivated by particular ideas. You can look at the French Revolution as an example. Uranus is very concerned with politics and with social and political images which are given extremely high value as a potential future. So a cross-aspect to my Uranus is going to stir all this up in me. I may find it very uncomfortable, especially if Uranus is in difficult aspect with other planets in my chart and I already find collective "isms" threatening. One of the things I might discover with these contacts is that I have sympathies with things I didn't want to admit sympathy with, particularly more iconoclastic movements or original and eccentric ideas. Or I may simply be forced to acknowledge that there is a world much larger than the one which contains my family, my house, my neighbourhood, and my country. So the other person will push me into an awareness of collective currents that are much larger than me and could swallow me up. This may change me very radically if I'm open to that kind of experience. I don't think for a moment that aspects to Uranus are insignificant in a relationship.

If one of your planets lands on my Neptune, this is even more peculiar. I have got one of the most valuable insights into the meaning of Neptune from kabbalistic symbolism, the kabbalistic Tree of Life. There are different systems of comparing astrology and kabbalah, but the one which I have found most useful places Neptune at the top of the Tree and associates it with *kether*, which means "the crown." Some writers on kabbalism put Pluto there, but it makes more sense to me to see it as Neptune. The crown is the highest point of contact with the divine that our little human egos can make. In kabbalism God is called *ain soph*, which implies nothing, no thing, a mystery about which nothing can be said. You can't even comprehend it, so the kabbalist says there is this awesome mystery that you can't even get near. But the little toe on the left foot of this ineffable mystery is the thing we call the human spirit, and this is our highest value. We have a fantasy of

what God might be like and strive and long for an experience of this thing. Neptune is very concerned with this longing, a sort of longing to go home again. It's the feeling of nostalgia for the Garden of Eden, for the time when we and God lived together in harmony before the Fall, before there was any experience of Original Sin. So Neptune in my chart is the antenna which picks up that other world, the place I came from, the place I long to go back to, where I once was and will be at one with the One. If any of your planets touch my Neptune, then you are going to stimulate that longing in me.

I may not know what that longing is, which is typical of Neptune. I may register it as only a strange feeling, a yearning, and I am going to associate that yearning with you. This is the same as if one of your planets aspects my Uranus. I may believe it's really your brilliant unconventional mind that I'm seeing, instead of realising that I am experiencing the creative mental vitality of my entire generation. So if you aspect my Neptune, I may think it's really you who are the godhead, the crown, the bit of divinity that I have been lucky enough to glimpse. And my longing for you is not going to be human longing like that which the moon feels. It isn't love in the sense of a human relationship. It's a longing for God.

Audience: Doesn't that lead to a lot of problems and disappointments?

Liz: Yes, of course. It reminds me of a line from one of Woody Allen's films, where someone says, "Who do you think you are, God?" and he replies, "Well, I have to model myself after someone." Yes, obviously this kind of thing leads to disappointments in relationship. But I think it's important to understand the nature of the disappointment. The longing in itself isn't wrong or misguided. If someone has the power to stir up that mystical yearning in me, it may be a marvellous thing that I am even capable of experiencing it. The problem is that I eventually have to recognise that what the other person has constellated is not his personal property or attribute, but something to do with my own spirituality. I may find this very uncomfortable if I am a particularly pragmatic or rational person, because then the other person becomes an enchanter. I may not trust him at all, because he has the power to make me feel things that don't belong to my rational framework of reality.

Now, if one of your planets lands on my Pluto, one of the obvious things that happens is that my gorgon appears. What the gorgon does in terms of a collective influence is that it gives me an experience of universal human darkness. There does seem to be such a thing as a collective shadow, collective human evil and destructiveness. If you don't believe in such a thing, then try turning on the news. There is an element in human nature

which is very dark, very archaic, very cruel and vengeful, and which has never been Christianised. I have thought for a long time that Pluto is the one planet that can't find a way into Judeo-Christian theology. There is a place in western religion for all the other planets. You can worship some aspect of God which represents or is symbolised by every other planet. If you want to find Neptune in God, you can look at the Virgin Mary or at the compassionate Christ. If you want to find Uranus, you can consider the Word. Or you can look at things like astrology and find God in its patterns, or go into science and feel awe at the miracle of matter. You can worship Saturn in God as God's law and justice. There are collectively acceptable religious images for the values which every planet represents. But for Pluto there is no place in our culture. In Hinduism there is Kali. But perhaps here we have not allowed God to have a dark face. This was a problem Jung went on about a lot, that for us God is only good and light.

Audience: I guess I would disagree, because it seems to me that the Crucifixion and Resurrection could be symbols for the transforming side of Pluto.

Liz: Yes, you're right, those images embody an experience of transformation. But, on the other hand, the Crucifixion and Resurrection are embedded in a context of meaning. We believe, if we are Christians, that these events meant something, had a purpose. I think there is an aspect of Pluto which deals with nature that has no purpose. I would not argue with you about the nicer side of Pluto being reflected in Christian doctrine. But Pluto has other sides. There is an essay by James Hillman which is worth reading, called *On the Necessity of Psychopathology*. He is writing about the Greek Goddess Necessity, who is called Ananke in Greek. She is also called Chaos. Plato had the idea that ninety-five percent of the cosmos was ruled by Reason, but five percent escaped Reason and was ruled by Ananke or Chaos. That five percent has no meaning, no reason, and cannot be changed. It's that aspect of life which we find intolerable. We cannot bear to look it in the face because it has no meaning, no ultimate spiritual goal. It's just cruel and messy. It's this side of life which I think Pluto, in part, represents. This is what I feel has no place in western religion. We can accept the agony of the Crucifixion because we believe there is meaning in it. But accepting raw human bestiality or irrevocable undeserved bad fate is quite intolerable to the ego, which is ruled by Reason.

Audience: I suppose it's the devil.

Liz: Yes, Christianity tends to call it the devil.

Audience: I was just going to point out that after Christ was crucified He descended into Hell for three days. I don't think I have ever heard any explanation of why that should be part of the Crucifixion myth. It has been dropped from Christian theology, whereas earlier it probably did hold a place.

Liz: The issue of the descent into Hell is again presented from the point of view of the Light, because it is a conquering of Hell. There is so much material on this which I wish I had time to go into, about what this Plutonian darkness might really be about and why it seems to us to be so intolerable.

Audience: I also feel there may be a chaotic element in the world. But most astrological writers tend to view Pluto as bringing terrible, disruptive, unpleasant things which all eventually have some meaning in the larger whole.

Liz: I am sure they must do, but I doubt that it is meaning in the sense that we understand it. You see, I think we are prepared to tolerate Pluto as long as we can say death-and-rebirth. As long as it's clear what the rebirth is supposed to be, as long as you know that at the end of all the chaos the result will be good for you, then you are alright. But when the result doesn't seem to be good for you, or when there isn't any result, when life hits you with something that's painful and pointless and unjust, then it is very difficult to pretend to be optimistic and cheerful about Pluto. I have a hunch that many of the eruptions of a terrifying kind that surface in the collective, like Nazi Germany or any other insane mob after blood when a whole collective goes mad, are connected with Pluto. This is, of course, in all of us. We can't really talk about those things being meaningful and serving some ultimate spiritual goal. They're horrible, and confront us with our own horribleness. There is a mystery in this; I don't doubt that in some very profound sense everything, even this kind of chaos, is a part of the whole, of the godhead. But I question whether it's possible for a human ego to really grasp what it's about. We make up philosophical systems to make ourselves feel better. This is what Plato means when he says that Reason rules ninety-five percent. We will never understand the other five percent, but will keep on trying to find reasons for it.

CHART COMPARISON & THE DYNAMICS OF RELATIONSHIP

God punishes Job for no reason, and this preoccupied Jung very strongly. He wrote an anguished book called *Answer to Job*. Why should God behave in this terrible way to his good servant? There is no reason, except that God is capricious. Jung felt that ultimately this served a purpose, but had no reason. There are a number of issues around this which have no answers. I think all these issues are stirred up when Pluto is touched, and they open an abyss beneath our feet. If something in your chart aspects my Pluto, then these kinds of questions begin to arise. If I am a very light-oriented personality, and believe that in the end the spirt always triumphs and everything contains order and meaning, then I am going to find this experience of Pluto quite terrifying. In Warren Kenton's writings about the kabbalistic Tree which I mentioned before, he associates Pluto with the *sephira* called *da'at*, which means unknowing. It is the abyss, the black hole where you experience the depths of what you do not know. Warren Kenton's books on the kabbala are well worth reading. In his workshops in London, he demonstrates physical postures which express the different levels of the Tree. The gesture he uses for *da'at* is that you put both hands over your eyes and face. You do this because you can no longer see. Everything that you thought you knew counts for nothing.

I think that Pluto is connected with the experience of despair. This doesn't mean that its effects are truly meaningless. But it isn't likely that we can ever wholly comprehend them, especially while they are happening. Obviously this is a very important issue when it's stirred up in a relationship. There are many relationships which start off very promising and then suddenly become depressive. You or your partner goes into a deep depression. And there isn't any reason for this depression. It doesn't seem possible to attribute it to what somebody else is doing to you. You just suddenly find that the ground seems to have vanished from beneath you, and you tumble into your own darkness. I don't think this is the personal shadow of Jungian jargon either, where the problem is to find out what has been repressed from your own personality. It is much more profound. Relationships always carry so much hope; they are our symbols for a hope of the future, the creation of the children of the future. It isn't surprising that many of us recoil from confronting the problem of general human despair and hopelessness right at the moment when you should be feeling joyful.

Audience: Would you relate that five percent of chaos that you were talking about to reincarnation or past karma? Things that the ego is not at all aware of in the present life?

Liz: You could make that connection if you wanted to. If this kind of

perspective is comfortable and works for you, it's as good as any other perspective. It is certainly reasonable. But I'm a little wary of any system that explains everything. Personally, I believe in some kind of reincarnation. But that's a personal belief, not an observation or an experience. I wouldn't use that belief to explain the mysteries in life which I can't understand.

I would like to wrap up loose threads now, and then perhaps we can open the talk up for discussion. Relationships which are very compulsive almost always have strong cross-aspects between the charts. When there are a lot of strong aspects, then I think the invocation of the inner psychic figures becomes very intense. If there is an exact aspect between your chart and mine, then the inner image is constellated before I've had any chance at all to realise what is happening. It emerges with such power that I become compelled or obsessed in the relationship, although usually I will think I am obsessed with you rather than being obsessed by my own unconscious. This doesn't seem to ultimately make a relationship more or less workable, but it does mean that you tend to plunge into it right away rather than shop around and consider. Where the orb of the aspect is wider, it seems to take longer for things to begin to cook, and the emergence of the images is gentler.

I would be very reluctant to read any configuration between two charts as auguring good or bad. I have seen them work both ways. I would strongly, I can't even do it too strongly, recommend that you suspend the kind of morality that passes judgment on what takes place within a relationship between two clients. If it's your own, fine; but for many people, experiences of destructiveness, hurt, frustration, restriction, betrayal and loneliness are needed and creative for that individual. You simply cannot judge from the point of view of "should" or "should not." I will mention one myth in this respect which I find very useful, the marriage of Zeus and Hera. This is the archetypal marriage for many people. Neither of these deities can live without the other. They are brother and sister as well as husband and wife. Zeus is of course the Greek Jupiter, and he certainly behaves like a textbook Sagittarius. He is congenitally promiscuous, because he symbolises the force of creative spirit without discrimination and without containment. He is the raw, fiery, boundlessness of the masculine spirit, whether in a man or a woman. Consequently, in myth, he must pursue every woman that he sees, because it represents a new possibility for creation. He plants his creative seed in dozens of mythical women, and there is an enormous list of his progeny, various demigods and heroes and monsters. The earth is peopled with his by-blows. His spirit must always find something new to fertilise.

At the opposite pole is Hera. She is goddess of the home and hearth,

patron of childbirth, and guardian of the family. She represents that which binds, whether by emotion or responsibility. They are, of course, forever quarrelling. Zeus the spirit takes off after yet another woman, and Hera takes off after Zeus. She is the world of form which demands that he contain himself. She is angry and vindictive to his lovers, yet is also the loving and bountiful Mother. Her highest value is fidelity, which is a very profound symbol. Obviously in the end the myth is not talking about literal sexual fidelity, because Zeus is not a person. He is creative life. Hera is the limitation of life, its form. She is the limitation of relationship, like the alchemical retort which seals the chaotic substance inside it so that it can transform. Without Hera, Zeus is nothing but hot air. He is just an indiscriminate waste of psychic energy. And I expect Zeus would not be even remotely interested in his constant pursuits unless he had a jealous wife. The whole excitement of it stems from the fact that he's not supposed to do it. And she would have no meaning or value if there weren't a husband she was perpetually trying to bring back home again.

So there is some way in which these two figures must have each other. They certainly represent a pattern you can see in many relationships on many levels. One person tries to escape and the other tries to bind, and both images belong to both people. So Zeus and Hera are an archetypal marriage, both of two people and of two images or poles within one person. In the end, no matter how much they complain and no matter how frustrating they find their situation, they are gods and lifegivers, and the whole family of gods and men spring from them. I think it's worthwhile remembering their dilemma before you judge a relationship from the outside. The implication is that without the tension and the challenge and the problems, there would be no life. This is why a difficult problem in a relationship, or a set of so-called bad aspects between two charts, does not necessarily mean one must write off the relationship.

Audience: Could you speak about some of the basic images you have noticed in different nations, and whether they differ in manifestation?

Liz: Yes, and we could go on about that for hours too. There do seem to be very different images of psychic values in different countries. The images of the ideal feminine and masculine, for example, vary enormously. At the roots there is the same common ground. But the American portrait of the ideal woman is very different from the English and the Italian and the French and the German. You have only to look at fashion magazines and films to see this. It probably has something to do with the charts of these countries. If you can set up the horoscope for a nation, you can

learn a lot about the myths and images that work in that particular collective. I suspect it's the reason why some individuals have to emigrate and cross cultures. If an image that is very important for my psyche cannot be accommodated by the culture in which I have been raised, I might be propelled out to seek some other background environment which is more amenable. It is very useful to go to the cinema and watch television and read magazines if you want some insight into what the collective says about its own images. What is fashionable at any given time is an expression of the values of the collective psyche, and it may support or conflict with your own individual images of masculine and feminine and other facets of life. I prefer the chart Dane Rudhyar gives for America to the traditional one with Gemini on the ascendant. His chart shows Sagittarius on the ascendant, which strikes me as extremely apt. The ascendant has a good deal to do with one's sense of purpose in life, the vision that you are pursuing.

Audience: Can you say something about Mars-Saturn aspects between charts?

Liz: If one of your planets lands on my Saturn, then what it's going to trigger is my wound. Saturn in alchemical symbolism is the base substance, the confused mass, as it was called. It is the part of me which is confused and in pain, the old crippled king. It is the place in me where I feel sterile, walled in, maimed in some way. Saturn belongs to the shadow side of life. There is an area in people which they don't want anyone near, because that's the place where they feel deeply damaged and inadequate. They may be very unconscious of it, which makes it even more painful. So your planet will make me very conscious of this painful part of myself. If I am already aware of this side of my nature, it may still be quite painful, but at least I have a chance to see how valuable it might be to be able to show this wound to someone else and learn to trust another person with it. And that other person is going to constantly force me to bring my crippled side into the relationship.

Now if it's your Mars that's involved, then what you will experience is desire, aggression and anger. Mars has many faces. On the one hand, he is my passion, what I want. Jung has a lovely, simple definition of masculinity: knowing what you want and doing what you have to do to get it. That seems to me to characterise Mars. Now if it's your Mars involved in a cross-aspect, then very likely what you will want is me. But there is also anger in it, which comes from anything getting in the way. Mars is, after all, the god of war. He loves challenge and crisis and battle, the feeling of having broken through something and won. Now my Saturn will make sure

that although you may want me, you'll never really have me. If you put these two figures together, Saturn will back off and say, "Oh no, he's seen my weak place, he's aware of my pain," and Mars replies, "Aha, what have we here—a little coyness? There's a mystery about this person, she's withholding something." Mars will try to stir things up, break down the barrier. He has to initiate, to change things.

The outcome is obviously very dubious. It depends very much on how people deal with it. It can be a very dynamic aspect, but the person whose Saturn is involved usually suffers quite a lot from it.

Audience: Does Saturn always tend to suffer through the contact with other planets? Or would that depend on the planet?

Liz: I think Saturn always suffers, although we are not always conscious of hurting. We develop things like psychosomatic symptoms instead. Saturn is a symbol of suffering and loneliness. He represents one's limitations. That is an archetypal situation, it is inherent in life. There are limits beyond which you cannot pass, and things in you which can never be made perfect. I think that one can deal with it in many ways. It is possible to learn to live with those limitations, rather than fighting against them all the time. They still hurt, but maybe not so much. Each time you confront them, they deepen you and strengthen you. Each time you mature, because Saturn is very much about the process of maturing and gaining internal strength. But I think Saturn always hurts. If we lost our capacity to be hurt, we would be dead to life.

Audience: Would you comment on the possibility of long-term transits of the outer planets activating a person's chart so that he becomes involved in a certain type of relationship?

Liz: Yes, that certainly happens. One of the ways in which I understand a progression or a transit is that it's time for something in the birth chart to come to life. If anything transits over one of the nodal points in my basic psychic stuff, it's as though something is saying, "Now it's time for this thing to come out and live." This may happen a number of times during the course of life with different planets transiting. Each time a new level unfolds of that basic potential. So what happens is that the image, the psychic content, projects itself. That seems to be the first thing that an inner image does when it's ready to emerge into life. It may surface first in dreams, and then if I won't or can't make anything of that, which one usually can't because dreams are so ambiguous anyway, then it will find an

object and attach itself. The outer planets never go over the same point in a chart more than once in a lifetime, although they may spend a long time retrograding over that point.

It's as though something in the collective psyche is trying to become manifested through you or me. It wants to become developed as an individual characteristic. And it seems to create an enormous change in the person. He doesn't just fall in love yet again, or get into yet another relationship muddle. His entire life-view and attitude toward himself is changed. So if I am going through the activation of such a powerful image, and the person who is already in my life can't or won't carry such a projection because he or she isn't able to expand and change as well, then I'm going to have to find another object. There is a terrible fascination about relationships that begin under Uranus, Neptune and Pluto transits, especially over Venus, the sun or the moon. It seems to involve something very transpersonal, very archetypal. It's always fascinating and terribly powerful, and it changes the individual. If I see this powerful image in another person, then I will get very compulsively involved with him, and the relationship will alter me. These kinds of transits often leave a lot of wreckage in their wake.

Very often the relationship which has grown out of such a transit doesn't outlast the term of the transit, unless you are at least a little conscious of what has been stimulated. Even then it's difficult, because you feel as though you have outgrown what was in your life before. Sometimes you have to face the problem of returning to mortal life, because the experience of the outer planets is like suddenly being plunged into a myth. They stir the spirit in a very profound way. They open new vistas and unearth new depths. If you associate these changes with the other person, then obviously that other person is given enormous power over you. But I think it helps to recognise that the other person is a catalyst, rather than the magical experience itself. Perhaps anyone would have sufficed as a catalyst at that time who could carry the projection even a little bit. People make the strangest choices in partners under these transits. Sometimes the relationship has some substance beneath all the fire and smoke, and sometimes it doesn't. We're back again to the problem of the mystery, because it's a mystery why some relationships stick beyond such transits and others don't. It's as though you encounter a god during a transit of the outer planets. Something breaks open into a very strange and exciting world. But it isn't a human world, and you have to have a human partner afterward.

Audience: How would you see a cross-aspect between Saturn and the moon?

Liz: Well, I can only repeat what I said about Saturn when I spoke about Mars-Saturn aspects. The moon needs and longs; the moon is mother and mothering. So if someone's Saturn aspects my moon, then the typical dynamic between them is that Saturn once again withdraws and the moon clings. You get a typical kind of dialogue: "Leave me alone," says Saturn. "But I just want to spend some time with you," pleads the moon. And so on. Or Saturn can get very critical, because he feels the moon's needs and they make him uncomfortable. "Why do you always have to do such-and-such?" he says. There is a pair of people I know who have this cross-aspect; it's the woman's Saturn in square to the man's moon. She always nagged at him for not rolling up the toothpaste tube. You may think that's funny, but she went on at him endlessly, picking at all his personal habits. "Why do you have to chew your food like that? Why do you make those slurping noises when you drink your coffee? Why do you leave used razor blades on the sink?" and on and on. Understandably he eventually left her. But Saturn does this to cover the real issue. There is something about the other person's emotional needs which is disturbing and frightening. It can make Saturn feel very guilty about not responding, and when you feel guilty, you start punishing the person who makes you feel that way. Perhaps this man needed too much, and his wife became frightened because he asked from the part of her that was crippled. Perhaps she was afraid she couldn't really give anything, so she turned it around and made it seem as though he was the selfish one with these terrible habits. This is a typical example of the moon-Saturn dynamic at its worst.

Audience: Could you comment on mutual Saturn cross-aspects?

Liz: The same figure is constellated in both people. That's as much as you can say. You can't predict the outcome. With two Saturns, both people's hurt sides are stirred up. You might get a mutual sympathy out of this: "Thank goodness, I've found somebody who understands my fears and insecurities." Or you might get a very negative reaction: "I can't stand being around this person because his ugliness reminds me too much of my own." With two people's Mars in cross-aspect, you can find tremendous desire and attraction, but you can also get endless fighting. "I'm going to be first," says one, and the other says, "Oh, no, I'm going to be first." You get a battle of wills. You can't really know how people will handle this kind of experience. All you know is that the same psychic experience is stirred up in both people. Sometimes you get the problem of blaming if the same inner figure is constellated and neither person wants it. Often it's hard for either person to apologise. One or the other gets to carry the

entire projection: "You're the argumentative one in this relationship," or, "You're the one who always shuts me out and withdraws." Whenever you hear this kind of dialogue, both people are generally involved. But one identifies with the figure, and it's difficult to break the pattern because there is a kind of agreement between them, a collusion. But sometimes there is a tremendous closeness from these kinds of aspects. You feel as though you've found a real friend.

Audience: You said before that when an outer planet is transiting something in the birth chart, you have to project it outward.

Liz: It projects itself. That's what usually happens.

Audience: So it's not that you automatically become conscious of it. It's that you have to project it on someone else.

Liz: It's not always somebody, it can be something too. But the image projects itself. It wants expression. No, you don't automatically become conscious of it. You don't automatically become conscious of anything. Consciousness is a struggle.

Audience: But the image can come out through the process of working on yourself.

Liz: Yes, it can find expression through creative work. Or it can be experienced through a new field of work or through a change of environment, changing house or even country. Somehow or other it will come out. Most of the time, although not always, when Venus is involved it usually gets mixed up with a relationship. The other planets offer other vehicles. But a relationship isn't mandatory with the outer planets. It's just a common occurrence.

Audience: At the very beginning when you talked about the elements, you mentioned that often we project a missing element into a relationship. What if both people share a missing element?

Liz: What usually happens is that both people will try to get the other one to carry that function in the relationship. Sometimes this can get exceedingly funny. If you have two people who both lack earth, they will both wait for the other one to do the cleaning up after them, and get angry at the partner's shortcomings or incompetence with practical things. You have to

keep a sense of humour, because otherwise you can get a terrifc battle going on, unless the couple can find a third person or thing to carry the missing bit. The third person is, unfortunately, very often a child. The child will always have to carry the unconscious of both parents if they are missing the same element. The child is forced into having to act out that element, even if it doesn't suit him. Sometimes, if you are aware of the problem, you can try to channel it into an object. Sometimes this works. If you both lack earth, for example, you can get a house together, and the house will carry the symbol of material stability so that each person isn't always trying to get the other one to manifest it. Or you can share work interests which supply this missing thing, and that can provide a tremendous bond. It's certainly worth trying, rather than bumbling along waiting for somebody else to carry the load.

3—The Myth of the Individual Journey

Liz Greene

I looked up the word "myth" in the dictionary, and the dictionary told me that a myth is an untrue story. Then I looked up the Greek root of the word, which is *mythos,* and found that there are two meanings for that root. One of them is simply a story—not an untrue one, mind you—just a story. The other meaning is a scheme or plan, and it's that latter meaning that I really want to build this talk around. It is myth as a plan or scheme that we need to consider, in the same way that we consider an astrological chart. In some way mythic images and mythic tales portray a dynamic plan of development. They are a map of something. They are the bare bones, in image form, of basic components of behaviour and experience. Insofar as they are given at birth, they are also our fate, which is a point I touched on yesterday.

I would like to talk about working with the birth chart by amplifying it with myth. I have a very strong conviction that if you are an astrologer you cannot isolate astrological symbolism from the broader fields of myth and fairy tale. Astrology is not a pure, isolated subject. To try to understand an astrological symbol, we can enter into it mythically as well as interpreting it analytically. I would prefer to go around an astrological indicator in a circular way, by amplifying, which means bringing other relevant images to the astrological significator. This allows some sense of common meaning to emerge, not in an intellectual way, but in a way where something says, "Aha!" and there is a feeling of comprehension and aliveness.

I will start with two very well-known myths. I would like to mention first that there are several writers on the subject of myth who are invaluable to read. One of them is Joseph Campbell, who I understand has lately become a bit of a superstar here because his knowledge of myth has suddenly become very popular. Another person who is worth reading on the subject of myth is Robert Graves, although he is not nearly as exciting reading as Campbell. You should all, of course, try to get to see *Clash of the Titans.* And there are two little volumes by a man called Robert Johnson. One of these is called *He* and the other, predictably, *She.* It is the themes of these two books which I would like to begin with: the myth of Parsifal and the myth of Psyche. I will touch on these very briefly, and then go into some of the mythic tales and figures which I think cluster around each zodiac sign. So I'll move right through the zodiac and talk about different myths, and then I

will bring in some case material of different people I have been working with to illustrate how these mythic themes appear both in their horoscopes and in their dreams.

Parsifal and Psyche seem to me to be two figures which epitomise a very basic pattern of development of the masculine and the feminine. You can take that as either meaning men and women, or as the development of the masculine and the feminine in both men and women. Their quests are very different.

In a sense you can look at the sun in the horoscope and relate it to the mythic hero or heroine. Psyche is, in a way, the sun in a woman's chart and Parsifal is, in a way, the sun in a man's. Psyche is a woman of unearthly beauty. As she grows up, everyone of course notices this beauty and they begin to worship her as the most exquisite creature ever born, even more beautiful than the goddess Aphrodite herself. Understandably, Aphrodite becomes exceedingly irritated and jealous, because a mortal is being considered equal to an Olympian deity. So the goddess decides to take vengeance upon her human rival, and arranges things so that Psyche must be offered to a monster in marriage. The goddess enlists her son, Eros, to take care of the details like finding an appropriate monster. Psyche is chained to a rock. This image we will meet again in the Perseus myth, of the woman chained to a rock and offered to a monster. In fact, this motif is extremely common in myth and fairy tales. Perhaps it's a way of saying that the feminine journey often begins with bondage, being chained and sacrificed to something which is neither one's choice nor one's fault.

Psyche is attached to her rock and everyone waits for the dreadful beast to come from the depths and claim her. But the god Eros accidentally pricks himself with one of his own arrows as he is setting things up, so that when he sees Psyche he immediately falls in love with her. He doesn't tell his mother, but carries Psyche off to his magical palace as his bride.

For a time they are blissfully happy. But Eros has demanded one condition from his new wife: she is not allowed to ever see his face or know his identity. She still thinks it's the monster who has carried her off, although they indulge in sensuous delights and she is treated with great reverence and love. This demand for blindness and acquiescence works for a while. But Psyche has two sisters, whom you will recognise as a similar breed to the ugly sisters in *Cinderella*. They appear in *Beauty and the Beast* as well. They are the jealous sisters, the shadow sisters. They have heard the rumour that Psyche has not been destroyed by a horrible monster, but is living in a magical palace in great bliss. They are very bitter and envious. They go to visit her and begin to work on her, saying, "Why does your husband never let you see his face? There must be something really ghastly about him. Why don't you

disobey his command and take a peep? You'll discover that he's really an awful beast with a serpent's tail, scales, etc." The sisters give Psyche a knife and an oil lamp, and tell her to creep up on her husband while he's sleeping, shine the light of the lamp on his face, and then kill him.

Psyche, because she is in the dark and very vulnerable and unconscious, believes them. So during the night she gets up and lights the lamp and approaches the sleeping form of her unknown spouse and takes a good look at him. To her horror and wonder and astonishment, she sees that he is not a beast at all, but divinely beautiful. In her confusion she pricks herself on one of the arrows in Eros' quiver, and falls in love with him immediately. But she also spills a drop of hot oil on his shoulder. The pain of the burn awakens him, so there they are confronting one another—she with her astonishing discovery of the real nature of her husband, he with the horrified realisation that she has found out his secret. So he leaves her, because he cannot bear to be seen.

That's only the beginning of the story. I'm not going to violate it by giving you analytic interpretations. I think it speaks for itself. Eros flies away, back to his mother. He goes into a sulk and hides himself away in Aphrodite's palace because he is injured and offended. Psyche meanwhile decides that, because she loves him, she is going to search for him. Thus begins her quest.

Unlike most heroes in myth, Psyche is not one of the brawny, courageous brigade like Herakles or Perseus or Theseus. She is a woman, and in a state of despair. She considers first destroying herself by throwing herself in the river. She gives vent to weeping and storming and wailing. But nevertheless she sticks to her decision to find her husband, despite the histrionics. Aphrodite, the mother-in-law, still hates her human rival and begins to set up tasks to obstruct her. So Psyche must undergo a series of labours, as does every heroic figure, male or female. At each step of the way the goddess tries to thwart her. Yet there is something very ambivalent about what Aphrodite is doing. At the same time that she presents the insurmountable tasks, her own creatures—ants, river reeds, creatures of nature—offer the solution. It's as though part of her wants to destroy Psyche and part of her wants Psyche to succeed. She could easily just strike Psyche dead, but she doesn't. And Psyche, even though she knows perfectly well who is persecuting her, nevertheless prays to Aphrodite for guidance.

Psyche's first test is that she is given an enormous heap of seeds of every conceivable size and shape, and she is told that she must sort them in a day. This is an inhuman task because there are so many millions of seeds. If she fails, then the goddess will kill her. Psyche goes into another hysterical fit and thinks about throwing herself in the river again and whines and moans a lot.

Then the ants come from deep within the earth and tell her to calm down, because they are perfectly capable of sorting the seeds. When the day is up Aphrodite finds the seeds are all neatly arranged in piles. The goddess is furious and thinks up another deadly task.

Now Psyche must gather some of the golden fleece from a herd of man-eating rams. Once again she falls into despair, because there is no possible way she can confront these savage animals and collect the fleece. She is about to throw herself into the river again when the reeds along the river bank tell her to relax, they will collect the wool for her from the backs of the rams while they are grazing. At sunset, when the rams are going to sleep, Psyche can come and collect the bits of wool from the river reeds.

Next, Psyche must collect a vial of water from the River Styx. This is both deadly poison and confers immortality. But it's impossible to get water from this river, because it is surrounded by jagged rocks and full of torrential rapids. Psyche naturally has another fit. But an eagle suddenly appears and offers to collect the water in the vial. He can, of course, get it because he hovers in the air above the dangerous rocks and rapids.

When faced with each of these tasks, Psyche, unlike the typical hero, doesn't do anything. She gives vent to her feelings, and this seems always to invoke some instinctual creature which can aid her because it knows a solution she herself could not possibly formulate. Psyche's weapons are not a sword or a club or even cunning or bravery. Her weapons are life itself.

Aphrodite gives her one final test. She orders Psyche to journey down to the underworld and bring back a pot of ointment from the underworld goddess Persephone. This ointment is said to confer immortal beauty. Psyche actually manages to persuade Persephone to give her the ointment. But right at the end of her quest she fails. Instead of giving the ointment to Aphrodite, in exchange for which the goddess has promised her a reunion with Eros, she opens the pot and tries to apply the ointment to her own face because she wishes to be beautiful for her reunion with her husband. The moment she touches the ointment, she sinks into a deep, deathlike sleep. Just as she is near death, Eros finally gets over his sulk and realises how much he wants her. He is able to confront his mother at last. So just at the point where Psyche is really about to fail, the whole story is redeemed. Psyche is rescued and revived and brought to Olympus where she is reunited with Eros and raised to the stature of a goddess. So they live happily ever after.

Psyche's story is a very curious one because of the strange mixture of passivity and utter commitment and determination. The two feminine protagonists—Aphrodite, the jealous mother-goddess, and Psyche, the beautiful mortal woman—seem to reflect a dialogue which is an essential part of a woman's development. Yesterday I mentioned the feminine figure of the

gorgon. In this story Aphrodite has a good deal in common with the gorgon. She is vain and spiteful and vindictive and jealous, and has no morality of any recognisable kind. She is Psyche's nemesis but also her redemption, for without those tasks Psyche herself could not develop to the point where she would be a fitting companion for her divine bridegroom.

You will have noticed that the quest in this tale is about relationship. It isn't about finding gold or killing dragons or seizing kingdoms. It's about a union with love, the god of love. I think it is a terribly important myth to bear in mind, because whatever other mythical themes you might find in an individual horoscope, the underlying journey of the feminine has a good deal to do with this story. I am sure there are other equally relevant myths of feminine development, but this is one of the most important. You can take it as an image of the external pattern of relationship or of the internal pattern where a woman seeks union with her own creative spirit. Both are equally valid. I have often found it interesting that many women dislike the myth of Psyche. They seem to find it insulting because Psyche doesn't kill any dragons. But this doesn't do justice to the difficulty of her tasks. And I suppose if you are an Aries or a Scorpio you can kill dragons and still find Psyche relevant anyway.

Parsifal is a very different figure, because he is active in a more overt way. His story begins with the child Parsifal and his mother living together in a wood. There is no father. In some of the versions of the story Parsifal's father is a noble knight who has been killed in battle. In other versions he is the Grail King. Either way, he is unknown to Parsifal, who lives in the woods in a state of wonderful peace, embraced in the maternal womb.

One day a troupe of gallant knights rides through the woods. Parsifal is terribly curious and wants to follow them. He becomes very restless and dissatisfied. He has a terrible argument with his mother, who doesn't want to let him go. She tells him that his father was killed because he was a knight, and that she will not permit her son to risk such danger. She threatens and weeps and wails and tries to hold him. In the end, of course, he leaves, dressed in a very silly parody of knightly armour, and goes off in pursuit of the knights. After this he goes through many adventures, including confrontations with both men and women. He gains in experience, although he is still very foolish. Then one day he finds himself in a magical castle. He doesn't really know how he got there, because he hasn't been aware that he was looking for it. He simply finds himself there in this strange, numinous place. There is a procession taking place. There is also a sick old king, with an incurable wound in his groin that bleeds and bleeds and cannot be healed. And Parsifal sees the Grail. In Wolfram von Eschenbach's version of the story, the Grail isn't a cup. It's a stone, like the Philosopher's Stone in alchemy. In

Chrêtien de Troyes' version it's a cup. Whichever way you take it, the Grail is a holy object with miraculous powers. Parsifal watches all this going on, and he's dying of curiosity, but he doesn't dare ask anything because he is still bound by the rules taught him when he was a child. He must not be rude and ask questions of strangers.

Parsifal sits with sealed lips, and the procession passes and he wakes up in the woods with the whole thing gone. He is then told that he has made a terrible error. Had he asked the right question, then the sick old king would have been redeemed and the barren land saved from destruction. But he very stupidly pretended that the entire vision had nothing to do with him. The question he should have asked was: "Whom does the Grail serve?"

After this, Parsifal begins his conscious quest, which is to find the Grail castle again and ask the right question. Now he knows what he has always looked for, once he has lost it. He was given something by an act of grace but failed to penetrate its meaning. After twenty years of suffering, hardship and further adventures he eventually finds the Grail again. Of course he knows enough now to ask the question. The old king can now be healed and die in peace, giving his kingdom and the right to be custodian of the Grail to Parsifal. Sometimes he marries the old Grail king's daughter, in some of the versions.

The myth of Parsifal would seem to touch on the issue of finding the real father, the spiritual source, and healing the wounded spirit. The old king can neither live nor die, but lives in a state of agony and impotence while his lands are laid waste. The youthful, foolish Parsifal must find him and care enough to ask the question of him. What is this Grail? Whom does it serve? What has happened to the old king? What is the meaning of this experience? Parsifal is not a heroic character. He is rash and impetuous throughout the story. He fumbles and bumbles. He is often a fool. He is also courageous, and learns compassion through suffering. He takes on challenges without at first realising what the consequences might be to himself or anybody else. He is a characteristic youthful masculine spirit, drawn by his fate to a destiny yet not realising even when it bursts on him that there might be such a thing as a destiny. The quality which he possesses in greatest abundance is his brash courage, just as the quality which Psyche possesses in greatest abundance is her fidelity to her love.

Parsifal and the old king are like Psyche and Aphrodite in the earlier story. They are two masculine figures in a dialogue. Their relationship is an image of an underlying pattern that I believe is relevant for any man, regardless of the individual themes in his horoscope.

Myths usually characterise a dynamic between two figures. Sometimes there are more than two, but a myth is never just a static picture. In a sense

you can see all the characters in a myth as part of one thing. Parsifal, the old king, and the Grail itself are all part of an inner dialogue. Psyche, her sisters, Aphrodite, and Eros are all part of an inner dialogue. If you can see it in this way, then you can also see that we sometimes identify with one character in that dialogue, and draw other people into our lives to play the other parts. But the whole story has something to do with ourselves.

The image of the quest is itself a mythical theme. The quest is a very powerful theme. It underpins many of our most popular films and novels, whether it is a seeking for treasure, for a man or woman, for knowledge, or even for exploration of outer space.

Now I would like to touch on different myths that seem to throw light on particular zodiacal signs. As I go through these, I hope you won't take them in a rigid or literal way. The whole point of my standing up here telling you stories instead of being analytical and full of professionally competent astrological definitions is that I am trying to open a door to the imaginal world. I don't mean these stories to be taken up by the intellect and used as keywords or rigid definitions. So the myths which I am about to mention are only a few among many which might be relevant. Myth is so vast a subject that you can spend your entire life learning about it. My knowledge of myth is, unfortunately, limited to certain cultural chunks. I have quite a good familiarity with Greek myth, but am virtually ignorant about North and South American myth. I know a little about Teutonic myth, but nothing to speak of about Indian and even less about Egyptian. So there are many relevant tales which I will not mention, simply because I don't have the knowledge to bring them in. If you are going to study myth so that you can swim in this imaginal world, then it is up to you to do your own pursuing of mythic themes which mean something to you. Different people have affinities with different gods.

One of the ways in which we tend to take each zodiac sign is that it represents an energy or set of characteristics, or an aspect of a cycle. All these different ways of approaching the signs have been explored in many books. But you can also look at a zodiac sign as a story. If you consider Aries, the first sign, you can certainly think of keywords like aggression, one-pointedness, impulsiveness, energy. One of the stories which immediately springs to my mind with Aries is the story of the knight who rescues the damsel. Medieval legend is full of these figures, like Lancelot and Gawain. Myth is also full of them. Perseus is a good example. The interchange between the knight and the damsel is something I associate very much with Aries. The damsel is always frail, helpless, and victimised. In order to rescue her, the knight must always confront some sort of monster. Often this is a giant or an ogre, who possesses the princess or holds the maiden in chains. Sometimes the

giant is the maiden's father, who obstructs the knight and won't let him have the woman. You often meet this motif in fairy tales. I think Aries particularly has to do with winning the maiden from the giant or terrible father, rather than from a dreadful mother or witch. Aries is about male-to-male combat, in order to win the prize. The whole of the Arthurian cycle of legends seems to me to have an Arien feel. The knight is always noble. He is never mean or petty, and he observes a clear and terribly high code of honour. He will risk his life in the most foolhardy ways to rescue the maiden.

There seems to be an issue here of rescuing some feminine value, something undervalued and small and helpless, by wrenching it from the grip of a tyrant who enslaves it. Jason, who goes in search of the golden fleece, rescues not only the fleece but Medea as well while her father comes in pursuit. When I have observed the ways in which this mythic theme might reveal itself in the lives of Aries people, I connect it with Aries' propensity to find a cause to fight for. There is something which the Aries person, man or woman, seeks to redeem, which everyone else has rejected or which is imprisoned in stifling collective values. The Aries may have to fight the tyrant of calcified collective values, the tyrant ogre or terrible father. Or it may be the monster of stupidity or stagnation. This helpless and precious thing which Aries values so much could never be freed without his interference and foolhardiness and courage.

Jason is a very good image of an Aries not only because of the obvious symbol of the golden fleece, but also because he reflects Aries' great weakness. Jason makes a terrible mistake in the myth. He mans his ship with the bravest warriors and goes off in pursuit of the fleece into unknown, uncharted territory. When he arrives at Colchis, he meets Medea, the daughter of the king of Colchis. She is a priestess and a sorceress. She helps him to get the fleece, and they manage to escape although her father follows in pursuit. But when they arrive back in civilised lands where Jason is known and welcomed by the collective, he abandons Medea. Although they have shared great adventures and she has borne him two children, he is offered a chance to become a king if he will marry a young girl who is the reigning king's daughter, so he sells out. He has forgotten his knightly code and is falling into the very collective which he had risen above in his courageous quest.

Medea, who is probably a Scorpio, destroys him in revenge. She murders his young fianceé, and then kills her own children. She curses Jason and vanishes in a chariot drawn by dragons. Jason is an Aries gone wrong. He has the typical chauvinism of an Aries. He gives value to the feminine as long as it is difficult to obtain; but once he has it, he loses interest in it. He forgets that he must fight the same fight over and over again on new levels. In the end he dies a very silly death. A piece of wood from his own ship falls on his head and kills him.

Myth is quite densely populated with Taurean bulls. One story about bulls which has caught my imagination and which I feel has some connection with Taurus is the story of King Minos of Crete. Minos is a very interesting character. In a way, he is Taurus, in both the best and worst senses. He is ruler of the whole Aegean Sea, with immense wealth and power. Under his rule the Cretan people rise to great heights of culture and refinement. He is favoured by the god Poseidon, lord of the ocean depths. In Greek myth Poseidon is not quite the same god as the later Neptune, who is much fishier. Poseidon is an elemental fertility god. He is called Earthshaker, because in the form of a great black bull he roars from within the subterranean caverns of the earth and makes the ground shake. He is also a god of horses and is the consort of the Mother Goddess. So Poseidon favours Minos and makes a deal with him. He promises Minos eternal supremacy over the seas, if Minos will offer him in sacrifice a beautiful and perfect white bull which is part of the sacred herd. The god keeps his side of the bargain, but Minos doesn't keep his. He looks at this splendid bull and says to himself, "Why should I give up this bull? It's my bull, my possession. Why should I sacrifice it? It looks much better alive in my herd, breeding more bulls, than it would dead on the altar offered to the god, who, after all, doesn't need it."

So Minos decides to cheat Poseidon and offers another bull, also white but just slightly blemished, in exchange. He cannot offer his precious possession, although by rights it belongs to the god. Because of this act of greed, he invokes the fate which follows. Poseidon is quite naturally irritated, and asks help from Aphrodite to avenge himself. Aphrodite afflicts Minos' wife with an overwhelming sexual passion for the white bull. Minos' wife and the bull manage to have a clandestine affair, which is accomplished by her crouching inside a wooden cow which Daedalus, the palace craftsman, has built. The queen becomes pregnant by the bull, and gives birth to the Minotaur, which is a hideous creature with a bull's head and a man's body. The Minotaur eats human flesh. Minos doesn't dare kill the Minotaur, because he recognises the god's punishment. But obviously he has to hide it, since people might talk. So, in shame and disgust, he builds the great labyrinth and hides the Minotaur at the heart of the maze. Twice yearly he must feed it victims, virginal youths and maidens. He cannot destroy it because it is the living embodiment of Poseidon's curse and the emblem of his guilt. In the end, Theseus must come and destroy the Minotaur. So the whole story ends in a kind of redemption, because Theseus becomes king of Crete and achieves heroic status through the Minotaur.

There is something inevitable about Minos' fate. He is not an evil man, but rather something like a figure from classical Greek tragedy—a great man with a fatal flaw. But the flaw, the mistake, is in some way necessary for the

development of the story and for the redemption at the end. Minos' greed and possessiveness is the very thing which allows Theseus to become a hero. If there had been no Minotaur, no one would have ever heard of Theseus. And all that Theseus brings to his people, the great deeds and laws and the uniting of Attica, follow directly from this fatal flaw in Minos.

It would seem that there is something very important about the way in which myth presents these flaws and mistakes without moral judgment. The gods get angry, but they themselves behave very badly, and their punishments are much more outrageous than the crimes they are meant to punish. Minos' mistake is a necessary mistake. It's something that must be gone through, and I have met a great many Taureans who have made this mistake. They fall into it once and it has serious consequences and in the end it can be redeemed. It's a necessary part of the pattern of development for Taurus. The issue is one of trying to cheat the gods of what has been promised by claiming it as one's own. It is really a religious issue, rather than a materialistic one. Minos' sin is that he doesn't show the proper willingness to offer up to the god the thing he values the most. Instead he claims it for himself. This seems to be very much about Taurus needing to acknowledge from whence the gift comes, rather than saying, "I own it, I built it, it's mine and no one can take it away from me. I owe no one anything." You find this same theme in Buddhism, the theme of nonattachment and recognition of the true inner self, and Buddha is traditionally a Taurus.

Gemini has a very different flavour. There are a number of stories of twins, and also of youthful lovers, which might be appropriate to mention in connection with Gemini. The story of Castor and Pollux, or Polydeuces in Greek, seems an obvious one, since these are the twin brothers for whom the constellation of Gemini is named. One twin is the son of a mortal man and one the son of Zeus. In that image alone I think a good deal of Gemini's meaning is imbedded.

The mortal twin is killed in battle, and the divine twin mourns and pleads with his father Zeus to restore the dead brother to life. Zeus makes an arrangement with them. He can't just bring a dead man back to life because Hades has claimed the soul, and once a soul has gone to the underworld, you can't get it back again. So they make a deal between Zeus and Hades, whereby one twin may remain alive on earth and the other must remain disincarnate in the spirit. They can never be in the same place at the same time. Zeus grants the boon of renewed life, but the twins must be forever separated, and while one of them exists in the divine world, the other must endure the difficulties of earthly life as well as its joys. Then they change places. Sometimes Castor is mortal and sometimes Polydeuces is mortal. And they forever long for each other.

Gemini seems very often to find the experience of mortality very dark and depressive. There is a loss of faith and of light, because when the mortal twin looks up and remembers his divine brother in the spiritual realm that he cannot reach, it casts a shadow on his own existence. For the divine twin, the loss of his brother and the compassion for the sorrows and tribulations he experiences on earth equally cause him suffering. There seems to be a very deep longing in Gemini for the reuniting of these two halves. Call it what you like, spirit and body or Self and ego or divine and human. But the myth seems to be saying something both very sad and also very comforting. Although the twins cannot be in the same place at the same time, they are part of one whole and can never really be separated.

There is another myth which I think is connected with Gemini. This is the story of the Kabiroi, the dwarf brothers. The Kabiroi were worshipped as gods on the island of Samothrace. Odysseus stops here in the long route of his travels from the Trojan War back home to Ithaca, and he is initiated into the Kabiroi's mystery cult. The secret of the Kabiroi seems to involve the killing of another brother by the dwarfs, so you have the theme of sibling jealousy and rivalry instead of the theme of sibling love. The Kabiroi particularly like suppliants who carry blood-guilt, especially if they have killed a brother, because this is their own crime. James Hillman writes about the Kabiroi mystery and feels it seems to be connected with the experience of duality. What the Kabiroi offer is not the peace of union and oneness with the spirit. They offer compassionate acceptance of the pain of duality, of ambivalence. They can give the capacity to live with the sense of distance between body and spirit, and the enmity between them, and yet draw something creative from embracing both. So I think this too is very important for Gemini.

Now we come to Cancer. I think it's important to remember that all these mythic images consist of a dynamic between two or more characters. We traditionally think of Cancer as the mother, but I feel this is a mistake. I believe that Cancer is about the mother and the son. After all, mother doesn't mean anything unless there is a child. Otherwise there is no mother, it's a meaningless concept. It seems to be a characteristic of mythic themes, if we look at them in terms of a pattern or a kind of fate, that we often elect to play one of the characters and then find the others somewhere outside ourselves in life. Aries can play either the gallant knight or the helpless maiden, and Taurus can be either Minos or his Minotaur, as well as Theseus. Gemini can be either of the two brothers. And Cancer can identify with either the mother or the son.

There are a great many mother-son stories in myth. Among these are Cybele and Attis, Ishtar and Tammuz, and Aphrodite and Adonis. Myth

abounds with great mother-goddesses who are fertilised by the wind, or by an almond seed, or by no visible father. Some of them perform parthenogenesis, which means fertilising themselves and bearing a son from their own creative source. The son is always a beautiful youth, and he is usually a god or *daimon* of vegetation and fertility. He is a kind of gentle, creative life-spirit who comes into birth in the spring with the new crops and dies before he has achieved manhood in the autumn. He returns to the womb, to the underworld, and spends the long winter in darkness. Then he is reborn in the spring. These cyclical changes were worshipped particularly by women throughout the Mediterranean countries and Asia Minor, with great processions of wailing and grief for the death of the young god in the autumn and rejoicing and orgiastic rites in the spring.

The relationship between the mother and the son is always highly ambivalent. She is first of all his mother, but also his lover. She initiates him into manhood, yet will not permit him to be a man, and must in the end call him back to herself. So she is responsible not only for his birth, but also for his death. In the story of Aphrodite and Adonis, which is a later version of Ishtar and Tammuz, the goddess adores and worships the youth, yet he is killed by a boar, which is one of her sacred animals. The divine side of the goddess loves him, but the dark instinctual side in the end destroys him. Then she mourns him all through the winter. The petals of the anemone are said to be blood-red because they grow out of the blood of Adonis which has spilled on the ground. But he is always reborn with the spring. I think there is a kind of cycle inherent in Cancer, of giving birth to something, some creative and beautiful young spirit, and then calling it back again. This whole story seems to be about the process of creating, and about the strange ambiguous relationship between the ego which creates and the unconscious matrix from which creative inspiration comes. I don't think Cancer is really about domesticity at all. If you are a Cancer and elect to identify with the mother, then you must find the son somewhere externally in your life. This can be someone with whom you are involved in a relationship where for a while he is your lover and then goes away. Or the son may be an inner son, a creative inspiration, which blossoms for a while and then mysteriously disappears and goes back into darkness and stagnation and depression until it's time for his rebirth.

If you elect to identify with the son, which is the case with many Cancerian men, then you must find the mother somewhere in your life. She may first appear as the actual personal mother, or the woman with whom you are involved. She can also be the power of your own emotions and instincts, which are sometimes life-giving and then threaten to destroy you. Incest with the mother in these stories is, I think, very much about incest with the

imagination, or with the unconscious. It is both life-giving and threatening, and demands a price. But there is always the promise of regeneration and rebirth.

I tend to associate Leo particularly with Parsifal, whom we have already met. Although Parsifal can be taken as an image of masculine development in a much broader sense, I think he is also the sun, and you can take the sun in the horoscope also as an image of the development of the masculine side of the personality. Leo has always seemed to me to deal with issues about the son-father relationship. Capricorn also deals with these things, but from a different point of view, and I'll get to that later. But I long ago became convinced that Leo is not really concerned with the showy, exhibitionistic, extroverted figure in popular sun-sign columns. I don't even think Leo is kingly. He's heroic rather than kingly. Apollo the sun-god is not king of the gods. Zeus is king, and I have felt for some time that if there is any sign which is really kingly and imperious, it's Sagittarius rather than Leo.

Whenever I have worked with Leos, I have found that the deepest longing and source of suffering is the need for the person to find his or her source. Of all the signs Leo is in many ways the most deeply religious. The theme of the search for the Grail and the healing of the sick spirit which is custodian of the Grail seem to be very much about the question, "Who am I and where do I come from?" This whole theme underpins Leo's creative drive. Leo's creativity, like Parsifal's quest, is not really for an audience, but is rather a way of trying to find something, to make contact with some inner thing. If I create, whether it's a child or something artistic, perhaps somewhere in my creation I might glimpse the footprints or the fingerprints of the life-source that has created me. I think children are so terribly important for Leo because they seek in the faces of their children the same miracle that gave birth to them. Leo is in many ways a deeply introverted sign which seeks nothing less than the Grail, in whatever form it might appear to the individual Leo. In Christian symbolism the Grail is the cup which holds Christ's blood as he hangs on the cross, or it is the cup from which he drinks at the Last Supper. But the Grail is actually a much older symbol than Christianity, and in early Celtic myth the Grail is a feminine vessel, Keridwen's cauldron, which is the soul and the source of life. I mentioned before that the Grail is also the alchemical Stone, which is eternal and incorruptible and gives the secret of immortality. It is the indestructible thing at the centre, the mystery of one's innermost identity. The Grail can only be found in company with the sick old king, and the sick old king is a part of Leo, which is terribly uncomfortable to experience. It is a kind of depression of the spirit.

Parsifal gets two tries, and so, I think, does Leo. The first time seems to be an act of grace, while the second is the reward for a life's long labour.

Sometimes the first glimpse comes in childhood, which is usually romanticised by Leo. I have seen this pattern in a great many Leos' lives. For a time everything is marvelous and blossoms, and they don't question why, anymore than a child questions why the sun shines. It's taken for granted. It just happens that way. Leo often has an aptitude for drawing the best things in life. Then it seems to go wrong. There is a sense of barrenness, and life becomes a wasteland. There is an experience often of loss of meaning. The right question wasn't asked. Once Leo begins asking the right question, which I think is this question of identity and source, then he has a chance to re-find what he has lost.

Virgo, in its original meaning, has nothing to do with sexual virginity. The word simply means an unmarried woman, i.e., a woman who does not belong to a man and is no one's wife, whose identity is her own. She is not the possession or the complement of anyone. Virgin goddesses abound in myth. There are a great many of them who are paradoxically virgins yet who also are impregnated, not by a mortal man, but by the spirit.

The last one of a long line of these virgin goddesses is, of course, Mary. But she has a great many predecessors who were assimilated into her when her cult began to flourish in the twelfth century. Most of these predecessors are not very chaste. But they are, like her, impregnated by something numinous and incorporeal, from within or from above. They are unmarried, but become vessels for the birth of a divine child.

One of the better known of these virgin goddesses is Persephone, a figure whom I connect very much with Virgo. She is a virgin goddess of spring. She is the daughter of Demeter, the goddess of the harvest, and she lives with her mother. She is enclosed in a sensual, maternal world. Life is bound up wholly with the senses, and as long as one knows the name of everything and the order and pattern of everything, then one is safe and sheltered and protected. The mother-daughter bond doesn't allow in any of those dreadful men who might shatter this safety.

But there is something in Persephone which seeks experience, and she goes off wandering by herself one day to pick flowers. Hades has had his eye on her for some time, so he plants a wonderful flower just where she can see it. It's a narcissus, which was associated with death. No sooner does she pick this flower than the ground opens up beneath her feet and the lord of the underworld arrives in his black chariot drawn by black horses. He abducts her and drags her down into the underworld and forces her into a death-marriage. She is given a pomegranate to eat, which is a fertility symbol because it has so many seeds. In the underworld she becomes queen of the dead and bears a child to Hades, the divine child who is called Dionysus.

The version of the myth which is taught to children in school is a little

cleaner, and there isn't any divine child. The word rape isn't mentioned. In that version Demeter, Persephone's mother, makes a great stink and demands the return of her daughter or she will lay the entire earth to waste. Eventually Demeter, Hades and Zeus make a deal whereby Persephone spends half the year with Hades in the underworld, and half the year with her mother. But in the older version, which seems to be the basis for the Eleusinian mysteries, the main point of the whole episode is the underworld child, Dionysus, who is also called Brimo or Zagreus. She remains queen of the underworld, and although she can be reunited with her mother, she cannot be the same again because she is mother and wife. Yet paradoxically she is still worshipped as virgin.

The issue of the rape from the underworld seems to have a good deal to do with Virgo. Something from the nonrational or unconscious realm comes up and penetrates the innocence of Persephone's world. And although she can go back again to her mother, there is always the divine child. Dionysus is a very interesting god. On one hand he is a god of ecstasy, the ecstasy of the flesh. On the other hand he is a god of death, which befits his begetting. So he rules both life and death. Whatever it is that Persephone gives birth to, it is a bit like the dark face of Christ. Dionysus is a redeemer, and he's the pagan answer to Christ. He possesses many of the same attributes as Christ. He is dismembered and resurrected. He is born of a virgin. He has a divine father. He offers something precious to mankind. In the case of Christ, it's redemption through the spirit. In the case of Dionysus, it's redemption through the senses.

Audience: On the subject of purity and Virgo, could you relate the symbol of the unicorn to the Virgin Mary?

Liz: The unicorn is supposed to be caught by a virgin. If you want to catch a unicorn, you must find a virgin, which may not be easy in San Francisco, and she must go and wait in the woods. Then the unicorn comes and lays its head in her lap. I think we have to ask what purity means. Perhaps it has to do with intactness, self-containment. I think it might be an individual who is himself or herself, whose values are not borrowed or contaminated.

Audience: It sounds as though sensuality is very strong in Virgo.

Liz: The sensual side of Virgo seems to me to be very much in evidence. Perhaps the more prudish Virgo of the textbooks is a Virgo who is terrified of the power of his or her sensuality. All you have to do is go to the

cinema and take a look at some of the Virgo actresses—Sophia Loren and Jacqueline Bisset and Lauren Bacall and Anne Bancroft—and you can see how strong a sensuality they exude. I think the issue of purity and sensuality is very paradoxical. Many of the ancient virgin goddesses are also harlots. They are fertile and promiscuous, but they belong only to themselves.

Audience: Do you think it's dangerous for Persephone to stay too close to her mother?

Liz: Yes, there is a danger in that. You could say that it's necessary for Persephone to be raped, because otherwise she never becomes anything more than an extension of her mother. Demeter is the earthy life of nature. I think Virgo at the beginning of its journey is often very bound up with the earth and with obeying the laws of nature. Then you get the classic Virgo, obsessed with hygiene and food and diet and all the rest of the paraphernalia. There's a terror of letting anything into life that isn't in accord with these laws. You can see that sometimes with Virgos who get overwhelmed with the idea of being clean, scrubbing the floor five times a day to keep out the germs. Then the mother becomes dangerous.

Audience: Persephone brings on her own fate.

Liz: Yes, in that way she's like Psyche. She invokes the entire thing by picking the narcissus. But it's not an overt, conscious action. I think that when myths portray this kind of apparent passivity, which both Psyche and Persephone have, it's very important to look at what they are actually doing. It looks as though life just happens to these women. But they have really invoked it. Perhaps some people need their experiences brought to them in that way, so that they can become aware that conscious will is not the only governor of life. Or perhaps this is a deeply feminine way of moving through life. I suspect that this is partly why the goddesses of fate are always goddesses rather than gods. There is a feeling that one's fate unfolds, and there is something apparently very passive about it which is bound up with the feminine.

To the masculine psyche this passivity and unfoldment is very offensive. When Parsifal finds out that he has botched it and lost the Grail, he doesn't just sit around waiting for ants and water reeds to find it for him. He pursues it with grim determination, which is appropriate for his quest. For a man the idea that one must accept something as given, or flow with something that unfolds itself according to its own design, is often very difficult. There is such a need to get up and do something, change some-

thing, make something happen. Perhaps this is why so many more women are drawn to astrology and also are more willing to go into analysis, which often means patiently waiting for something to unfold. But it isn't real passivity when you look closely at it.

Persephone's flaw is her innocence. In all these mythic stories there is a fatal flaw, which I think is, again, the myth telling us something fundamental. There is a basic flaw in every zodiac sign, and it's that flaw which invokes the fate and unfolds the story. There is no way that flaw can be avoided, because it's a central ingredient in the story. Apropos the issue of the flaw, I would like to tell you one quick fairy tale. It's about a king with three sons. This is a common motif in fairy tales, and you might enjoy reading what Marie-Louise von Franz has to say about it in her books on fairy tales. The king is a kind of ruling principle, a dominant value. In this story he has a tree with golden apples. This is his great treasure, and the source of his wealth. One day a thief breaks into his orchard and starts stealing the golden apples from the tree. The king goes out to the orchard to catch the thief, but he does it according to the usual rules for catching thieves. He does it in accord with the way he has always done things. Of course he fails because this is a very tricky thief. The king falls asleep in the orchard, and the thief makes off with another apple.

The king then sends his eldest son out to catch the thief. But the eldest son is just like the king, and uses the same approach. He too falls asleep and the thief manages to get away with another apple. This goes on night after night. Then the king sends out his second son. The second son is a little livelier, but basically just like his elder brother. He's a disciple of the king. He also falls asleep, and more apples disappear.

By this time the tree is almost denuded, and the king is on the verge of collapse. Everyone is hysterical because the wealth is gone and the land will go barren and the kingdom will fall apart. Then the third son comes along. This third son is the king's flaw. He's usually very stupid in the fairy tales, or clumsy, or rides his horse backwards. He's generally unpresentable and sometimes rather nasty. He's often called the dummling, because he's really dumb. When he tries to eat he spills food all over himself. He's socially unacceptable. You can't introduce this side of yourself to your boyfriend's parents. The dummling is the crippled, stupid, undeveloped part of us.

The dummling goes up to the king and asks if he can be allowed to try to catch the thief. Whereupon everyone laughs at him and mocks him. The king and the king's handsome elder sons have tried and failed, so how can this idiot expect to achieve what they couldn't? But the dummling keeps on asking. Finally they allow him into the orchard, since it couldn't possibly get

any worse. The dummling makes himself a pillow of thorns and waits for the thief. Each time he starts to fall asleep, the pain of his head hitting the thorn-pillow wakes him up. So he manages to catch the thief, and all the golden apples are returned, and the dummling is made heir to the kingdom.

This is perhaps one of the meanings of the flaw. It is the place where one must suffer. It becomes visible only when things start going wrong and one can no longer live life with the same old answers and the same old solutions. There is a place where one is clumsy or greedy or stupid or infantile, but that is where the solution comes from. Obviously it's very uncomfortable to trust something that is ridiculous or offensive. But the flawed part often opens the way to a solution. Persephone's flaw is her innocence. Minos' is his greed. Jason's is his chauvinism. The mother's flaw is her possessiveness, and the son's his neediness. Parsifal is too much of a fool to ask the right question. And so on. All these flaws are necessary.

Audience: Do you think the flaw comes from difficult aspects?

Liz: I don't think so. I think it's just inherent in the sign. There is an area where every sign is stupid and crippled and embarrassing. This is where I keep coming back to the word fate. There is some area where each sign is blind, and the myths seem to be saying, "Don't be so frightened of the blindness or the mistake, because it will lead to something creative."

Now we can go on to Libra. There are a couple of figures worth mentioning. One of them is Paris. He is a young, handsome Trojan prince, son of King Priam. Three goddesses pursue him, each one vying for his favour. They are Hera, goddess of marriage and hearth, Athene, goddess of wisdom, and Aphrodite, goddess of love and beauty and lust. They tell Paris he must choose which of them is the most beautiful. In return they promise him gifts according to their natures. If he chooses Hera, she will bless him with a fertile marriage and wealth and power. If he chooses Athene, she will bless him with wisdom. Aphrodite, however, promises him the most beautiful woman in the world. And Aphrodite cheats, too, because she doesn't just promise a reward. She simply undresses, whereupon Paris really has no choice left. The woman whom he receives is Helen. I think Paris is a bit of a Libran, because Libra will in the end, choose beauty much more quickly than other less appealing virtues. The abduction of Helen of course starts the Trojan War, in which Paris is killed and Troy is burned to ashes. But on the other hand, all kinds of things come out of the Trojan War—many heroes fulfill their quests and the refugee Trojans sail to Italy and found the Roman Empire.

Another figure that I think has some connection with Libra is a very strange man called Teiresias, who is a blind prophet. One day he is walking along and sees two snakes coupling in the goddess Hera's sacred grove. He is very curious about this, but it happens that he is in the wrong place at the right time, because it seems that Hera has been quarrelling with Zeus about which of them has the greater sexual pleasure, man or woman. Poor Teiresias, because he has stopped to watch the snakes, is visited by Hera, who transforms him into a woman. For seven years he experiences life as a woman. After this time he returns to the sacred grove and again sees the snakes coupling. Hera transforms him back into a man. Then he is brought before Zeus and Hera and asked to arbitrate in their quarrel, since he is in the exceptional position of having experienced both male and female sexuality.

Teiresias, being a Libran, feels obligated to give the most impartial and most truthful answer. So he very foolishly says, "Well, from my experience it's the woman who experiences the greater pleasure." Hera is furious at this reply because she has been emotionally blackmailing Zeus by telling him *he* got more out of it. In a rage she strikes Teiresias blind. Out of pity, Zeus gives him the gift of prophecy. From that point on, the blind prophet appears in various myths, particularly in the tragic story of Oidipus, when he warns Oidipus that the accursed thing he is hunting in Thebes is really himself.

There is another fragment of the Teiresias story where, after he dies, he is the only mortal soul in the underworld who is permitted to keep his intellect and judgment intact. He is a very odd mythic figure, and I think he has some connection with Libra. First of all comes his experience of the opposites, both male and female, and the necessity to make an unbiased judgment. I have a feeling that Libra is very bound up with the problem of androgyny. The issue of balance means both sides of an experience must be tasted. I have certainly encountered a very strong, almost masculine initiative in Libra women, living in a female body, and a very sensitive and aesthetic nature in Libra men living in a male body.

Teiresias, like all the other characters we have met, has a flaw. His flaw is the silly assumption that the gods are just. His blindness is the price he must pay for this flaw. Blindness, in myth, often suggests a kind of inward seeing, a seeing below the surface of things. This insight comes from Teiresias' collision with the unfairness of the gods. I think this problem of a fair universe is very bound up with Libra's fate. If you really want to get a feeling of Libra's cosmology, you should read Plato, who, according to the chart given by the Renaissance Neoplatonist Marsilio Ficino, had a Libra ascendant. For Libra the universe is orderly. It's balanced and neat and geometric. It functions according to a beautiful pattern and the gods are always just. At the centre

of the universe the goddess Necessity sits with her spindle, around which everything circles in perfect harmony. And the inner world of ideas is the real world for Plato, while the world of form is a shadowy reflection, imperfect and marred.

Libra tends to collide with the unfairness and injustice in life, which is a bit like Teiresias being struck blind. There are many blind figures in myth, and they usually receive their blindness along with insight. Oidipus blinds himself when he discovers the true nature of his deeds. Wotan in Teutonic myth voluntarily gives up the sight of one eye in order to have the gift of prophecy. Teiresias discovers something about the gods as a result of his experience, and learns something about the nature of truth. Because he has made this discovery, he and he alone can think and remember in the underworld after death. He has a kind of immortality because of what has happened to him. I will tell you one more myth which I think is connected with Libra now because it leads into Scorpio. This is the story of Orion the hunter.

Orion is in many ways a Libra, because he is a hero who has achieved perfect equilibrium. He is the epitome of the reasonable, courageous, controlled, balanced man. He is a little arrogant, because he knows the answers to everything. Like Plato, he believes in the justice of the gods. And because of his complacency, he is afflicted with *hubris,* which means that he lacks humility. Orion manages to offend the goddess Artemis. Artemis is a very curious deity, because she is the goddess of instinctual nature. She is the unknown thing in life. You cannot see Artemis. Her world is wild and hidden and secret. Anyone who stumbles upon her in the wood is liable to be destroyed. Orion tries to rape one of her nymphs. She is understandably rather angry about this lack of respect, so she sends a giant scorpion after him. The scorpion crawls up from the bowels of the earth and bites Orion in the heel and kills him. The manner in which Scorpio follows Libra seems to be reflected in that little story. The scorpion is the creature that revenges *hubris* and destroys equilibrium. Just when every question has apparently been answered and everything has been worked out according to a pattern and all the laws by which life and relationships ought to operate have been written down, then up comes the scorpion and spoils that beautiful universe that Libra has spent so long designing. The scorpion belongs to the goddess of instinctual nature, which revenges itself upon too much rationality.

There are obviously a great many myths one can connect with Scorpio which involve scorpions, spiders, snakes, dragons and other creatures of the Dark Mother. One of my favourites is the story of Herakles and the Hydra. You usually find that poisonous creatures in myth have some connection with Scorpio. The Hydra is a nine-headed poisonous monster which bites like a snake with all nine heads and lives in a cave in the middle of a swamp. It

amuses itself by destroying the folk of the countryside. Herakles is sent to kill the Hydra as one of his famous labours. He is warned that he cannot kill it by cutting off its heads, because every head you cut off sprouts three more. The only way you can destroy the Hydra is to hold it up in the sunlight, because it cannot bear light.

Herakles goes out to find the Hydra, but he can't get it to come out of its cave. It remains hidden in the dark. He has to shoot flaming arrows blindly into the cave mouth until finally it gets very angry and comes lumbering out. He forgets the warning and starts off trying to club its heads, but it keeps sprouting more and more heads. At this point he is almost overcome by the monster, but then he remembers the warning and gets down on his knees and heaves the creature up into the air. He can't do this from any other posture except genuflexion. As he exposes it to the sun, all of the heads but one begin to shrivel up. The one remaining head is immortal, but he buries that head under a big rock. One head is manageable. I'm not even going to attempt to offer any interpretive comments on this story. I think it's very explicit as it stands. But it's worth remembering that getting down on your knees has always been a symbol of worship. The Hydra, however disgusting and deadly, deserves recognition as something divine.

There are two myths I would like to touch on in relation to Sagittarius. One of them I mentioned yesterday, the marriage of Zeus and Hera. This story has particular relevance for Sagittarius, because the character of Zeus is so much like the character of the zodiac sign he rules under the name of Jupiter. I think every Sagittarian carries around a dynamic between both these figures, whether they are felt as an internal conflict or a conflict with somebody outside. This battle occurs between the unbridled creative spirit and the world of form and responsibility which seeks to confine and discipline that spirit and keep it at home. I think this conflict underpins Sagittarius' whole journey. Sagittarius isn't just free impulsive fire. Otherwise it would dissipate itself. There is a strong pull of something else which keeps dragging the Sagittarian back to form. I think it is this conflict which is behind the tremendous drive and energy you see in Sagittarians.

The second figure that I connect with Sagittarius is that of Chiron. Unfortunately his name has been given to the little planet found recently between Saturn and Uranus, but I don't think this makes the mythic figure any less relevant to Sagittarius. Chiron is a centaur, but he is also a god. He is the brother of Zeus, Hades and Poseidon, so he shares divine status with the Olympians. But half of him is animal, and he is the lord of herbs and healing and alchemy. He knows magic and the wisdom of nature. In one of the stories about him, he is wounded in the horse's flank, in the animal part of him, with an arrow dipped in the blood of the Hydra whom we have just met.

Because the Hydra's blood is poisonous, he has an incurable wound. He cannot die because he is an immortal, but he cannot be healed and his own arts cannot help him. So he endures great suffering because of this wound. He is a sage and a teacher, and his wisdom increases with his suffering. At the end of the story he offers himself in place of another soul condemned to death so that he can be released from his pain.

This figure of the wounded healer is a favourite of psychotherapists everywhere. It's quite usual to mention it as an explanation of why so many analysts and psychiatrists are incapable of solving their own problems. But the myth of Chiron seems to suggest that this incurable wound is necessary. Without the wound, there would be no understanding of suffering and no compassion, unless one suffers oneself. The interesting thing about Chiron is that his wound lies in the horse part of him, not the human. My own fantasy about this myth is that it suggests in some way that Sagittarius' suffering is connected with his instincts, with his relation to earthy life. The wound isn't in his vision, because his vision is immaculate. It isn't damaged in any way—it's boundless. But something hurts in the part of him which is mortal and animal and bound to instinct and nature. At the height of his vision or spiritual climb, this suffering is at its worst. I've often found that beneath Sagittarius' rather manic gaiety, there is often a very deep depression. The depression is connected with the pain of being confined in life, the tragedy of the animal which goes through its suffering and its sacrifice blind and unknowing.

You cannot explain to a beast why it is being sacrificed. If you have to put a dog down, you can't tell it why it's mortal, why it must die. You can explain to a person and he can make an effort to consciously grasp the meaning of his suffering when something goes wrong in his life or he loses something he cares about. If he's a religious person, or has a strong intuition that things have some meaning, then he can draw a lesson from his experience. But if the body is in pain you cannot explain to it that the pain has meaning. It simply hurts. And for the animal in us no explanation is possible, because the animal simply cannot understand. In Sagittarius, with his vision of life as inspiring and meaningful, that wound never heals. Even growing old is part of the wound, because the spirit of Sagittarius is eternally youthful. Yet it's out of this wound that Sagittarius really gains wisdom and can offer it in a practical way and remain in touch with ordinary life.

There are a number of mythic themes which one can attach to Capricorn. One that seems particularly applicable for me is the aspect of Christian myth which is called the Crucifixion. The entire theme of the descent of spirit into material form and its bondage and suffering there are connected to Capricorn. The despair of Christ on the cross and his cry, "Father, why hast thou for-

saken me?" are, I feel, very important insights into Capricorn's psychology. All the mythic themes of imprisonment and voluntary bondage, the taking on of the burden of worldly life, are connected to Capricorn. There is a willingness to undergo these things because there is a sense of duty, a need to serve something. Like Leo, I think Capricorn deals with the father-son relationship. But Leo is trying to find the creative father who is his source. Capricorn, I believe, fights the father because he is bound to serve him, and must rebel and be beaten to his knees and learn humility before he and the father can be united. This theme of bondage, the heavy prison of body and matter and material responsibility, seems acceptable to Capricorn only as long as there is some sense of its purpose. But there is always a moment when the sense of purpose is lost. The entire drama of the crucifixion is meaningless without the despair.

There is no sign as prone to depression as Capricorn, because that crucifixion is enacted over and over again in life. One takes on the labour because one is seeking to serve some guiding principle or ethical code. It could be called religious belief, or duty to family or country, or whatever. In the end it's a belief in the *logos*, the patriarchal spirit. The service is undergone willingly, but then there comes that moment, which may be several years long, when the sense of faith in the conviction or ethical code or spirit collapses. Everything seems meaningless and pointless and the thing one thought one was serving has gone, leaving only blackness. In alchemical symbolism they talk about the base matter as Saturn, which must be cooked in the alembic until it turns black and starts to stink. This stage of despair and depression is a prelude to the release of the spirit, and the forming of the philosopher's stone. There is a very deep religious drive in Capricorn, although the sign is usually too hard-headed and pragmatic to admit this in mystical terms. So they talk about duty.

The burial or entombment is another motif which is connected with Capricorn. This is a Christian image, and also an Egyptian one. The god Osiris is dismembered by his evil brother Set. His sister and wife, Isis, gather the pieces together and then mummify him. Eventually he is resurrected. This theme predates Christianity by several millenia. The experience of entombment and waiting silently, whether it's behind a stone or wrapped in mummy bandages, is peculiarly Capricornian. Capricorn begins with the winter solstice, when the sun is at its weakest and the day is shortest. Many early religions used this time of year to celebrate the death of the old year and the seed of the new one. So Capricorn is a period of death and gestation prior to rebirth. Many solar gods and heroes are born at the winter solstice. The birth of Christ is the most recent. But Mithras is born at the winter solstice too, and so is King Arthur. The winter solstice is the longest, darkest night of the

year, and the Capricorn monster—the seagoat—eats the dying fragments of the waning old year. The new beginning is still entombed in the monster's belly, like Jonah is entombed in the belly of the whale. In the midst of this depression and darkness a seed begins to sprout. In the moment of despair on the cross, humanity is redeemed, because at that moment God becomes truly human and suffers.

We can now go on to Aquarius and the mythic figure called Prometheus. His name means foresight. Prometheus is one of the Titans, the earth gods who are the original children of Ouranos. During the time when Zeus has just become king of the Olympian gods and man is still primitive and uncivilised, Prometheus looks down at man and observes that if only he had some of the divine fire, he could achieve something more than a life in coldness and darkness. Prometheus takes pity on the struggling human creatures whom the gods have created and then abandoned without any inspiration or light. Prometheus is the first cosmic social worker. He decides to do a very illicit thing. He steals some of Zeus' fire for mankind. He doesn't do this for himself, because he has no need of fire. But he bestows the gift upon man. Zeus is outraged because man can now aspire to be godlike. He inflicts a very cruel punishment on Prometheus. He chains the Titan to a rock. Every day an eagle flies down and eats away Prometheus' liver. Every night the liver grows back again, and the next day the eagle comes and eats it, and so on. Eventually Prometheus is released by Herakles, who breaks his chains.

There is another chapter in the Prometheus story which I think also has bearing on Aquarius. Prometheus has a brother called Epimetheus, whose name means hindsight. Zeus is still fuming because man has some of his precious fire, so he decides to revenge himself upon humanity as well as upon Prometheus. He makes a perfect woman, called Pandora. Then he offers her to Prometheus as a bride. She comes complete with an unopened box of treasures from Olympus. But Prometheus, because he has foresight, says, "No, thanks very much, but I don't think I trust you after what you've done to my liver." Zeus then goes to the brother, Epimetheus, who is a good deal stupider than Prometheus and could, in some ways, be the dummling side of Aquarius, the blind and naive side which doesn't recognise a villain until it's been butchered. Epimetheus takes one look at Pandora and says, "Yes, I'll have her." Whereupon Pandora is unleashed upon mankind, bringing with her the unopened box. I'm sure you all know the story. In the box, once she opens it, are all kinds of disgusting plague-ridden creatures like fear, terror, war, death, sickness, despair, depression and loneliness. These are Zeus' gifts to mankind in retaliation for the fire. But there is one other thing in the box which redeems it all, and that thing is hope.

All of these themes are bound up with Aquarius. There is the noble and altruistic impulse to offer a potential to mankind, and the ugly consequences of that altruism which must be endured for a time. Although Prometheus has done a noble deed, he has also committed a sin according to divine law. I believe this issue is very connected with something Jung writes about, the experience of sin, which comes with consciousness. There is a deep guilt in every struggle for consciousness, because in a sense, it is a sin against nature, against the primordial gods. A stronger and more conscious ego means having to steal something from the unconscious. We have claimed lost land from the sea and enlarged ourselves in the process. Although we call this evolution, it angers the unconscious, even though the drive for greater awareness also seems to come from the same place as the anger. It is horribly paradoxical. There is also the myth of Adam and Eve in the garden, which deals with this same theme of the "good sin." When they eat the apple, God is furious and expels them, because they are more conscious and have some godlike knowledge of the opposites. They can now see the mystery of good and evil, and God is jealous. The flaw in Prometheus is that he doesn't acknowledge that he has committed a sin. His punishment is a kind of inner torment, being eaten away from inside. Although he does not retract what he has done, he must take the consequences of his sin. I feel that this deep guilt is in some way connected with the way in which Aquarians devalue themselves so much. They are really guilt-ridden about being selfish and self-indulgent, and they often punish themselves terribly in the name of their ideals. This issue also makes me think of the scientific discoveries that are often associated with Aquarius, the secrets which are stolen from nature. If there is no respect for the sin inherent in this, then there is no respect for nature, and the great discovery which is supposed to benefit mankind turns out to injure or destroy.

Audience: Wouldn't the guilt of consciousness be tied in with the need to take responsibility for having knowledge?

Liz: Yes, you could put it that way. I don't think one can really have a sense of responsibility without having suffered to get what one has learned. It's terribly easy to say that we must be more conscious. It's become very fashionable to talk in this way, because of our Aquarian *zeitgeist*. Everybody wants consciousness. What we don't realise is what it feels like when the terrible sense of sin comes up with it, or the suffering which a broader viewpoint entails. Being aware of ambivalence is a terrifying and painful thing, because you can't hide anymore in the comfort of one-pointedness. The peculiar justice which Zeus inflicts on Prometheus seems outrageous

from man's point of view. It's unjust. But from the point of view of the gods, it's fully merited. What Prometheus has done is unforgiveable. He didn't ask permission for that fire. The alchemists put it this way: Our art is against nature. The consequences of any effort to become more conscious are very painful. You would think that discovering deeper things about yourself ought to make your life better and solve your problems. People very often go into psychotherapy with this kind of attitude. They believe that consciousness is the same as knowing something intellectually. This is especially true of airy signs. They think, "If only I can be more conscious, everything will get better." Of course it gets much worse, because you take on all the demons of the unconscious, and the sense of guilt. Yet at the same time, you also get some of Zeus' fire.

Audience: Why is it an eagle that eats the liver? It's Scorpio's bird.

Liz: I don't know. I suppose because the eagle is Zeus' bird. It isn't just a Scorpio bird, as some astrologers claim. The eagle in myth has nothing to do with Scorpio. It belongs to Zeus and is one of the symbols of the heavenly creative spirit. That's why we use so many eagles on national flags. They fly higher than other birds, they have incredibly keen eyesight, and they are loners. It's the eagle which rescues Psyche by getting the vial of water from the Styx, which seems to have something to do with inspiration and spirit. I don't think we have to limit the eagle to only one sign. But for Prometheus the eagle is really Zeus in animal form. The god reminds him every day that he has not forgiven the sin. The liver is where the ancients believed you found the seat of life. That's why Jupiter in medical astrology is said to rule the liver. Prometheus feels his life force destroyed and renewed and destroyed and renewed. It's an intimate experience of the god through the god's eagle. Initially, Prometheus doesn't have this intimacy with Zeus. He has no idea how Zeus will react. Afterward he understands both the gods and men.

Audience: I didn't think Greek myths had much to do with the idea of sin and punishment.

Liz: They don't. The issue of sin in the Judeo-Christian sense isn't very relevant in Greek myth. The stories are very amoral and often obscene, like the story of Minos' wife and the bull. No judgment is given for ordinary vices. But there is one sin which appears over and over again in Greek myth, and that is the sin of *hubris*. This is the arrogant pride of man trying to step beyond his mortal limits to be godlike. It's the one sin which really

preoccupied the Greeks. They worried a lot about fate and limits and transgression of limits. The punishment of *hubris* appears in many images of souls in the underworld, like Ixion, who is tied to an eternal wheel which goes around and around. Sisyphus has to roll a rock up a mountain over and over again, and every time it rolls back down. Tantalus has to stand forever in a pool of water dying of thirst because every time he bends down to drink the water, it vanishes. All these men are amoral by Biblical standards, but so are the gods. They have all offended the gods, however, by overstepping their mortal boundaries. Perhaps this problem is inherent in the Western psyche. If you look at Eastern myths, the issue doesn't really seem to be present, because it isn't a problem for Eastern psychology. It's a much more introverted psychology and less likely to be arrogant about defying the gods. I think the two are very different. Jung suggests that you can't graft one culture's collective psychic heritage onto another's. We can't abandon the problems of our Western heritage by taking up Eastern techniques which seem to offer a way of getting out of them.

This problem of the sin against the gods runs right through Egyptian and Greek and Babylonian and Roman myth. The mythology of the West seems to suggest that in the end man cannot outstep his boundaries, but that he is very likely to go on trying. That seems to be peculiarly a Western issue. I don't know why the East should be different, except that they have different gods and a different psyche. The accent in Western myth seems to be on living in the world. It has a very extroverted feeling, with adventures and conquests. It would be very nice if we could escape our collective background and espouse the Eastern way. But I don't actually think it works. We can learn a great deal from their experience of relating man to the gods. But in the end one still has to carry one's own heritage. There are two phrases which seem to express the whole of Greek thought for us: Know thyself, and, Nothing in excess. The problem of knowing one's mortal nature and of not overstepping boundaries is lodged very deeply in us. I think the issue of sin is in the end a very personal thing, but in my analytic work, I have seen it come up over and over again. Even when one believes that one has transcended the moral code and vanquished any sense of conventional guilt, there is, somewhere within, a very much deeper morality. That morality is not the sort which concerns people like Anita Bryant. It's far more profound, and seems to be concerned with the issue of man remaining within the limits of his mortal nature, yet fulfilling the dictates of his individual spirit.

I think we had better go on to Pisces, because otherwise Pisces will get lost, which is, unfortunately, its propensity most of the time. There are two

themes I would like to mention. The first is a figure from fairy tale, rather than from traditional myth. But I like it very much for Pisces because it seems to describe something very intimate about the sign. This is what alchemy called the melusine and what fairy tales call the mermaid. There is a large group of stories about this creature. Occasionally it's male, but most of the time it's a female creature with a fish's tale who lives beneath the water. One day a handsome young man, a farmer or a miller or a soldier, goes down to the lake. He goes to fish or admire the scenery or whatever. The melusine decides he looks like a good prospect for a lover, and she rises up out of the water and reveals herself. In some of the stories the young man accidentally catches her in his fishing net and falls in love with her. But, unfortunately, they belong to different worlds, and the idea of any kind of marriage between them seems an enormous dilemma. The melusine offers to make a sacrifice. Obviously the young man can't, because he's only mortal and would drown. But the melusine has magical powers. She says, "I will come and join you in your mortal life and assume the shape of a mortal woman. But you must make me one promise in exchange." This promise varies from tale to tale, but it always has to do with not asking too many questions. She says, "Don't ask me where I go on Saturday afternoons," or, "Don't open this golden box which I keep in the bedroom," or, "Don't ask me my true name." The theme is not to pry into the melusine's secrets. Only under this condition can she live in the young man's world. What usually happens is that the marriage is very happy for a time and there are healthy children born and so on. Then one day the young man's curiosity gets the better of him. He can't bear to be kept in ignorance. He says, finally, "Where do you go on Saturday afternoons?" and the melusine gives a terrible cry and vanishes. Sometimes she destroys her children and curses her husband as well. This is one of the legends about the French house of Anjou in medieval times. One of them marries a melusine who curses the line.

The melusine is a creature which belongs to the imaginal world. She is nonhuman and magical, but she will make the effort to come and live in a relationship with a mortal man as long as he respects her mystery. The moment he violates the mystery and asks her where she has come from, he loses her—over and over again. I think these themes are very bound up with Pisces. The terms on which Pisces lives with his or her melusine are obviously critical. As long as one doesn't analyse too much, one can create, because the melusine is the one who writes the poetry and plays the music and paints the paintings and dances the dance and sees visions which the ordinary ego cannot see. But the moment the Pisces tries to bind her or define her, he loses her, and very often in the stories he goes into despair and leaps into the water

after her and drowns. Or he mourns her loss. But he may be lucky, because if he can atone, she may perhaps come back again.

The second figure that I connect with Pisces is the god Dionysus, whom I mentioned earlier. The story of Dionysus involves a particular approach to the experience of the godhead. It involves abandonment, ecstasy and redemption. Dionysus is a god of women, and if you try to translate that symbolically, perhaps it suggests that he brings release and redemption through the feminine side of the personality.

There is one rather nasty story about Dionysus which is a warning note to anyone with a lot of Pisces in the chart who doesn't respect the nature of the energy. This is the story of Pentheus, King of Thebes. Pentheus is a typical rationalist. He is the sort of Pisces who doesn't want to be a Pisces. You can meet many of them—particularly Piscean men who are profoundly uncomfortable with having the wild Dionysus as a bedfellow. Dionysus arrives in Thebes with his train of hysterical women dancing and having fits. The god himself has been struck mad by Hera, so you can imagine what Pentheus feels when this troupe arrives on his doorstep. Dionysus asks Pentheus to install his rites of worship in Thebes. Pentheus is horrified, and replies, "Don't be ridiculous, you can't possibly be a god. You'll have to get out of Thebes." He refuses to recognise this bizarre divinity dressed in animal skins with animals and crazy women all over the place. Dionysus says, "Right!" and puts a spell on all the Theban women, including Pentheus' mother. They all go into ecstatic fits and rush up to the mountain top where the rites are celebrated. In this state of madness, they tear apart animals and behave generally badly. Meanwhile, Dionysus has put a little spell on Pentheus himself, so that he is overcome with curiosity about what exactly happens at these secret rites. Pentheus dresses himself up as a woman and climbs the mountain and hides behind a tree to watch the performance. The women are in a state of complete blissful frenzy, and they spot Pentheus in his hiding place. They all think he's an animal. Agave, Pentheus' mother, leads them chasing after him, and they catch him and dismember him. Agave takes his head and sticks it at the top of her staff. When the women eventually return to rationality and have come down from the rites on the mountain top, Agave looks at her staff and discovers her own son's head dripping blood at the end of it.

If Pisces tries to be Pentheus and repudiates the divinity of the god, that seems to be one possible result. Perhaps this might be taken as an archaic image of what happens when the unconscious erupts and swamps the ego and disintegrates consciousness. In this myth Dionysus has a very cruel face. But he can also be a Christ-like god, a gentle healer and redeemer. It would seem to be necessary to acknowledge both the creative gifts and the madness as

part of the same divinity. As in all the other myths, there seems to be an important statement or theme, that if you are linked with a god, then that god must receive some recognition and allegiance. Otherwise the creative force turns destructive.

Perhaps we can stop here and open the talk up for questions and discussion.

Audience: Are there any myths connected with the fixed stars?

Liz: I don't know very much about them. I only know about Algol, which is the gorgon's head, and which, as you would expect, has a very bad reputation. I'm sure there is a lot of material worth exploring around the fixed stars, but I don't know much about them yet.

Audience: Do you think Cinderella is a Pisces?

Liz: Yes, Cinderella is a happy Pisces.

Audience: How do you deal with the issue of guilt with a client?

Liz: I don't have a formula. I don't know. I tend to inch my way along with a great deal of diffidence and try to see what is appropriate for that person. I think for some people it's very important to get free of guilt when guilt is imposed from without, say, by a very dominant mother. But for other people it's very important to get some experience of guilt, because it's the beginning of actually feeling something besides infantile rage and need. It seems to vary enormously from one person to another.

Audience: I have always connected Pan with Capricorn.

Liz: Yes, I also think he has something to do with Capricorn. He's the lustful side of Capricorn. Pan is the life of the earth itself. He is a fertility god. Dionysus also has a goat as one of his sacred animals, so perhaps there's a bit of Dionysus in Capricorn as well.

Audience: What about Artemis and Virgo?

Liz: Yes, you could make that connection too. She is a virgin goddess, a goddess of nature.

Audience: I particularly like the story of Actaeon, who was transformed into

a stag. Maybe there is a part of Virgo which transforms other people into their baser selves by withholding.

Liz: Yes, perhaps. I know that virgins in myth have a tendency to get themselves pursued and raped. The nymph and the satyr go together. But Actaeon's sin is really *hubris*. He doesn't avert his eyes when he realises he has come upon the goddess, but stares like a good voyeur. Artemis dismembers him because of his voyeurism, his lack of respect.

Audience: Can you give us any insights into Saturn or Kronos?

Liz: I would rather that you just bought the book. I would be happy to talk about Saturn, but I don't like to quote myself all the time. Anyway I will be talking about Saturn when I discuss the Jupiter-Saturn conjunction. If you could wait until then, I will go into quite a bit of his mythology.

Audience: What about the asteroids?

Liz: Once again, I don't know much about them. I've done a little work with them and I'm rather suspicious of them, and rather unimpressed. But that may be a prejudice of mine. My fantasy is that they are no longer a planet, and whatever they once might have been, they are now the dead pieces of something.

Audience: With which sign would you associate Cassandra?

Liz: I'm not sure. She is a prophetess, and prophecy in Renaissance astrology was always associated with Saturn. She always foretells gloom and doom and divine punishment. Perhaps there's a little of that in Capricorn. Perhaps it's a little Scorpionic, because of the issue of fate and the sense of things being fated. But I don't think it's very helpful to just pick out a mythic figure and then try to guess what sign it belongs to. I don't think you can do it. Some figures in myth don't really seem to have bearing on any particular sign. I asked you earlier to please not take me literally when I link mythic figures with zodiacal signs. I am trying to suggest a way of working imaginatively, rather than offering formulas. I think you have to make your own connections. It's certainly not an intellectual exercise, and it doesn't produce anything very useful when you try to use it that way.

When you actually work with people in a consultation or in ongoing work, you can very often see a mythic theme running through their lives. You see it very clearly in their dreams. Sometimes the myth may enact

itself very overtly as well as inwardly, like the rape of Persephone or the quarrel between the hostile siblings. But there is always an internal level even when it manifests outwardly like that. All you can do is to take your cue from your client, rather than trying to impose a formula of this myth going with that sign. What I am really trying to do with this material is to suggest that you can amplify factors in a horoscope with myths. Very often you can try to explain something conceptually and it just doesn't make sense to the person. But you can tell a story. The language in which these things are couched touches the child in us and stirs the imagination. It gets through a block and reaches feelings which the mind cannot articulate or explain.

Audience: Do you just connect myths with the sun-sign?

Liz: I think it's broader than that. You can take anything in a chart and amplify it with relevant myths—particularly the ascendant.

Audience: What about people born on the cusp? Would you talk about both signs?

Liz: I've never been very happy with the concept of cusps. I have not found that a person who is born in 29 degrees of something is any less characteristic of that sign than someone who is 10 degrees of the sign. The very first degree is often very strongly typical of the sign. I'm not happy with the whole idea of cusps. But if the sun is close to the end or the beginning of a sign, then very often Mercury and Venus will be in the preceding or the next sign. So there is often a combination of influences, but it's explicable because of the minor planets. When Mercury and Venus are in the same sign as the sun and the sun is on a cusp, I have not seen the combination of influences. I don't find it helpful to think in terms of cusps.

Audience: Do you find that dreams will correlate with a problematic area of the chart at the time that the area is being transited?

Liz: Yes, absolutely.

Audience: In a chart with a Libran sun in square to Pluto, would you look for an even heavier influence of Pluto there than you would if the sun were in some other sign?

Liz: I think it is harder to accept Pluto if you are a Libran. If you are born

under a sign that has more affinity with Pluto's kingdom, then you will have an easier time coming to terms with Pluto. But I think Libra feels a sense of outrage when confronted with Pluto.

Audience: I wonder if you could generally comment on what all this accomplishes. I'm having a hard time phrasing the question. I assume that in dealing with people who are going through crises, that the use of myth in a chart reading is helpful in some way.

Liz: One thing that it does is to enlarge the scope of the problem. When someone is in a dilemma, there is a tendency to feel, "It's my problem, my little sordid mess, and nobody is suffering the way that I am, and even if you've had a hard time, it's nothing compared to mine." There's a kind of indrawn fixation on the difficulty so that one gets stuck in it. That's all there is in life, and one identifies with it. You get all the issues of blaming other people, self-pity, self-disgust, despair, and bewilderment that such a thing could have happened. When suffering is blind, it's quite intolerable. The moment you open the problem out, it acquires a sense of meaningfulness. Of course people don't believe in myth. You can't take myth literally in a twentieth-century world and think that there was actually a real person called Perseus who cut off a gorgon's head. But on some level myths are true, because they describe archetypal human situations. They do something to a person's sense of scope. They release energy. Symbols have a magical capacity to contain and shift energy. And there is something about myth that gives a quality of sacredness to an ordinary human mess. It's no longer petty and pathetic and sordid. It's sacred, it has the dignity of man's noble suffering and striving in it. And it can go somewhere, because mythic stories always go somewhere. They are never stuck. Even Prometheus gets unchained eventually. Myths have a point to them. Persephone isn't just raped and bad luck. She's raped because she represents a lopsided consciousness, and the whole affair culminates in the birth of a divine child. Minos doesn't just make a ghastly mistake with his bull. His sin results in a monstrous creature which allows a young man to become a hero and a redeemer. All these stories are teleological, which means that there is a sense of purpose in them. I think using mythic material in a session with someone communicates or invokes this sense of purpose without being didactic or pedantic. So another important thing that I think myth offers is a feeling that the problem may not be a problem. It may be a process.

I believe it's also relevant not just for the client, but for you and me as astrologers, because it opens and deepens one's own perception of life. It

allows some room for the nonrational, and this is terribly important if
you're a very intellectual sort of astrologer who interprets everything
according to logical concepts and categories. This kind of study seems
loose and pointless and cloudy, but I feel it does something to us inside.
It humbles the intellect in a very subtle way and gives dignity to the
imagination and the soul. These images are so much older than our recent
cleverness. It is a very powerful experience to discover myths living them-
selves through your own life. You see that they are living things, not just
untrue stories with no point other than entertainment. It does tend to
make one feel very humble about what one thought was knowledge.

Audience: Do you have any thoughts about myths for the new age?

Liz: Well, we are supposed to be entering the age of Aquarius, which once
upon a time everyone believed would be an age of love and brotherhood. I
would look again at the story of Prometheus. The political aspect of this
is, unfortunately, an area where each person brings in his own personal
complexes, and there are arguments on every side of all the social and
political issues which are rooted in each person's own psychology. I'm
not particularly political, so I would rather not hazard guesses about what
sort of social and political changes and movements might be connected
with Aquarius. But Prometheus' problem of the urge toward conscious-
ness and the price he must pay is probably very relevant. In the end, all
we can do is try to deal with the Prometheus in ourselves. Jung thought
that the age of Aquarius represented the final opportunity to sort out the
problem of good and evil. I only know that whatever negative manifesta-
tions arise, it is part of the cycle, which means that it is a necessary stage. I
don't know whether this has to be lethal externally, or whether it can be
dealt with in a more interiorised form. One hopes that it will be interior-
ised, and that the enemy will be acknowledged inside rather than in
particular economic or political entities.

Audience: How do you see things developing in the world picture in the next
couple of decades?

Liz: I find this whole issue very difficult to talk about, because I simply
don't have any answers. I have been speaking of myths in very general
terms, but for me they're highly personal and relate to an individual's
journey. As soon as the conversation starts getting into world problems, I

can only shrug and say I don't know. "The world" is a very abstract idea for me. The world is my world or your world. I haven't a clue what's going to happen to the world. I only know that it's very productive to go home and look in the mirror.

4—Key Issues in Astrology Today

Stephen Arroyo

I am going to lay the philosophical groundwork for all the talks I'll be doing at this conference by making some general comments on my approach to astrology, the current state of the astrology field, the relationship between astrology and counseling and therapy, and how astrology might be viewed in the modern era *in contrast to* the scientific-materialistic worldview. More specifically, this talk will also be an introduction to some key issues dealing with *relationships,* which we can then discuss further in my next talk on "Person-to-Person Astrology." It is, after all, only appropriate that the subject of relationship be emphasized even in this talk, as Jupiter and Saturn conjoin in Libra.

More and more I feel that there are essential questions about astrology and its practice that are rarely dealt with in the astrology literature or at astrology conferences.* In fact, I think many of you would agree that many books on astrology pretend that everything is sewn up in neat little packages —the "cookbook" approach to astrology. Most authors of astrology books must feel that they have to *pretend to know everything,* or so it seems. Therefore, they pad everything! If they are discussing the moon in the signs and they themselves have the moon in Aries, they may write ten very good pages on the moon in Aries. But then they go to the moon in Taurus and think, "Well, I have to write ten pages on this also." So they do it, even if they don't know anything about it beyond perhaps one small paragraph. So, in these talks, as well as in books I'm writing, I'm going to try to focus on things that I'm comfortable with or feel familiar with. By no means do I feel like I am an expert on every little aspect of astrology. It is necessary today to specialize in a specific area or application of astrology, because it's a field that has tremendously expanded in the last ten years—as you well know. This is partly due to the influx of computer technology, partly due to more intelligent people getting intrigued with its validity, and partly due to the increasing interest of many people in a very specialized scientific or pseudo-scientific type of astrology that emphasizes measurement and infinite analysis of endless details. I'll mention more about this in my Chart Synthesis talk.

*See Arroyo's *The Practice & Profession of Astrology: Astrological Counseling in Modern Society,* published by CRCS Publications, for a thorough discussion of key social, professional, therapeutic, and ethical issues in the astrology field.

What I want to emphasize now is that I don't really have neat little packages of data anymore. I don't claim to have an *absolute* understanding of anything! To me, astrology is a cosmic science; *using* it *is* an art, but ultimately astrology is a science. But this cosmic science is so high in its essence, so vast, that very few people can reach that high level of consciousness where they can understand it thoroughly. I certainly don't purport to. This is why we all need to retain a bit of humility in our dealings with astrology; it is *always* somewhat beyond us. There are many levels on which we can use it as a tool; we all use it differently and we should all try to do our best, while still acknowledging that we have not mastered it. Once in a while someone will ask me a question, and I may say, "I really have no idea." And people hate those kinds of answers, of course, but that's the way it is. Even if I played the know-it-all role and gave out some sort of make-shift reply, the person still may not be satisfied if the answer didn't harmonize with their predisposition, prejudices, or unconscious expectations. You see, I can't win trying to respond to questions!

One cannot talk about the key issues in astrology today without considering the cultural and social context within which astrology is being studied and applied. So we have to consider this first. I have here the latest edition of *National Geographic* magazine; and in their spectacularly colorful fold-out map here, we can read descriptions of planets that exemplify the current cultural approach to life and to the solar system. Did you know that Jupiter is "a rapidly spinning ball of gas, compressed to liquid in the interior?" Did you know that Saturn is merely "countless icy particles orbiting like tiny moons making up seven rings" and then inside, a lot of nitrogen? Did you know that Neptune is primarily methane and various other gases? You see, the so-called scientific approach, which is really simply a materialistic approach to life, ultimately reduces everything to a bunch of dirt and gas. A chemistry professor who also studied astrology once told me that chemistry's "reality" is to reduce everything in the universe to "balls and springs." This is an approach which is ultimately destructive. As Dane Rudhyar began pointing out in the 1930s, if astrology goes in that direction as it develops over the next few decades, its capacity to infuse life with meaning will be dissipated as it becomes more and more a part of the established materialistic lifestyle of modern society. Astrology, among many other uses, constitutes an alternative language through which to understand life. If astrology cannot enable us to *understand* life more deeply and thoroughly, then I personally have no interest in it.

Unfortunately, we have today a rigid uniformity of worldview throughout all branches of the mass media and most of academia. We even have the so-called Public Broadcasting System in the United States endorsing the

materialistic worldview unquestioningly and admiringly. The recent series called "Cosmos," which deified the high priests of materialistic science such as the program's cheerleader Carl Sagan, elicited surprisingly and depressingly little critical evaluation from those in our culture who have access to the media. I was therefore extremely happy to see an editorial in, of all places, the *Wall Street Journal* which systematically punched holes in the doctrinal assertions of such programs. To quote some of the most important points, which also apply equally to a great many other things that we and our children are taught by our culture to regard as absolute truth:

> However "Cosmos" has been advertized, Mr. Sagan is not simply presenting science to his TV audience. He is also sharing his philosophical world view, his religious testimony—a blend of nature mysticism, materialism and scientism. . . . his tendency to mix metaphysical and scientific statements is confusing to the careful listener. He announces and proclaims but does not offer supporting evidence or indicate that he is simply sharing unprovable assumptions.
>
> In "Cosmos" scientists come across as the high priests of humanity. With the help of science, claims Mr. Sagan, we can come to know "the universe that made us." . . . To the degree that Mr. Sagan suggests that science alone will prove adequate to unravel the mysteries of life, he commits what philosopher A. N. Whitehead called "the fallacy of misplaced concreteness." That is, he changes a fruitful method for discovering truth into an all-embracing philosophical world view. . . . such a procedure seems woefully deficient if we want to understand human freedom and responsibility or if we want to deal with the qualitative dimensions of human experience.
>
> Mr. Sagan's sarcastic voice reveals even more clearly than the script his bias against religion and the church. . . . But perhaps such a truncated and superficial historical perspective should not be too surprising to the thoughtful viewer, for Mr. Sagan seems less concerned to interpret history and culture sympathetically than to discredit rivals to his own scientism. (From *TV: Carl Sagan's Narrow View of the Cosmos* by Richard A. Baer, Jr., in *Wall Street Journal* of October 24, 1980.)

These unthinking biases are not, as I said, limited to Sagan's juvenile self-deceptions. They pervade so much of our culture that most people take such unexamined assumptions for granted as part of modern reality. I am pointing out such a state of affairs because we as astrologers have to realize that we are swimming against the current of modern life and consciousness (or should I say *unconsciousness*!). The lack of both a historical perspective and a philosophical framework in our society and also in academia today permit such developments to continue and to dominate, and I am afraid that most people active in the astrology field today also lack both the historical and philosophical foundations that would give them at least some perspective and possibly some confidence and inner strength.

Such problems are not limited to the USA. The BBC was working on a TV program on astrology, with the cooperation of a couple of people who were quite competent in it, and—I am given to believe—the political pressures got to be such that the entire project was shelved. The Canadian Broadcasting Company has experienced similar pressures when tackling the subject of astrology. So, when you talk about freedom of speech in these countries, you might as well accept the sad fact that it doesn't pertain to astrology in the mass media today. I do not expect the media's fondness for being power brokers and cultural dogmatists to diminish in the coming decades. The culture's dominant worldview is sold as truth through the media today. So, whether we like it or not, anyone active and sincere in the astrology field today is in a very small minority, a trod-upon minority in fact. I often feel like Rodney Dangerfield... "I can't get no respect!" If you mention that you're involved with astrology, so often the response is a sneer, if not worse. This is a situation today that we have to acknowledge; it won't change if we keep ignoring it.

My view, for the benefit of astrologers, is that we should beware of playing into the hands of those who would have a destructive impact on astrology. Instead of putting oneself at the mercy of incredibly limited assumptions and paradigms by *forcing* one's mode of observation and expression to fit the "scientists'" mold, we should realize that their molds are not "objective" as they pretend. Instead of *forcing* our way of thinking and expression into their molds, which is what a lot of astrologers are now trying to do, we should find our own way and not play into the hands of those with a very limited concept of life. By trying to force astrology into severely limited patterns that are inappropriate for it, all we will be doing is *mangling* the incredibly unlimited potential of astrology, because we'll be putting astrology into the hands of people whose conceptual manipulations are going to rip it apart, and its most beautiful and valuable qualities will be destroyed. Don't worry—I'm not going to be this political for most of the conference; I'm just starting that way because some things need to be said and no one else seems to be saying them. So, I have that unpleasant task.

I feel that astrologers would do better for themselves, and for the field of astrology as a unique study, to express their observations and empirical experience in clear English. Astrology needs what Jung did for psychology. Whether or not you like Jung's work, it is hard not to admit that he was an example of a *real* scientist: he saw something and reported on it, he saw something else and he reported that; he put forth theories and admitted that they may not be true and that they were mere conceptual inventions on his part, that they were simply tools to be *used* in the process of finding truth. I think *that's* what astrologers have to do, especially in their published writings.

More and more they should say, "I've seen this, I've observed that, a client did and said this" and so on, saying it in clear English. And whether or not they come out with so-called positive or negative results, I haven't seen one statistical study of astrology yet that has any significance at all or that helped any astrologer to deal with a client who needs help.

Unfortunately, any sort of observations or examples tend to be missing from astrological writings. Usually one finds only an assemblage of pat statements; it's a lot of hooey in many cases, a lot of hot air! Oftentimes people just repeat what's been said since 1910, which is great if a core truth has been discovered and proves true over the years. But at least they should update the language! Do we still have to read about "This native will...."? When the general reader who is new to astrology opens such a book and sees repeated mention of "natives" everywhere, they imagine early Tarzan movies, not an intelligent book about human beings. Such astrological "literature" is just incredibly limiting for astrology. Another criticism of astrological books published today is the almost complete lack of authors' acknowledgment of the long and beautiful astrological tradition. Why do authors of astrology books never refer to other authors? Why don't they ever have any references? Why don't they say, "Charles Carter said this in 1930."? Or why don't they say, "Alan Leo was the first one to come up with this idea."? No, you don't see anything resembling scholarship, except an occasional book which is usually a self-congratulatory attempt to destroy as much of astrological tradition as possible.

A good example of that would be Dean and Mather's *Recent Advances in Natal Astrology,* which *purports* to be an objective survey of modern astrology. As Dennis Elwell wrote in his review of the book, it should have been titled *Recent Retreats in Natal Astrology*! In any case, after a few critical comments of mine were published in the British Astrological Association's journal, the authors of that book suggested that I contribute to their next book. But I refused. You see, I had already expressed my point of view at great length in my books, in such a way that I could *develop* the thoughts in some detail and with some degree of depth. There was no way that I could abbreviate such a presentation to fit their format of excerpting minute little quotations that they could then carve to pieces. In other words, what they wanted me to do was to narrow my ideas and method of presentation to fit their little microscopic way of seeing the world. I preferred not to distort my original vision of things simply to fit someone else's narrow assumptions. I feel that astrologers have to keep going in *their own* directions positively and creatively and quit defending themselves! This is not to exempt astrologers from creative self-analysis and self-criticism. But as long as we busy ourselves with thinking, "Oh, we have to prove this; we have to prove that

with a statistical study," we're going to waste our whole life away! We're not really going to *learn* anything, and we'll then merely be playing into the hands of people who really want to get rid of astrology, in spite of what they may say.

My overall view of astrology today is best described by this quotation from Charles Carter, who wrote the following in 1947. I often feel that Carter says things better than I could, and I've come to appreciate his work more and more as I've gotten older:

> Astrology, I believe, is part of an Arcane Tradition of inestimable antiquity and value. This tradition has suffered some corruption and has in part been overlaid with mistaken additions. But the cure for this is not a wholesale attack upon all Astrology, but a search for the *first principles* of the science, and a reconstruction of our theory and practice on these foundations.

Carter himself made great strides in following his own advice, in such books as *Principles of Astrology* and *Astrological Aspects*. My favorite of his works is an excellent book called *Essays on the Foundations of Astrology,* which is a beautiful little book on fundamental principles. Some of the language is a little out of date, but the book was still way ahead of its time and remains one of the better books available even today. Carter's quotation continues:

> In the light of astrological first principles we can see that, even in its present form, astrological science is *substantially correct*.... I assail nothing, and have not a word to say against any reputable systems....
> (From the Introduction to *Symbolic Directions in Modern Astrology*)

In other words, Carter is pursuing the positive while recognizing that astrology can benefit from some keen evaluation and "reconstruction" in some areas. I am merely saying all this because it is important for astrologers to see what they're up against and thereby to define more clearly **their own** unique directions, values, and contributions that no other profession or field of study can provide. Twelve years ago I felt that astrology was developing in its own way rapidly and also slowly integrating its way into society. Many of you remember the astrology boom of the '60s and early 1970s and the media attention it got. I feel it's now time, during this new Jupiter-Saturn cycle, to take stock and perhaps once again to release a new burst of energy toward clarifying and broadening astrology's uses and capabilities.

CURRENT PSYCHOLOGICAL THEORY IN RELATION TO ASTROLOGY

The next subjects I want to discuss will be presented from the angle of current theories that specifically deal with human relationship and sexuality, and I'm presenting it this way as a lead-in to my next lecture on person-to-

person astrology. The period of Uranus in Scorpio that we have just finished has brought about a tremendous amount of sexual experimentation and sexual fixation, and those of you who do counseling with astrology are well aware of how many people are extremely confused about their sexuality and its place in their lives. Hence, in the following, I will to some extent be emphasizing this dimension of relationships—Venus and Mars, you might say —and this seems appropriate as we begin a Jupiter-Saturn conjunction in Libra that will be closely followed by Jupiter's transit into Scorpio and then Saturn's and then Pluto's entrance into that sign.

As Jim mentioned in his introduction, I have done a lot of counseling and want to avoid beating around the bush; so here's one of my conclusions, which won't surprise many of you but which would be unthinkable to the average psychologist: When in the hands of an experienced, competent practitioner who has some mental and ego discipline, one who is not trying to prove himself or to prove that astrology works or to impress the client with sensationalistic predictions, when in the hands of such a person, astrology works almost unerringly as a tool for understanding person-to-person activities and experiences. I have absolutely no doubt about that; it works if you understand this great science. This statement is, of course, based on the assumption that one is using the true astrological science in a comprehensive way, and therefore this excludes most mass market books that purport to explain astrological compatibility.

Most of you probably know that my emphasis has always been on understanding, using astrology as a tool for understanding, rather than as a guessing game to impress people. And my emphasis has also always been much more on *counseling* than on doing *readings*. No doubt many people end up doing readings even if they don't want to, because people come to astrologers expecting readings, expecting a one-sided performance on the astrologer's part. These types of clients sit back, close off completely, and expect you to entertain them by your clever guesses or wonderful predictions. Unfortunately, that *is* definitely the astrological tradition that has developed over the years; there's no doubt about it. In fact, our tradition in this country was imported from England where people rarely saw the client in person—everything was done by mail, and it still is in many, many cases. The original explosion in astrological popularity started about 1890 or so and grew tremendously with Alan Leo's mass-produced horoscopes that were mailed to clients all over the world. So, that is the tradition we have to work with and, in many ways, I feel that is the tradition we have to reject if ever we are to be taken seriously as a legitimate profession with a therapeutic capability.

No doubt you often have to do some sort of "reading," especially if a client is skeptical; and so you have to gain their confidence, although one might question if you should have screened out overly skeptical clients to

begin with, which might have saved you a lot of time and frustration! But often asking the client some questions to begin with is a much better approach, because that might incline them to open up a bit, especially if they find that you're a good listener. Unfortunately, many astrologers are much better talkers than listeners. I've had appointments that practicing astrologers made with me, supposedly to "get another perspective," in which I couldn't get in a word edgewise! They much preferred hearing themselves talk and trying to impress me with their viewpoints than hearing anything I might have to say. I never did so little work and still got paid for it! With the usual client, however, very often the person really just wants to talk to somebody, and you have to give them space to ventilate rather than intruding your own ideas and proving your own cleverness. If the person really needs to talk to someone but you wind up being the only one doing the talking, you're probably giving them "information overload." The client will then perhaps try to sort out all the information you poured out some time after the appointment; they'll sift it through their normal thought patterns and prejudices and then will dispose of most of it right away because it won't fit! A real dialogue is a much better approach.

Now, the fact is that most of what one author calls the "black-and-blue trauma of ordinary living" is revealed to *non-professional* counselors. Very few people want to go to psychiatrists or psychologists. Number one, they're expensive; number two, they usually involve long-term commitments. And very few people want what they feel might be a stigma in their community for going to such professionals. So, most of the real problems of life, the problems everyone has in just being human, are disclosed to non-licensed, non-credentialed, untrained people who may never think of themselves as "counselors." Lawyers get a lot of this; so do doctors. Ministers get a lot of it, and of course bosses may find their ear being bent by employees in personal ways. And of course astrologers are *de facto* counselors, since almost all of their clients want advice or at least another perspective, even if the clients proclaim that they are "merely curious." Astrologers therefore get a lot of counseling opportunities, but if they don't know what to do about it, they are missing these opportunities to use what I think is the most valuable tool of all for understanding people's problems and giving them a sense of order and direction in life; and that is astrology. In astrology we have a map of the entire psychic territory of the individual, permanent patterns *and* current trends. It is important that astrologers do not abuse the trust that people have in them, even those people who profess to have no trust in astrology at all. The client's trust is what one counseling author calls "the main therapeutic strength of these troubled individuals." Surely accepting that trust requires the astrologer to respond with complete honesty, even

KEY ISSUES IN ASTROLOGY TODAY

if that entails a stark admission of total ignorance about some pressing questions.

As I just mentioned, much of the trauma of everyday life is disclosed to people, including astrologers, who have no formal training in counseling procedures. This can in fact be a strength for the non-professional counselor; it need not be seen as a serious drawback for doing good, supportive counseling work. As Eugene Kennedy, the author of three excellent books on counseling, has written:

> This ability to get the main idea of the other's life may be a special strength of those who have not had much professional training. Theories and preconceptions do not clutter their consciousness nor clog the pores of their understanding. Undergraduate students in counseling often make better and more natural responses to troubled people than do more advanced graduate students. The latter carry a greater burden of trying to make a clinically correct or approved response, to prove their competence. The more naive, however, merely try to understand people and their responses. (*Sexual Counseling,* page x)

I also believe, however, that astrologers sometimes have too much training or too many criteria in their minds, which prevent them from focusing simply on trying to understand people and their responses. For example, we'll never get the main idea or theme of someone's life if we are too fixated on the petty details of a chart. You've got to let the chart open up and stay open to you and let the person open up to you, and *you* have to stay open to the reality of the person, even if it doesn't always "fit" your preconceived astrological theories.

As some of you know, the education of most counselors, psychologists, psychiatrists, and other therapists over-emphasizes nit-picking analysis, over-emphasizes mental cleverness. The ability of many such people to react simply from the gut level has often been permanently impaired. I am not saying that many counselors and therapists are not really good; many of them are excellent and quite effective. My major criticisms of modern psychology are directed toward the training and the theory that dominates the field rather than toward the people involved. There is, though, in modern psychology a definite lack of a true and valid theory of psychological functioning and of the nature of the psyche itself. Astrology is of course the very theory that is so desperately needed. If one is practicing counseling or therapy and does not have a valid framework for understanding, then one is always merely guessing and groping in the dark.

I feel that astrologers also, as well as psychologists, must guard against being too *problem-oriented.* If we specialize in identifying and labeling "problems," which by definition comprise tension, we are *increasing* the

tension level of the client. It is far better to use the chart to focus on the *whole life pattern* and to encourage people to find meaning in it—a *larger reference* for one's life situations and conflicts. This kind of holistic approach has a far more therapeutic effect than endless sessions that focus on labeling and dissecting the components of the person's psyche.

This Uranus in Scorpio period that is now ending has witnessed a proliferation of publicity and theory and advice regarding sexual life. Even a conservative magazine like *Reader's Digest* now regularly runs articles about "how to improve your sex life." However, as Eugene Kennedy writes in his book *Sexual Counseling,*

> Ill-informed advice is still given despite the explosion of knowledge about sexuality in recent years. Data have not been enough to lift the grey cloud of our unknowing about sexuality.

We might also add that this "cloud of unknowing" also shrouds our modern perceptions of "love" and "relationships." All these things are profound mysteries of life; you can't understand them fully nor explain them with *any* theory. Astrology will not totally explain everything either, but it does deal with *cosmic* principles. It will get you much closer to an understanding of life's mysteries than will faddish contemporary theories which primarily reflect current cultural trends.

Because people's sexual and relationship lives today bear so much of the brunt of inner conflicts, partly because many people who have larger problems with life try to find salvation or escape through an overemphasis on sex and exciting relationships, we as counselors—and this even applies to those who are doing a "reading" by mail—have to maintain a certain sensitivity and openness in our attitudes toward the individual's intimate life. "You have to do this" or "you should do that" merely injects more tension into the person's life, and so we are challenged to deal straightforwardly and even bluntly with delicate issues, with what Kennedy calls "the tender points of [the clients'] personalities, the most available focus for other conflicts and rumbling dynamics." Most people's psyches today are being bounced back and forth like a tennis ball, by all the little voices inside and outside them. We as astrologers have an opportunity to encourage a little peace of mind, but I'm afraid that many styles of astrological practice induce more tension, more pointless analysis, and more confusion . . . very often through information overload such as ". . . your 14 solstice points are square to every asteroid and opposite your part of idiocy." Pretty soon, everything is out of control, and all respect for astrology in the mind of the client has evaporated! Eugene Kennedy puts this situation very well:

One thing people do not need is more tension surrounding their sexual lives. Anxiety regarding the expectations of others and the need to perform well sexually is already widespread enough to be classified as epidemic. Neither do people need their sexuality transformed, as it often is these days, into a political weapon in the cause of others. There are those who know just how to manipulate the secret needs of people that get expressed through sexuality; they do this quite regularly, much to the confusion of the persons involved. What most people need in this difficult area is not excessive direction or supervision but rather some time and space in which they can begin to consolidate their sense of themselves and perhaps sort out the motivations that are caught up in their sexual activity. This is precisely the atmosphere which the para-professional counselor can provide. (*Sexual Counseling*, page 10)

To "sort out the motivations" involved in various intimate inner struggles is precisely one of astrology's greatest uses. It is especially in the area of *motivation* that astrology is so strong and powerful a tool. No other method, technique, or theory can touch it. There are all kinds of tests, personality inventory tests, motivational tests, vocational aptitude tests available, but none of them get so quickly to the core of individual motivation. And if you begin to understand motivation, you're getting to the roots of the person's psychic nature—you're getting to see what they are really after, what they really want, or what they are being pushed toward. And very often that is unconscious, but the astrology shows it clearly. For example, if you just point out to a person a simple, deeply penetrating truth of their nature, you have gone a long way toward healing. If you say to one person, for example, "Look, you have half a dozen planets in Leo; you want to be *noticed* and *appreciated*!", you are helping the person to admit what he is. Right there you've got one of the most powerful therapies on the planet!

So, the type and quality of motivation is often accessible to the understanding of an experienced astrologer, in a way that is not even to experienced counselors who do not have the help of a cosmic framework. And the *quality* of human experience in general can be elucidated through astrology better than through any other method I know of. And very often you can achieve that clarity without using a million different abstract techniques—just look at the basic sign emphasis and the dominant elements, and right there you've got so much to work with that it's mind-boggling. I remember a talk I gave at the American Federation of Astrologers Convention some years ago, a talk on the four elements, which I think are profoundly important and a bit neglected in astrology today. After the talk, a man raised his hand and said, "You know, since I've begun to use the four elements more and more lately, I'm almost embarrassed by the fact that just using the

elements lets you understand so much that you often hardly need the aspects and houses and the rest!" If you deal with the basic energies and thus with the basic motivations of the person, you can do so much; very often you can do an effective counseling session by just referring to the sign positions and the elements of the planets. Very often someone's problems are related mainly to the Sun sign, for example, and they've never quite accepted that part of their nature. If they were born, say, with Saturn opposite the Sun or something similar, they may never have really accepted themselves. And they may benefit greatly from a helpful dialogue that clarifies their identity needs and ego motivations. This would of course not be a "comprehensive reading," but it could be extremely appropriate in some cases. I am talking here of what is *effective* in one-to-one interchanges with clients.

In the last two years I've made very intensive studies of the current literature in psychotherapy that deals with sexual problems, sexual incompatibility, relationship difficulties, and so on. I did this partly as background research for a book I'm working on and partly because I had to take more training in sex therapy theories in order to renew my counseling license since a new law was passed. I'm glad I did that research and the additional training, mainly because it gave me *more confidence in astrology*. So much modern theory on sex, sex therapy, and emotional and sexual compatibility is based purely on *quantity*. For example, the studies usually focus on how much sex, how often, etc. Such studies reveal almost nothing about the *person* or the *quality* of the experience. Even when an occasional article talks about "sex energy," it still focuses on quantity, such as the recent article in *Readers Digest* entitled "Sex Energy—How You Can Get It!" This approach implies that you *can* go out and get it, that it is not *within* you, that it is something that you can go out and find and take, like a pill—a typical American approach! Astrology, on the other hand, shows the *quality* of energy exchange, what the people are actually *experiencing*. Astrology recognizes that emotional and sexual compatibility are always "pair-specific"; that is, a particular person may be completely asexual with one person and may thus *seem* to be a cold fish and then may be completely, fanatically attracted to another person two minutes later. It's an energy exchange. It is an obvious fact of life, and yet orthodox psychology has no means of explaining this phenomenon and refuses to see the one method that explains it completely—astrology.

I should make it clear at this point that my main purpose in making so many critical statements about current psychological theory and pretense is not to put it down in a gleeful exercise of negativity. It is largely to help all of us in the astrology field to have more confidence in what we do. An astrological practice, I feel, can be much more valuable than most kinds of psycho-

logical practices, and many of the general public agree with that. If we realize therefore not only our own faults and needs for improving our attitudes and approach but also the limitations of the other helping professions, maybe we'll start to value our own services and capacities more. And maybe we'll all be a little less defensive.

Many experienced therapists and counselors will admit that their function is often merely giving people the *right* to have the feelings that they're feeling and to be what they are! They often don't know anything and don't do anything, but because they are an *authority* in the society, they can merely say, "It's OK to feel like that." And the other person is often surprised to hear it. For example, if clients come in who have strong Saturn squares to personal planets, they may never have been given permission to be what they are. Many therapists will also admit that their therapy does indeed often consist of guessing games, false starts, dead ends, and that in fact they are groping in the dark. There is a huge gap in the theory of psychology and psychotherapy today; they have virtually no knowledge of individual differences and attunements and motivations, and this gap is then filled up by intellectual gymnastics and speculation. Because there is always a need for some overview theory when doing counseling or therapy of any kind, and because most practitioners cannot accept the validity of astrology—a true science of individual uniqueness—there is left a void that pulls in every sort of speculative notion. That is one reason why every few years there is some new popular psychology method or theory that gains a huge following rapidly and then fizzles out within a few years. A number of studies have shown that most therapeutic systems are much more effective in their first few years, and then their effectiveness seems to decline. A number of studies have found similar results from widely different methods: one-third cured, one-third helped, and one-third not improved.

In an article called "Recent American Psychiatric Developments," published in the *American Handbook of Psychiatry,* George Mora stated the following:

> We find increasing acknowledgement of the fact that psychotherapeutic results are strikingly similar regardless of the theoretical framework followed by each therapist, that the personality of the therapist is more important than his adherence to a particular school of thought.

Do you think this would be true if therapists were working with a true science of the psyche with an inherent healing power attuned to the cosmos itself? This quotation is identical with what Jung stated many years ago, that it is the personality of the doctor or therapist or counselor that has the heal-

ing impact with the client. Perhaps only about one-third of any group of counselors or therapists, astrologers included, have much real ability to relate to people effectively. Or perhaps only about one-third of the people who see counselors or therapists are able to be helped by any means. Lest astrologers become arrogant about these facts, I should say that a survey of astrologers' clients may well reveal similar results! I know of no such study, although— come to think of it—this could be one of the most valuable types of studies of astrologers' effectiveness or lack of it. The difference between the astrologer's use of astrology and the psychologist's or psychiatrist's use of some theory is that, I believe, the astrology itself has an inherent healing power *if it can be communicated effectively* to the client. In other words, the astrologer has to be able to get out of the way, to get his or her ego out of the healing dialogue, in order to let the real effectiveness of astrology flow through—the capacity to reattune the person's consciousness to his or her true nature.

So, it seems to me that although psychology *poses* as a science, there is very little real science upon which it is based. Ultimately, psychology needs a cosmic framework for dealing with the real energy forces and living principles of life that enliven the child of the cosmos that a human being is and which psychology claims to study. This is one primary thing that astrology can contribute to psychology. And, to be fair, we must admit that astrology can gain from more contact with real life, more detailed reporting of empirical observations and correlations, and some of psychology's methodology can be useful in this way. It is a fair question to ask what specifically can a truly scientific system of astrology contribute to the helping professions, particularly—in this conference's context—to counseling and therapy that emphasizes life's relationship and sexual dimensions? This is a question that an open-minded nonastrologer therapist might well ask us.

So, to sum up the potential contributions of astrology to psychology and psychotherapy, I'll enumerate them briefly; and this will serve to summarize this talk as well. We will build upon today's theoretical groundwork in my next talk, at which time we will go into a great many specifics and direct applications of astrological factors to an understanding of relationship, sexual, and compatibility issues.

1. There are cycles of sexual and emotional energy that can be outlined and understood through astrology. These include cycles of heightened interest and then comparative disinterest in relationships or sex which may be traced with great accuracy and considerable predictability by using planetary transits. For example, Uranus and Saturn transits to the Sun or Mars or Venus or Moon (different from person to person and depending on the natal chart and the individual's sex) correlate with such cycles very well, as do

transiting planets going through the houses. The fact that there *are* cycles in life and that they can be readily understood could be a great boon for therapists and their clients; such an awareness would eliminate so much unnecessary worry and self-doubt!

2. The birth chart shows clearly that levels of desire and the intensity of need for love, sex, touching, closeness, opposite-sex companionship, and interpersonal activity vary *tremendously* from person to person. No longer do counselors or therapists have *any excuse* for lumping all human beings into one theoretical basket and thereby considering all of them to have similar natures and needs! The birth chart reveals the individual differences with embarrassing accuracy (that is, embarrassing to many psychologists who have the chance for a dialogue with a good astrologer!). And this revelation can lead to a more healthy acceptance of each person's uniqueness.

3. The chart shows the *objective reality* of which the individual may be completely unconscious because of social pressures, cultural biases, or any number of other reasons. For example, many people *overestimate* their need for sex, especially men. And many people *underestimate* their need for sex, especially women. And many people overestimate their need for dealings with people in general, even though they may be quite impersonal in nature or even deeply antisocial. In other words, many of us feel that we should be or might be something that we shouldn't even worry about! And the chart gives an objective map of our deeper nature, before it was colored by many overlays. The transits to the chart will also give you this sort of objectivity. For example, a specific transit can often explain the transitory sexual or relational problems, fears, blockages, conflicts, or confusion periods that might otherwise get blown out of proportion and then become chronic sources of anxiety. Many of you have seen the look of relief on a client's face when you surprised them in the early part of a consultation with a question like, "Have you felt exceptionally aloof, cold, and disinterested in your partner lately?" Suddenly, the person knows that it is OK to be and feel what they are at that time in their life cycles! In other words, astrology can explain and define what is right and natural for a given person. There then becomes less need to label people "abnormal."

4. The chart shows how well one can really relate to others and how well one can truly understand the opposite sex and one's own sex. For example, many men with Venus in Aries cannot easily establish rapport with *most* women. Or many women with Mars in Pisces may be easily frightened of most men.

5. The chart can show a person's tendency to judge or value oneself positively or negatively in regard to love, sex, and relationships. For example, Virgo may doubt one's worth or think of sex as dirty, Libra may think of it

as gross, Scorpio may see it as a threat to his self-control, Sagittarius may see sex as *beneath* his or her dignity, and so on. Also, by looking at Venus' relation or lack of it to Mars in a particular chart, we can see how one's concept of beauty and love is or is not related to sex and passionate desire. In other words, how we aesthetically judge sex may be seen through the interrelationship of Venus and Mars, as well as through those planets' sign positions and aspects.

These are some of the specific contributions of astrology to the helping professions, with respect to relationship and sexual issues. I need not repeat here the overall contributions of astrology to the counseling field since Chapter 7 of my book *Astrology, Psychology & the Four Elements* is called "The Uses of Astrology in the Counseling Arts" and outlines numerous applications of astrology to counseling and its great value to any counselor. Before we stop, I only want to emphasize that counseling people in their more intimate problems is a challenge to your artistry. Many people are reticent to reveal themselves in such vulnerable areas of life, and in many cases it is too painful for them to confront a long-term self-deception that has helped them get through life for years. It is not always advisable to be too truthful, therefore; it is not always our place to force a person to look at painful aspects of his or her life. And certainly it is not our job to destroy what for some person may be a powerful and strengthening value or belief. So, although some people may be short-changing themselves by not opening up to a real dialogue with you, sometimes you have no choice but to go along with their evasion. This is a question of judgment that you cannot solve by formal training; this is the real art of counseling.

5—Person-to-Person Astrology: Summary of Results of On-going Relationship Research

Stephen Arroyo

The title of this talk is also the title of a book that I've been working on for many years. Currently, I'm revising the entire concept of that book because I wasn't satisfied with it, and—the older I get—the more I want to include *facts* rather than just more theory. I feel that almost every conceivable theory about astrology has been put forth in some book or journal or magazine article, and I'm becoming much more interested in specifics, definite observations, people's *experience,* and—as I gather information on relationships through observation, interviews, questionnaire responses, and so on—I'm coming to realize the vastness of this subject and therefore of the book's scope. This talk is a compilation of a lot of results, conclusions, observations, hypotheses, and preliminary findings excerpted from the notes of the book I am writing. This book is still quite far from being finished, since I do keep changing it and adding to it. So, today I'm going to give you a summary of some of this research.

I am going to cover many topics rather briefly, to tell you the basic outlines of my approach and various findings. A lot of it is traditional astrology. A lot of it confirms traditional astrology, and some of it contradicts it. Many of these conclusions and observations are based on interviews I've done with dozens of people, an approach I had to adopt because anyone's experience in relationships is naturally limited. There are only so many people you've known or loved or been closely involved with, and of course each person is naturally attuned to certain types and repelled from other types. So I started doing a lot of in-depth interviews, and I still plan on doing a lot more. And I am also using responses from a long questionnaire I devised, which has already resulted in over a hundred detailed responses, and we're still sending them out in large numbers.

This talk focuses primarily on Venus and Mars, which admittedly comprise only one aspect of the vast subject of relationship and "person-to-person" astrology. But I had to limit this talk in some way, and the amount of material I've gathered for the book is so vast that it could never be adequately covered in a lecture. So, I've chosen to focus on Mars and Venus

because it's always an interesting subject for everyone and also because, for those of you doing counseling with astrology, as you well know, probably 70% of the people who come to see you are strongly interested in their love life and sex life as major concerns. I will therefore try to express the key interpretive guidelines that I've found especially useful, many of which I've had to struggle for years to find or to understand. They're often simple once they are stated clearly, but it was not always simple and easy to define them!

One final note before we begin . . . I must acknowledge the importance of the Moon in all human relationships, although we won't be covering that subject today. But I do want to say that, if there is anyone here who feels that he or she has an especially good understanding of the Moon, please write a book on it! It would probably be a woman, I assume, or perhaps a Cancerian male, but there really needs to be more material on the Moon in our literature. The Sun sign takes all the glory, but the Moon is there behind the scenes pulling many of the strings! But the Moon's very nature is such that it is difficult to define, to verbalize, and to understand logically and systematically. It is a lot like trying to pin down a Cancer to a definite opinion!

As mentioned in my last talk, astrology can reveal the various levels of desire and the various kinds of needs for closeness, affection, sex, touching, and so on. Mars and Venus are the primary indicators of these needs, although various sign emphases in the chart, as well as the Moon sign and house, also have an impact on this. It is important to differentiate between the sexual and the sensual in discussing Mars and Venus. Mars of course tends more toward the sexual and Venus toward the sensual, although the sign position of each can alter this archetypal manifestation. For example, air sign people are not very physical as a rule and may not be very sensual but may indeed be quite sexual if Mars is strongly placed. Or a given person may have lots of earth sign emphasis and be very sensual, always touching you while they're talking, etc., but yet may not be that sexual. Or you may have a person who has no earth but lots of Scorpio who will be very sexual but not at all sensual. You can read all this from the chart very quickly once you are familiar with the types in an in-depth way.

Some people need a great deal of emotional closeness. Say there's a strong emphasis on Pisces or Cancer; they are very emotional, and that *need not be* sexual. But other people will often interpret their emotional expression as sexual, and they'll be misread and misunderstood all the time because in our culture there's a very narrow scope of expression allowed for emotions. Try living outside the USA for a while, and then come back here to an urban environment. The emotional constriction can then be felt powerfully since you won't be so used to it. In modern, hectic, urban society, we are not

grounded anymore. We walk on concrete and linoleum in plastic-soled shoes, and we have no grounding of our energy any longer. We get disembodied, out of touch with the earth. So naturally we then start groping for some kind of experience of intensity and intimacy.

As I mentioned in the last talk, one of astrology's great values is that it can explain and define what is right and natural for a given person. In other words, you can gain a perspective on yourself that is far beyond the guessing-game labels that most therapists would like to use on you. You need not be labeled "abnormal" just because you are a radically different sort of person from the psychologist who is doing the labeling. A good example of this is the recent experience of a friend of mine who was born with Sun, Mars, and Uranus conjunct in Cancer... a powerful stellium in Cancer that squares a Saturn-Neptune conjunction in Libra! Transiting Pluto has recently been squaring all that massive Cancer energy and conjuncting the Libra planets. When a natal Mars-Uranus-Sun configuration gets activated by anything powerful, you can bet that there will be a manifestation of considerable power. So, as Pluto repeatedly transited this configuration, she starts to go crazy as the power begins to transform her unmercifully. Her body starts to break out in boils and welts and acne. She's almost thirty years old, and she's breaking out all over with teenage blemishes! With Pluto, there is always some kind of eruption, one way or another. She does know a lot of astrology, and she did have the advantage of knowing that Pluto transits are often accompanied by unfathomable changes in personality and emotional-mental patterns.

So she finally said to herself, "Although I do know the Astrology, maybe talking to a counselor could help elucidate what I'm going through because I'm just going nuts!" I mean, she was not used to having this Plutonian eruption constantly pervading her emotional and mental life. So she went to a very traditional psychologist, a woman psychologist, and the lady listened to her fantasies and listened to her problems and said, "Well, I hate to tell you this, but you are really on the verge of going crazy, and I really think you should check into a psychiatric ward." So my friend walked out and never saw the lady again and felt much better afterwards, because then at least she knew that some people were crazier than she was! But also, she saw that the lady psychologist couldn't help at all, and that "I'm just going to have to face these things on my own," which is really what she needed to do. The timidity and self-doubt and fearfulness shown by the natal Saturn and Neptune in the 5th house, squaring the Cancer planets, were transformed! And the potential courage and daring shown by a Mars-Sun-Uranus stellium began to come to the surface.

THE CONCEPT OF "COMPATIBILITY"

Before we get into specifics on Venus and Mars and details about compatibility, I want to define what I mean by the term "compatibility." The word comes from the Latin *cum passus,* which means "to step with" or "to step together." It's a dynamic word which means that you *move* along together, you step along with somebody else. I did a comparison once for a Leo man who had been married thirty-five years to an Aries woman. I asked, "How did you make this last all this time since you are both always yelling and fighting all the time?" And he simply said, "We get along." That was his whole explanation; it was the literal meaning of the word *compatibility.* We should also mention that a later Latin word *compati* came to mean "to sympathize." Hence, a secondary meaning of the word is a state of resonant harmony of energy with another person. And please note the similarity of these words to our word *compassion.* So what do we have implicit in the word "compatibility"? To use another person? No. To derive pleasure from that other person? No. To find in the other person someone who is always agreeing with us and serving us? No. The meaning can be summed up as: a state of being in which you flow with someone, mutually moving together harmoniously, while maintaining some degree of sympathy for the other person's nature and current direction of movement.

One thing about relationships that you should especially keep in mind if you are doing counseling work is the importance of *defining the scope of the relationship* being considered. One should not talk about relationships too broadly or make unwarranted assumptions about any person's intentions in a given relationship. In other words, what kind of relationship does the person want in a particular situation? If you don't define it, it's possible that you'll always be trying to relate *your whole self* to the other person's *whole self* (even unconsciously). And if you do this, it may be impossible for you ever to get along with anyone for very long. If you really consider it, how often have you met somebody to whom you can relate even 50%, let alone 100%? So, by defining what you're after in a given relationship, whether it be a love relationship, a sexual relationship, a business relationship, or whatever, then immediately you know from a chart comparison point of view that certain astrological factors will be especially crucial. By defining the scope of the relationship and what limits are appropriate, you'll be able to use just *some* of the astrological factors in a more purposeful way and not get lost and scattered in the infinite details of the chart.

For example, if you are doing a business compatibility study of two charts, you have to focus on Saturn and Jupiter and Mars for sure, or it just won't work. In love and romance, however, people tend to want to lose

themselves totally, which confuses the issues and makes discriminating understanding vanish. Very earthy people may do a comparison of this sort and say, "Well, this will work and this will work; that's good enough." The practical sort of earthy person may take limitation for granted. However, the more idealistic, romantic sorts of people keep trying to relate their whole beings to somebody else and to merge totally with someone, and of course they're often disappointed. They create images in their own minds that often turn out to be mere self-deceptions; they just want so much to have some kind of total experience. And that tends to be especially true of those people who have strong Libra and/or water signs. And the fire signs in some respects also have that tendency since they are often so obsessed with big, grandiose dreams and huge images. We will go through each of the elements shortly in this regard.

One thing I have learned from doing many hundreds of chart comparisons and from my own personal experience in relationships is: You have to take risks! You'll *never* "figure it all out." Even if you're a great astrologer with a fantastic mastery of the art, you still won't get the ultimate understanding through analysis alone. The deeper understanding of a relationship in your own life won't come until you give yourself to it without reservation. Then the chart will really open up; then the comparison will give you a lot. Approaching a relationship for yourself personally only from a cautious, studious distance and running its experience through your astrological equations in advance won't get you too far. Obviously, even at the beginning of a relationship, a chart comparison *can* tell you an awful lot, but so much are we being motivated by unconscious things—some people would say by *karma*—that we don't see everything. Often we don't want to see it, and in other cases you just can't see it until the time is ripe. There is no way to know all the deep-down stuff all at once and before you're ready to *experience* it. I'm sure many of us have seen astrologers trying feverishly to figure out all the potential details of a new potential relationship without giving anything of themselves to it (and thus risking some hurt). By the time they're finished ruminating about it, the person may have left!

The Persian mystic Rumi has written, "Love is the astrolabe of God's mysteries." That is a quote I really like. Think about it . . . through love you can see more of God's mysteries, more of the cosmic reality or more of divine law or whatever you want to call it. *Through* love, he says, you can *experience* something of these ultimate realities, not through endless analysis. You cannot *explain* love. It is a divine mystery. Astrology is better at explaining "getting along" than "love." I realize that even talking about "love" is perhaps rather unfashionable these days, but with a Jupiter-Saturn conjunction in *Libra*, how can I help it? Today there is so much calculating talk

about relationships: "Let's have a relationship"; "the man in my life", and similar cold, detached phrases, as if he were put into a little box until someone else would replace him in that box; "I've got to have my own space"; and all the talk about self-assertion. Individualism has gone a little wild lately, and I hope that the Jupiter-Saturn cycle in Libra will bring about a little more cooperation and human sorts of interchange and a recognition that people do in fact need intimate human contact, giving as well as taking, as long as they're living in this world.

When investigating the subject of compatibility, especially when doing so through establishing certain rules of chart interpretation, a great deal of caution is necessary. Every astrologer will have his or her own bias based on his or her particular tastes, experience, and attunement. There is no way they can avoid it. This was strongly impressed on me a few months ago during an open-ended discussion group that was organized to talk about and elicit many people's views and experience of relationship as expressed through the astrological language. All the people attending were astrologers, professional or amateur, and the event went on for hours. At one point, a woman got very agitated and opinionated when she was describing men with Mars in Aquarius; she had evidently known a few of them quite intimately. This woman had Venus in Taurus and, when describing one particular man, she said, "He was just terrible. I hated him! He drove me crazy—he was so frustrating. He was always totally asexual." Then she began to get angrier and angrier as she said, "I've had six boyfriends, and they all had Mars in Aquarius, and they all drove me nuts with frustration!" She was climbing the walls as she described how aloof and cold they were, never of course acknowledging anything about her own demanding nature.

Just then another woman raised her hand and said, "I've known a number of men with Mars in Aquarius, and they're all wonderful. They're so nice and gentle, and they're very helpful. They're always mediating disputes." So I asked her, "Where's your Venus?" And she said, "Oh, Gemini!" So here you've got a perfect example of bias based on one's own attunement. When you talk about compatibility, there is always a point of view. Here you have two people and one is totally critical of Mars in Aquarius men; and the other person just loves them and thinks they're God's gift to humanity! Why is this? Because of the compatibility; the flow of energy is there; there's a *satisfaction* and emotional appeal and nourishment that the Venus in Gemini woman feels for Mars in Aquarius, whereas the Venus in Taurus person simply feels deprivation and frustration.

Also, when you talk about compatibility, you have to talk about the various *levels* of compatibility. In any thorough chart comparison, although I've never seen this specifically mentioned in any synastry book, you have to

acknowledge which levels of energy exchange are most important for the particular people involved. Although the following are obvious truths, it is the obvious that is often overlooked: sexual compatibility is most important for especially sexual people; emotional compatibility is especially important for particularly emotional people, such as watery types or lunar types; mental compatibility is most important for those who are especially Mercurian, with a strongly placed Mercury or a powerful emphasis on Gemini or Virgo. Another example would be a Venusian type of person who has a heavy emphasis on Libra or Taurus; this type of person needs compatible Venus energies with another person more than compatible Mars or Mercury energy, and a Venus square Venus between the two charts, for example, would be much more problematical for such a person than it might be for a different kind of person. Yes, these are obvious observations, but don't we often tend to assume, "Oh, everybody's really like me; because I'm this way, that person must be like that also." We may deny that we think like this consciously, but there is often that sort of assumption or bias deep down.

Here's a good example of what I'm talking about. A Venus in Scorpio woman that I interviewed said the following: "I hate people who judge others' sexuality and sexual behavior. They don't know how important it is to someone like me and what functions it has in the lives of people like me. I started making love at age thirteen, and I've been fighting accusations from everybody ever since!" In other words, many people think that she's extremely immoral, but she has Venus conjunct the Sun in Scorpio—what is important to her for compatibility and for fulfillment may not be nearly so important for someone of a different nature. And therefore it follows that if one is very airy, for example with Venus *and* Mars both in air signs as well as the Sun or Moon or Ascendant, that person may not care so much if there's a lack of sexual compatibility in a relationship. Or at least he or she can more easily cope with a lack of sexual or emotional compatibility because such a person lives more in the head; their motivations and attunements are principally on a mental level, and so mental rapport and good verbal communication with another person may be quite enough for them in a long-term relationship.

On the other hand, a person with a lot of emphasis on the earth and water elements would react in a completely different way to a lack of sexual and emotional compatibility; they would experience such a lack as a completely devitalizing experience. It would deeply affect them; they couldn't rise above it easily because they're not airy types—they need the physical and emotional closeness. In fact, to use an extreme example, if the person had all the major planets and points in water and earth and not a strong Mercury placement either, they may not need *any* kind of intellectual com-

patibility. If you are an airy person and therefore really need to communicate verbally, and you have to go on a long trip with someone who has no such need, you'll soon learn about the air element and what it signifies! No matter what you say to such a person, you don't get much response. If you ask them many questions trying to draw them out, you get very short, curt answers. In summary, what is *life itself* to one person may be completely uninteresting or irrelevant to another; that's why any chart comparison should begin by evaluating the individual charts first!

It occurred to me after doing so many comparisons that one can classify intimate relationships in various ways, and each has its astrological indicators. For doing counseling work, it may be useful to categorize the relationship being discussed (at least in your own mind) in order to clarify what the person is feeling. Type One is, "I like (love) you but don't like lots of things about you." This is to say that the center, the self, is OK, but the peripheral things are not. Translated into astrologese, there may be some very pleasant aspects between Sun, Moon, Ascendant, and maybe Jupiter or Venus also, something very positive which shows a mutual appreciation of each other, but there's also all these little irritating interchart aspects, like Mars square the Moon, Mercury square Saturn, and so forth. In a case like this, you probably shouldn't try to live with the person.

Type Two is "I like (love) lots of things *about* you, but not really *you!*" This of course comes as quite a shock when it is finally revealed after you've been involved with someone for a long time. People rarely admit this to others or even to themselves, but it's really very common, especially in sexually convenient or sexually manipulative relationships, in which you really like someone's body or his style or the way he spends money on you, but you don't really like him, or her. This kind of situation is also often found by Mercurian types of people who are easily interested in peripheral things about a person, until they eventually get bored and find that the essential person does not intrigue them whatsoever. You know this kind of relationship has happened when, all of a sudden, a long-time lover yells at you, "I'm so sick of you!" Astrologically, you find in this sort of relationship numerous incompatibilities between Sun, Moon, and/or Ascendant, although numerous less central factors may harmonize nicely.

Type Three is simple: "I dislike you and lots of things about you." Obviously, you don't want to socialize with those people much. The astrological language in this kind of comparison will inevitably reveal either many obvious stresses and conflicts or some extremely close aspects of repulsion involving Saturn or Pluto; or you may have both.

Type Four is very rare, and although the astrology will *reflect* such compatibility if you have such a relationship, it won't really completely *explain*

it. Type Four is, "I like (love) you *and* lots of things about you." In these cases, you have the center and the whole; you have two entire solar systems of relatedness. I'm not saying the people agree in every petty little detail; there are invariably differences, but the two wholes merge with a kind of rare magic. The chart comparison will inevitably reflect a great deal of positive, harmonious energy flow, but it's the unique way the two people interact and "step together" in life that makes it all work. And I'd say no one could *predict* such an outcome through a study of the comparison alone. There are major factors in life that tend to be inexplicable, like karma, magic, dharma, a sense of duty, a sense of mission, and so on. This must be why it is so much easier to predict the hard things in life than to predict the truly rare and great and beautiful things.

So, as I said, the main reason I mention these four types is that, in counseling, it can be useful to elicit enough information from the client so that you can evaluate what sort of relationship it is. For example, does the other person really like some things about him or her, but yet the individual's real self is being neglected? If you can categorize things like that, it gives you some ground to stand on that's often very useful, and you get a direction. In fact, questions like that sometimes get the person ventilating all sorts of frustrations right away; it's like opening a little trap door, and they fall through. Then you have plenty to work with!

COMMUNICATION & THE ILLUSION OF COMMUNICATION

Although therapists and counselors constantly emphasize "communication" in order to resolve relationship difficulties, my observation is: if the foundation of empathy, energy harmony, caring, and mutual understanding is not there spontaneously—and that will be reflected in the chart comparison—then there cannot be real communication. Trading words is not communication! If any of you have been through certain psychotherapeutic procedures in which you are supposed to "communicate," you'll recognize this sequence of events: after some big emotional storms and often some yelling and crying, one often gets the illusion of communication and the feeling that now there will be more empathy with your partner. Yet, two weeks later you're right back where you started. I am not putting down all those therapeutic methods, because they are just right for certain people at certain times in their lives. But false hopes are often raised, and new illusions often take the place of old ones if you lose your psychic balance.

If you think of the word "communication," you may well think of Mercury first. Of course, there is communication at all levels of all the planets

and elements, but let's focus on Mercury for a moment, symbolizing the intellectual, verbal, rational sort of communication. Even if two peoples' Mercuries are not in harmony or even if there are certain strong "afflicted" Mercury aspects in the comparison, a strong current of affection and sympathy between the people (shown by other interchart factors) can nevertheless establish a channel of understanding between the two such that the lack of Mercury communication may not be apparent. You may be communicating on so many other levels that you don't have to talk very much to understand each other; at the emotional level, at the intuitive level, you just know how the other person *feels,* and sometimes you can read his mind. In fact, in this kind of relationship, if you try to talk to the other person too specifically, often everything gets all fouled up and confused! But, in relationships like this, should the channels of emotional harmony be shattered or closed off by one person's disillusionment or disappointment in the relationship or by one person's radical change of attitude during a personal crisis period, then it doesn't take long for both people to start realizing, "My God! We haven't communicated in years!" Then all the Mercury problems come to the surface very obviously. This is true in many other respects also, not just with Mercury. In relationships, as in individual lives, things are constantly changing. Let a strong transit simultaneously transform a major planet's expression in each person's chart, and many latent long-term problems may begin to be noticed as former channels of harmony and rapport start to disintegrate. You have to be able to go with the changes, to keep your perspective, to know that everything changes and transforms over time.

On the subject of communication, let's briefly go through the four elements and see how each deals with "communication" and how each discusses problems. Air signs will jump on specific ideas, facts or concepts. If you're counseling them, they'll often interrupt you and try to show their cleverness. They don't always communicate as well as they like to appear! Earth signs will often patiently wait and pretend to listen, especially if he or she thinks such overt behavior will help get what he or she wants. Then, after the discussion, the earth sign usually goes right back to the old habits, although Virgo will worry about it for some time! Communication, especially for Capricorn and Taurus, feels like a price they have to pay rather than an activity which in itself has value.

Fire signs are usually too impatient to talk things out. They'll often do it, however, to get things out of the way so that they can then continue on their merry way and their fire can continue to flow freely again, unencumbered by intellectual considerations. Sagittarians of course may be willing to "communicate," but only if they do all the talking! Water signs tend to distrust talk itself. They know that talk is cheap, because they know that so

much of life and relationship happens on a deeper level. In counseling situations, watery people will sometimes explode with emotion or anger about the pseudo-communication that they've been subjected to by their close partners or lovers. Somehow, they've found, all the talk was empty and has proved unreal. Sometimes it was merely a means of manipulating them ... the poor, trusting, naive water signs! So, water signs will often get absolutely sick of all this talk. They realize that talk is indeed cheap and that talking is not communicating. This is why they often become defensive, evasive, and irrational instead of overtly communicative.

In intimate relationships, as well as in everyday life, when you are really attuned to someone harmoniously, there is no problem with the pace, rhythm, or intensity of your energy flow in relation to the other person's. That all flows together naturally, and you're not secretly criticizing each other because you sense each other and merge together easily. However, in intimate relationships, the more different you are from your partner, the more unattuned to him or her you are, the more you'll need to reduce the distance between you through creating some special mood, spell, trance, or atmosphere. Reducing the distance between the two people will help in temporarily reducing the differences between the two. This is a Neptune phenomenon that we're going to explore which is another "illusion of communication."

For example, everyone knows that in a classic romantic situation, there is usually an attempt to create a special mood or spell. It's an ideal (Neptune) that people carefully try to create; and if you successfully create that atmosphere, then you find yourself in a magical place, your own little world, in which your tension and your real, obvious differences are reduced. The less compatible you really are, the more you *need* to do this, the more you need to cultivate this archetypal illusory state of trance, because it helps the two of you melt together. This Neptunian mood or spell, however, often aided by Neptunian substances or candles or music (Neptune), is very fragile if it is not based on anything real, which is often the case. If it's not based on real energy flow and real communication, then it's self-created out of imagination, desire, and visualization and based on images and illusions. The mood is then unreal and so can have its fragile reality shattered amazingly fast. All one has to do is say the "wrong thing" or make the "wrong move" for the other person to notice that your words or act don't fit the ideal image. The bubble gets punctured; the fragile bowl won't hold water.

Intimacy, close emotional sharing, and sex are for most people very special experiences. Therefore, people try to *coax* it into being by setting up a Neptunian mood, a special atmosphere; but still the resulting experience can fail to be special if the energy flow is not there or is not especially

dynamic. Instantaneous communication through the electro-magnetic waves and energy fields that enliven us *can* occur. We cannot make it happen. So many of people's problems, including sexual problems, derive from their trying to *force* a certain state of energy flow into being. They pressure their partners and themselves into pretending all sorts of things. But such pretense never lasts. Over time in any relationship, the images and illusions eventually shatter, and you start seeing what's there, which was shown in the charts all the time, but which we were not ready to see.

Carl Payne Tobey had the concept of "mate signs," two signs linked by their shared ancient ruling planet. The following are mate signs according to Tobey:

> Gemini & Virgo, ruled by Mercury
> Aries & Scorpio, ruled by Mars
> Taurus & Libra, ruled by Venus
> Sagittarius & Pisces, ruled by Jupiter
> Aquarius & Capricorn, ruled by Saturn
> Cancer & Leo, ruled by the luminaries, the Sun & Moon

I assume that Tobey came up with this concept because he observed that these two signs so often pair off in various kinds of relationships. And indeed, you do often find these signs paired off, but I disagree with his idea that these pairs are ideally suited as "mates." In fact, this concept is a perfect example of what I call "the illusion of communication." Note that Water and Fire signs share a ruler, as do Earth and Air signs. Since each pair of signs shares a ruling planet, often people of those attunements *think* that they're communicating or sharing an experience *in the same way* and from the same point of view. However, all the four elements are inimical in essence; and, especially, the positive elements are incompatible with the negative elements. This is not to deny their *complementary* nature in some ways and thus the good contributions they can make to complex relationships; but purely on the energy compatibility level, one must say that these so-called mate signs are operating on completely different levels and have totally different motivations. Hence, I maintain that the "communication" that often is apparent is not as it seems, although the incompatibility is not obvious at first.

Now, *in a specific relationship,* you do often find these sign combinations working quite well, so please don't confuse the general principles I'm stating with any sort of assertion of perpetual incompatibility for people with such combinations in their chart comparison! You have to look at the whole charts and the people's entire situations and expectations. In doing counseling of a couple, you don't *know* whether or not they are compatible; you don't know what they're going to get out of the relationship or what they

want or what they need to experience to grow. But you *do know* that there may be a tremendous amount of energy flowing in the early stages of such a relationship that may not last too long after the people start to communicate more profoundly on deeper levels. And, as a counselor, you need to be aware of this progression of development.

DEFINING THE VENUS & MARS PRINCIPLES IN INDIVIDUALS

Although just about every textbook of astrology defines the meaning of the planets in one way or another, I always feel compelled to define the planetary principles *in my own* language before talking about them, rather than using 1920s terminology or having you imagine implications that I am definitely not including. For both sexes, Venus shows how one gives and expresses affection, *and how one receives it from others.* It's a flow, a symbol of give and take, giving and receiving. If somebody's Venus is highly stressed by challenging aspects, it's not just that the person doesn't *give* easily, it's also that the person has trouble *receiving*—it's all one thing, one channel of energy exchange. Venus' sign position also shows how you sense appreciation and closeness—what makes you feel appreciated? What makes you feel close to someone else?

For example, if your Venus is in an Air sign and you're with someone whose Venus is in a Water sign, the Watery Venus person may be expressing things like, "Oh, you're so sweet and nice," etc.; they're always "watering" you. Your Venus in Air may not at all appreciate such expressions; they may seem unreal. So, you dismiss it, and you may not feel appreciated at all. You may think, "Yes, they're talking to me and seeming to be expressing affection, but it's not really personal to me. They're not really respecting my mind and my personal needs for communication of ideas." This is an example of what I meant earlier by the different *levels* of communication that are nonverbal. Someone may *intensely* love you, but you may be completely unable to see it, believe it, or appreciate it. You may dismiss it as irrelevant to your life and needs.

By sign position and a bit by aspect also, Venus also indicates *tastes,* emotionally-colored values, which tastes and values influence not only your artistic and aesthetic preferences but also strongly influence your emotional, sensual, romantic, and sexual inclinations and urges for satisfaction. It represents all these images of beauty and love, your feeling tastes, your emotional tastes, your feelings of what gives you *pleasure.* The Sun, I feel, more represents your *visual* tastes, your overall tastes in life; Venus' tastes are more sensual, tactile, overtly pleasurable. As one person said, "Well, the Sun's

tastes are nice, but Venus' have more pizzazz!" Venus, in other words, has more of an emotional charge, unless of course your Sun is in a water sign! As an example of this differentiation, say you're a Taurus Sun sign man with Venus in Gemini; Taurian women may well look very nice to you, visually, but since your Venus is in Gemini, more clever, intellectual women will probably have more real excitement for you, more of an emotional charge.

Venus also indicates your *attitude* toward love and relationship, and your attitude toward *all social interaction*. You can determine it especially by Venus' sign and element. Venus in all the Water signs is quite private, often a bit reclusive. Venus in the Earth signs is retentive and therefore often a bit introverted, sometimes shy and quite passive. The Air signs of course are more outgoing, as are the Fire signs. Venus also shows, by sign as well as by aspects, something very essential about your relating and receptive *capacity*. For example, the relating capacity of Venus in Aries or Leo is often rather limited and sometimes problematical, because they're not receptive. Aries and Leo are quite "masculine," very outgoing, so much so that it's hard for such people to take in energy from others. It's hard for them to receive someone else into them emotionally, which of course brings about certain problems in relationship. And if that Venus is stressfully aspected, it may be even more difficult to express and satisfy the Venus principle in their lives. They are so extroverted that it's really hard for them to let go and receive someone else into their lives.

Now let's explain some ways of defining Mars. By sign, Mars indicates how you go after what you want. It has to do with getting what you want. It also has to do with your particular methods of operation. In fact, I always find that term useful in evaluating someone's Mars: *method of operation.* Especially if you are going to work with someone in daily contact or when you're doing a specific project with someone, look at each person's Mars to see if your methods of operation will be harmonious. In other words, how do you two actually go about getting things done? Mars represents your methods, your techniques, your approach toward proceeding toward a goal systematically.

Mars also shows how one expresses desires and how one asserts oneself, especially by its sign position. Not just passionate desires either, but how in general you express what you want. For example, Mars in the often-confused, undirected sign of Pisces may quite often be unable to express what they want. They may have considerable trouble asserting themselves, especially if they have no other forceful indicators in their chart, such as Scorpio or Aries planets. And this impotence often leads to the well-known Piscean tendency toward undermining themselves by allowing this weakness and

confusion to direct their lives, and then blaming it on someone else. A clear direction never surfaced until it was too late. Sometimes you'll find this kind of rage in Mars in Pisces that is supposed to be found only in Mars in Scorpio, but the anger went unexpressed for so long that the person winds up harming himself or herself. One's capacity for forcefulness is sometimes dissipated in emotion with a Pisces Mars. One young boy I'm familiar with has always felt since he was very young that his biggest problem was that he would easily start crying under stress, rather than taking forceful action with a clear sense of direction.

Mars shows how you go about trying to get your desires fulfilled too; again, it's your method of going after something. Your Mars sign energy has to be activated and stimulated for you to feel that your desires are acceptable. In the area of sexual satisfaction, your Mars sign and your Mars element have to be somehow activated by the other person for you to feel that it's really OK to have that kind of sexual energy and passion, for you to feel that the natural desires that you have are all right. If you always feel that it's not quite all right for you to have the desires and passions that you do, there is a definite blockage that the astrology factors will reflect, either in your chart or in the comparison or both.

Mars' sign, and to some extent the aspects with Mars, also has to do with the *attitude* toward sex. It's a very complicated and of course somewhat controversial subject to speculate about the differences between the sexes, but I feel that anyone who is aware of the energy-dimension of life that activates all the moving forms we see with our physical eyes cannot deny one obvious truth: the basic energy patterns that mold and create the physical forms that we see must be at least somewhat different in the two sexes in some major ways in order for the resultant physical forms to take such different shapes. Now, in many interviews I've done, many people of both sexes tell me that women's sexuality is incredibly more complex than men's. Astrologically speaking, one might say that Venus and the Moon are also closely interwoven with Mars in a woman's pattern of sexuality. But, in spite of these major differences, in both sexes the *attitude* toward sex and specifically toward the sex act is defined by the Mars sign and to some extent by the aspects with Mars. The fundamental attunement of the orgasmic sexual energy is also indicated by Mars' sign and, to an extent, the aspects. In other words, how one's sexual energy is stimulated, excited, and the actual mode of energy release are all shown by Mars. Mars is of course the gross physical energy, both muscular energy and the sexually released energy.

Another thing that Mars indicates, which is especially important to know if you work in the healing arts or with medical astrology, is your "throwing

off power," your ability to throw off disease or—for that matter—problems and worries. A strong Mars, especially as judged by sign position, is much more able to throw off all sorts of problems, both physical and mental, as well as to re-energize the body and to fight infection. Note the correlation of Mars, the "God of War," with *fighting*. The importance and value of Mars and its correlation to fighting, anger, and various other expressions of force that are too often labeled as "negative" should not be underestimated within the spectrum of the healing experience, and not just physically but also emotionally. A strong, fighting Mars can contribute to health and healing.

For example, one thing I found interesting in the sex therapy workshop I attended was the common finding that people often cannot express sexual desire and passion freely until they can also express their negative feelings. Now what is Mars traditionally? The "God of War," hatred, anger, destruction, resentment, frustrated desire, and so on. And of course, in traditional astrology, Mars "rules" all these emotions and sex as well. Why is Mars traditionally exalted in Capricorn, the sign of strong self-discipline? Because, if you discipline and thus channel that Mars energy, you can go anywhere with it and accomplish great things. When trying to understand Mars, you've got to be willing to acknowledge that Mars in part *does* represent negative energy, brute raw power, and that—if it's not disciplined as its exaltation in Capricorn symbolizes—it is then often destructive. But too much discipline becomes suppression and produces a seething cauldron of resentment and frustration. We see a lot of this coming out, especially in women lately, when people finally begin to take the cap off their Mars expression; out comes anger, rage, resentment, and destructive emotions of all kinds. The Mars energy has not been flowing in many people, so when it does begin to flow, look out!

So, many of the sex therapists have noted that if people can be helped to express their negative feelings, their anger, their resentment, and so on, then the sexual energy can also begin to function more smoothly. I do not deny that there are dangers in encouraging the expression of negative emotions like this. It can be taken too far, or it can be done in such a way that the person is left high and dry, drowning in negative feelings without also being helped to transform the negativity into productive, creative energy. But when you're talking about sexuality, you've got to be willing to hurt somebody, you've got to take a risk now and then, you've got to be willing to assert yourself before satisfying Mars energy can begin to flow. This is most true for people, male or female, who are particularly assertive and Martian by nature. They simply cannot suppress that large a part of their nature without some kind of backlash.

MARS & VENUS IN MEN

It is difficult to talk about sex roles at all anymore, since every role is being tested, flaunted, and many people are rebelling against all roles with a sort of psychic hysteria. However, we have to use some kind of categories or we can't talk at all! So what might we say Mars means for men in general? *How he gives of himself, powerfully and assertively, including sexually.* Mars is not talked about in terms of *giving of oneself* in any astrology book I've ever seen. For most men, certainly for Martian sorts of heterosexual men, Mars has a lot to do with giving of themselves. They're giving of their power in a sexual relationship. They're giving of their masculinity, which to them is taking a risk. And Mars therefore has a great deal to do with what I now call the *male ego*. Of course, if you read a few dozen astrology books, you see many different attempts to correlate psychological terms with astrological factors. People say, "The Sun is the ego." Others say, "The Ascendant is the ego." Just ignore all these limited concepts and futile attempts to correlate unrelated terms from quite different conceptual systems. The "ego" is a multi-dimensional thing of so many layers that it defies simple explanation. But in most men, it's useful and safe to say that Mars is the "male ego."

In men, Venus is in part what Jung called the "anima." Actually, it's a partial anima image, since you would also have to include other feminine factors in the man's chart, especially the Moon. In other words, Venus has to do with what kind of person attracts him, and not just the opposite sex either—also in a friendly, social way. Venus also has to do with the ideals about love, sex, and romance; in fact, Venus is the romantic image for both sexes. Venus' sign colors the romantic image as well as all social inclinations.

VENUS & MARS IN WOMEN

Now Venus in women has to do with the *female ego*. It shows *how she receives and gives of herself in love and sex.* That's not to say that she's not giving with her Mars energy, but Venus is specifically receiving and giving of affection. Venus is also much more of a sexual indicator in women than it is for men. For men, Venus tends to be more associated with romance and beauty-oriented images; their sexuality tends to be more associated with Mars. Venus also has to do with how a woman approaches relationships, including how she approaches relationships that might lead to sex. It is much more common in women than in men for there to be a Venusian approach before Mars ever gets involved. I'm speaking now of archetypal levels. Obviously, if you have a real Marsy woman, her Mars will be more evident

immediately. And an especially lunar or Venusian man is going to relate much more than most men with his Moon or Venus energy and qualities, even before his Mars energy comes into play.

In a woman's chart, among other things, Mars is a partial animus image, in part the male image in her psyche, to which her Sun and often Saturn may also contribute. In most women's charts, the Mars sign is closely associated with some kind of exciting and/or romantic image. That does not mean that she will necessarily act on that image or attraction! And whether or not a relationship of that kind or with that kind of man would work very well is another question entirely, but the Mars energies will be activated by that type of person. One principle thing shown by a woman's Mars is what sort of person—especially what sort of man—is found to be physically attractive. Mars is always physical energy in both sexes. Here's a quote from an interview with a woman who has Mars in Virgo, and this quotation is a good example of the difference between Mars and Venus in women. Remember that I said that Mars has to do with your *attitude* toward sex.

> When I put out energy aggressively, that's Mars. When I want to be made love to, that's Venus. When I *plan* a seduction, I plan every detail.

This woman obviously knew some astrology. I would have never thought of Mars in Virgo women planning every detail. Do you see why these interviews are so useful? The astrology comes alive in such a way that I don't need to do nearly so much elaboration or theorizing.

By the way, a good exercise for differentiating between the Venus and Mars functions and energies is to find two people with reverse Venus/Mars placements. For example, if you have one person with Mars in Gemini and Venus in Cancer, then find another of the same sex with Venus in Gemini and Mars in Cancer. Compare how they approach relationships, how they approach satisfying their needs for intimacy, sex, and so on. Such a comparison is quite revealing, although admittedly you need rather intimate knowledge of the people before the astrology really comes to life. But such an exercise will show you how deceptive appearances can be and on how many levels people operate. A woman with, for example, a fairly unsensual and asexual Venus placement may seem quite aloof but may be rather explosive sexually with those few people who get to know her that well; this is assuming her Mars is in a powerfully sensual or sexual sign. On the other hand, a woman who may have Venus in a very flirtatious or sensual placement but who has Mars in a relatively asexual sign may give off messages constantly that men misinterpret. And therefore a woman like this may find herself completely bewildered when a variety of men get angry at her for "promising more than she delivers." This is one reason why having Venus and Mars

in harmonious relationship with each other helps you get through life: what's on the inside may be more accurately reflected to the outside. In doing such contrasts, keep in mind one simple rule: most men relate to the opposite sex through their Mars first, and most women relate to the opposite sex through their Venus first. Even if they are consciously trying not to do so, the impersonal energies of the chakras naturally start to flow if those energies are active in the person.

In order to elaborate on this, let's say that *most* men have to get sex out of the way before they can really tune in on their Venus, before they can open the channels to their feelings. So, therefore, women will very often have to go *through* a man's Mars to reach his Venus. Likewise, *most* women have to get Venus out of the way before the more impersonal Mars energy can flow. That is, the personal relationship must be evaluated and clear before she can thoroughly relax into sex. A man therefore has to go *through* her Venus to reach her Mars. These are the archetypal modes of functioning. Obviously, a minority of women have their Mars right on the surface and may have very little Venus quality in their personality. And a minority of men have their Venus right on the surface and may have very little Mars quality in their personality. The chart will inevitably reflect this about each person's nature.

Talking about Venus as the "female ego," let me give you some examples of what I mean. Say your Venus is in Leo; there would be a tendency to project an image of bigness and generosity. This is the kind of woman you are ... large-hearted, generous, tending to dress in a fairly elaborate way. With Venus in Virgo, you might project an image of purity, helpfulness, discrimination, propriety, tending to dress in a relatively conservative way, wearing clothes with definite lines and angles. A Venus in Libra woman would tend to project an image of gentleness, grace, aesthetic sensitivity, tending to wear clothes of classic cut and design and simplicity, sometimes with a flair toward elegance. The woman wants to *be* this image, and so it's connected with the female ego in major ways. *A woman needs to feel that she has the qualities of her Venus sign in order to feel feminine!* And those qualities are real at least to some extent, even if all other parts of the chart and aspects of her self contradict it. If your Venus is in Leo, for example, you *need* to feel like that image or you simply don't feel feminine, and the feminine qualities then may begin to atrophy or get distorted.

However, the Venus image *is an image* and only one energy dynamic, not necessarily something that is true for the entire self. (The image is most true to the real self if Venus is in the Sun sign.) In other words, if you're just wrapped up in the female image and female roles, you're limiting the rest of what you can express, particularly if your Venus is in a sign that is not com-

patible with a lot of the other factors in your chart. Venus in women, therefore, is also indicative of *demands* in the sense that a woman will subtly (or not so subtly) elicit behavior and gestures from others that support or match her Venus qualities. If she does not get that kind of input (e.g., if the aspects with her Venus are mostly stressful and/or most of the rest of her chart is at odds with her Venus sign qualities), she then feels unloved, unfeminine, and unneeded. She can then easily become angry and negative because she experiences so little of the needed energy current and *polarization* that feeds her emotionally and aesthetically.

And, to draw a few examples of how Mars is representative of the "male ego," first let's consider Aries. An Aries Mars projects an image of a brave, dashing soul. Now please remember that Mars is *more* than just an image; it is a real, powerful energy as well. But so often, it seems that men all over the world get more wrapped up in the male ego *image* than in the real energy itself. If that image becomes the dominant feature of the man's personality, as it so often does in many males (Arabs, Italians, many American males, etc.), so much of the rest of themselves is neglected. For another example, if a man has Mars in Taurus, he projects an image of a comfortable, easy-going guy, self-satisfied, fairly confident. I should also mention here that an image, like a mirror, has one polished side that reflects out to the world, but there is always the reverse of every image also . . . the self-doubts, the negative qualities, the fears. This is true for Mars also, as well as for Venus. A man with Mars in Gemini would project the image of a clever, communicative, open-minded person, more youthful than his years, even if he were inwardly a rigid, opinionated, uncommunicative person.

So, the principle is that *a man needs to feel that he has the qualities of his Mars sign in order to feel masculine.* Even if all other parts of the self (and thus the chart) contradict the Mars image and energy, it is nevertheless real and important. But it is not true of the entire self. It may be very difficult for him to play the male role in the world if he does not feel confident that he has the qualities of his Mars sign. Now if a man's Mars is not received and accepted and absorbed by a woman, the man may get angry, irritated, grouchy, and devitalized because he's not getting polarized sufficiently to get his energy flowing. So, a man's Mars also indicates *demands* in the sense that he wants satisfaction and acceptance and acknowledgement of his masculinity. Understanding these Venus and Mars images and needs and the demands that are implicit in them can explain many of the disappointing relationship experiences that people have. And having such an understanding can also enable one to adapt to the other person's needs without resenting it, based on understanding and acceptance.

In evaluating the *quality* of expression shown by a person's natal Mars or Venus, it is my contention that sign position is the most dominant factor, more dominant than house position by far and also more dominant than the aspects that may exist with that planet. The sign position is dominant in describing the actual *quality of energy release* and the *tone* of the dimension of experience represented by the planet. For example, if you have Venus in Libra square Uranus, the Libra quality will be more dominant, more *consistently* expressed, and usually more obvious to others than the Uranus energy that is also involved. The importance of sign position as the dominant factor is likewise true of the Sun, Moon, Mercury, Jupiter, and Saturn also. By the time you get to the outer planets, the sign becomes less important than house position and aspects.

The aspects show *how* the energy is released and how easily you can express it or fulfill those needs shown by the planet involved. The aspects reveal how the basic energy of a planet in a sign is regulated, with what intensity it is expressed. Aspects do *tone* the expression of a planetary energy strongly; the closer the aspect is, the more the tone applies—I don't want to underestimate the importance of aspects. For some examples of aspects' strength, let's look at these, assuming all are close to exact in the natal chart. A close Venus square Uranus would give *some* of the open-mindedness, curiosity, and unconventionality of a Venus in Aquarius, no matter what sign Venus is in. But the Uranian tone would be most marked if the Venus was in one of the lighter, more experimental signs, such as Gemini or Aquarius or perhaps Sagittarius. A Venus conjunction with Neptune would give some of the compassion and passivity and sensitivity of a Venus in Pisces; however, this tone would be expressed more or less depending on the sign position of Venus and the rest of the chart. I've seen a woman with Venus in Aries and Moon in Aries, both opposite Neptune. She is a very kind person and very compassionate, and yet those qualities are curiously mixed with impatience with people and a chronic restlessness! Or, as another example, take a Mars-Pluto conjunction. A person with such an aspect would curiously have a significant tendency toward the same kinds of qualities as a person with Mars in Scorpio, whether or not he or she had any planets in Scorpio.

One final thing deserves mention when evaluating Venus and Mars in the natal chart. Always look to the sign of the dispositor of that planet! In other words, if you have Mars in Cancer, also look to the *Moon's* sign because that sign will also color your Mars' expression. If you have Mars in Cancer with the Moon in Pisces, your Mars will be especially watery and colored by great emotionality and sensitivity. If, however, your Mars is in Cancer, but your Moon is in Aries or Leo or Sagittarius, your Mars in Cancer will have the

additional tone of outgoingness, drive, forcefulness, and perhaps more confidence than a Cancer Mars is ordinarily known for. This ancient concept of dispositors should not be underestimated. The *sign* of a planet's *dispositor* is just as significant as a planet's aspects or house position! And following the dispositors through a chart will often enable you to weave your way more sensitively through the intricacies of a chart, and thus more understandingly through the intricacies of an individual's wholeness and complexity.

In considering the dispositors, remember two things. First, a planet that is dignified, that is, in the sign it rules, won't have a dispositor; so that planet's sign is doubly strong as a dominant quality of expression for the person. And secondly, in following dispositors through a chart, ignore the outer three planets—they are too impersonal. Just use the ancient rulers. For example, if you have Venus in Aquarius, look to Saturn's sign as a secondary tone to your Venus. And if you have Mars in Pisces, the fact that Jupiter is in Leo will add a generous, more outgoing tone to your usually timid Pisces Mars. The secondary tone or the sign of a planet's dispositor is what I've come to call the planet's *subtone,* and I'm even gathering material for a book on the subtones.* We don't have time to go into it here in any more detail than giving you one more example of the importance of the subtones.

Why is Venus in Gemini in one person completely intellectual, extremely aloof, and totally lacking physicality to the extent that he or she may seem asexual? And yet, Venus in Gemini in another person may be expressed with much more sensual enthusiasm and evident relish for sex. All right, look to the sign position of Mercury in the birth charts since Mercury in both cases is the dispositor of Venus. In the first case, Mercury is *also* in Gemini, whereas in the second case Mercury is in Taurus. So, in the first case you have a Venus in Gemini with a Gemini subtone as well ... a very mental approach to Venusian interaction! In the second case, you have a Venus in Gemini with a Taurus subtone ... the Geminian mental approach and curiosity infused with a need for tactile communication, an acute attunement to the senses, and a wide-ranging curiosity about sensuality and physical needs. Paying attention to the subtones helps you tie together the entire chart very rapidly with impressive precision, and yet still utilizing only simple astrological fundamentals that anyone can understand. Try it!

*This book is tentatively entitled *The Sun, Moon & Ascendant Subtones: A Method of Individualizing the Birth Chart.* No publication date has yet been set since it is a long-term research project.

VENUS & MARS IN THE ELEMENTS

Although Venus and Mars in the elements are treated *in a general way* in my book on the elements,* I have been gathering a great deal more material on this subject. And I've also gathered many quotations from interviews that dynamically illustrate the reality and importance of the elemental attunement of the planets. We won't have time for all this material today, but I do want to cover the basic principles with some key examples.

Some expecially interesting quotes come from one particular interview with a double-Cancer man who is also an "underground astrologer," in contrast to his extremely conservative and traditional appearance and profession. With Venus in Gemini along with Uranus, he's been quite observant of many people over the years, and also—since his Cancer Mercury squares my Mercury —he gives me another perspective that I felt contributed a new slant to my research. So I asked him, "How would you define 'compatibility' on the various levels symbolized by the elements, on those energy levels?" And what he said is worth quoting.

On the Water level, he said, you lose your sense of time and space, you just lose your self totally and merge into the other person. With compatibility on the Air level, the way he put it was that you lose your mental boundaries and your definitions shift. There is a genuine friendliness and rapport and an easy understanding of each other's mind and a personal liking of the other person. There's also often play and humor. Compatibility on the Fire level, he said, manifests as a person feeling that his enthusiasm and spirit is coming from a bigger source, like the two of you are part of something huge and cosmic. You're caught up in a huge release of energy, and you're both mutually participating in this larger-than-life energy source that is so powerful that both people often wind up running around madly, thoroughly zapped with excessive energy. And compatibility on the Earth element level he defines like so: your sense of environment and what is real changes; your sense of your body changes. You experience what he called "an ecstatic sense of security"—you are both there, your senses come alive, and your perceptions of physical reality become extremely clear and sharp. You come into the present in a tremendously intense but relaxed state of being.

When people have Mars and Venus in Water and Earth signs, their emotional/sexual responses are connected to old memories, past experiences, past conditioning, pain and suffering, as well as past pleasures. There is

*Cf. the author's *Astrology, Psychology & the Four Elements: An Energy Approach to Astrology & Its Use in the Counseling Arts,* available from the publisher of this book.

usually a tremendous depth of the emotional and sexual nature in people who have both Mars and Venus in Water and/or Earth signs. In many ways, they seem to need the Mars and Venus activities as a way of releasing negative energy. When Venus and Mars are in Air and Fire signs, the so-called "positive" signs, love and sex are closely related to images, future longings, and conscious intentions and ideals. I would venture to say that those with Mars or Venus in positive signs—and this is especially true for those who have both planets in the positive signs—are more able consciously to control these energies; it's easier for them to direct them and also to deny or channel or neglect them. The energies and needs are not so unconsciously compelling as with the Water and Earth placements. The Water and Earth placements are more instinctive, more insistent, and have an impact on the person more at the ground level of the person's being . . . so much so that it is much harder to ignore. Whereas, for those with Venus and Mars in the positive signs, it's not too much of an exaggeration to say that their emotional and sexual nature is somewhat disembodied; it's not quite such an intimate, undeniable part of the core nature . . . it's a bit more peripheral to the person's everyday experience in the physical world.

Now, as an example of compatibility or lack of it between inharmonious elements, a relationship between somebody with a light, playful Venus or Mars (Air or Fire) and one with a much more serious Venus or Mars (Water or Earth) can be a real drag or can be a great learning experience . . . or possibly both over time! The more serious types often feel that the lightness, playfulness, and high-spiritedness of the other types are extremely disconcerting and not to be trusted. The more serious person may feel neglected and unappreciated, while the more extroverted, easy-going person may feel that the other one is a dreadfully boring wet blanket who is completely unable to have any fun.

However, there is another side to this "incompatibility" of the elements. Not everything in life that is valuable comes easily. Over time, especially in a committed relationship, the two people can get a lot from each other. The heavy one can perhaps learn to laugh at himself and loosen up, and the lighter person may develop more depth of expression. The two people can actually learn to accept and appreciate the other person's energies and attitudes *in an authentic way*; there's no point in trying to force it . . . the change and acceptance must come from within and grow gradually. For this sort of mutual acceptance to occur, you have to be extremely fortunate! Your natures have to be close enough in quality that the differences can be bridged. Also, there must be a great deal of love and caring present. And finally, this balance usually comes only after a long period of ups and downs and frustrations and misunderstandings, and after you've learned to deal with these

things through courageous, blunt communication. The truth must have a chance to be expressed. But blunt communication does not imply cruel, always-angry communication; you do, however, have to risk some hurt and anger now and then.

There is a quote which sheds light on this issue of reaching a harmonious acceptance and even appreciation of someone else's quite incompatible qualities. A great spiritual master once said while answering a question, "Understanding is more important than love." In other words, while speaking about how to improve close relationships, he stated that a real effort at understanding and tolerant acceptance was more effective than what the world generally calls "love." And, of course, what better means is there of reaching a greater understanding and acceptance of others than astrology?

MARS & VENUS IN THE WATER ELEMENT

Since water of itself is formless, those with Venus or Mars in Water signs often don't really know what they feel or what they want without experimenting. It's only when they experiment that their feelings are drawn out and thus experienced more consciously. Remember, water is *formless*, and so watery people's feelings need to be given form by being with and relating to another person. Water is a passive element; it *reflects*. Anyone with a Venus or Mars in a Water sign reflects other people's desires; and so, they want to be wanted. If another person really wants you, it turns you on! The Water signs don't like to make themselves too vulnerable, which is another reason that they will often wait for the other person to show desire or feeling first. The Water signs tend to be very passive, especially Pisces and Cancer, reacting to the other person's intentions and desires before they discover where they're at. This is somewhat true of Scorpio also, but Scorpio is a more desirous sign with more initiative, and—even though Scorpio doesn't like to be vulnerable either—those with strong Scorpio attunement often get so desperate for sex and/or emotional intensity that they take the risk.

Mars and Venus in Water signs are extremely sensitive, and hence they experience sexual pleasure and emotional intimacy with even the subtlest of stimuli. Sex for them is closely associated with emotional security and emotional release, as well as with emotional *belonging*. The sensitivity of Mars and Venus in Water signs is not limited to their own feelings; they are also extraordinarily sensitive to where the other person is at and how he or she is responding emotionally and sexually. They *reflect* the other person's state of feeling and energy. They *merge* into the other person's feelings and so adapt themselves to the other person's emotions. They get a lot of pleasure out of sensing the other person's subtler feelings and needs.

Those with Venus and/or Mars in Water signs get a lot of *feeding* themselves from feeding the other person. Now Cancer and Pisces are traditionally known for being giving and nurturing signs; but I think Scorpio is often much more giving and nurturing than they're given credit for, although admittedly they can be seen to *consume* others just as often as they feed others. They're simply so private that their better qualities are not often noticed! Yes, they are often extremely cheap with emotions as well as with money; but if they decide to give, they can give tremendously! All of the Water signs can be cheap and can be takers, as well as givers. Cancer is of course often extremely cheap with money and self-protective of their feelings, sometimes to the point of becoming almost totally identified with the rigid mask that they often wear. And Pisces, while not often specifically known for being cheap, is often a taker in the sense that they can endlessly leach energy or money from others without contributing any energy themselves. So, there are two sides to any astrological factor. We shouldn't heap all the negative qualities of a certain element onto just one sign of that element.

One last note about Water sign Venus or Mars: they get personal satisfaction from feeding another person emotionally and by being fed also, all this happening in a mysterious sort of way that is beyond concepts. Since Water is a silent element, slowly working its will without much flamboyance, those with a Water sign Venus or Mars don't like talking very much in romantic or sexual situations. They tend to prefer a very silent sort of merging and blending, a quiet harmony that is rarely experienced and which is something to be savored in depth.

MARS & VENUS IN THE AIR ELEMENT

In contrast to the Water element's propensity toward silence, the Air element placements of Venus and Mars are inclined toward talk—verbal communication and expressions of feeling and desire. They can even be rather noisy at times! And, as mentioned earlier, Venus and Mars in Air do not tend to be particularly sensual, which is to say that they do not need to feel *physically* close to another person in the same way that those with Water and Earth emphasis do. However, if the person has an Earth Sun sign, for example, this alone can add a strong tone of sensuality to the personality, even if Venus and Mars are both in Air. So, once again, I must caution you that the entire chart must be considered! And again, this is why an in-person dialogue is so much better than any kind of written "chart interpretation"; it's easier to blend all the factors in person, to achieve an accurate and realistic impression of the whole person, whereas you have to be a *great* writer to achieve this same sort of blend and complex impression in a mail-order interpretation.

Mars in the Air element does not indicate a particularly strong sexual energy, although they may get the prize for flirtatious remarks! Sex for those with Mars in Air is tied in with *communication* and with fun, mental stimulation, and mental images. This is the kind of person who may go out on the town with someone and actually enjoy the entire evening even though there is no emotional or physical sharing of an intense sort, so long as the conversation and communication are interesting. This sort of approach will bewilder those with a more erotic and physical orientation—it staggers their imagination that anyone can be satisfied with talk alone!

As I said, those with the Air emphasis are stimulated by mental forms and images. They have a very *personal* orientation. I would say that Libra is the most personal, hopelessly personal in fact. As Dane Rudhyar wrote in *The Pulse of Life,* Libras take all social and personal activities with the utmost seriousness; and that often makes life difficult for them because they assume that everyone else is as sincere as they are! Gemini is probably the second most personal sign, although they also have an impersonal streak that surprises those who were taken in by their charm. And then Aquarius is the least personal of the Air signs. Aquarius can be personal, but only for certain periods of time. Their impersonality will eventually surface, so you'd have to get used to being periodically ignored... which is not hard for you if you have some Aquarius or Aries in your chart also.

In fact, if you've ever been jilted by someone with Venus or Mars in Aquarius, you know what I mean by the impersonal quality. This is also found in anyone who has strong Uranus in his or her chart. With Aquarius, at a certain point as a relationship with them is being terminated, you may suddenly realize that he or she was *never* really relating to you personally. Evidently, you were merely a category of person who temporarily was needed to fill a particular slot in the Aquarian's mental reality-model. So, Aquarius can act very personal, and they can be personal in their own way, in an authentic way; but when the impersonality comes through, it's almost frighteningly aloof and detached.

I have had counseling sessions with so many women who have Venus in Aquarius who come to the office and immediately say, "I just have big problems with relationships. None of the men I've known understand me. I'm completely frustrated. I need them but I also need independence from them!" All of these women were so independent that it was obvious to the men that these women didn't need them as much as the men would like them to! And yet, they enjoy men's intelligence and they enjoy flirting and socializing; they tend to be quite vivacious. But their independence and detachment is very disconcerting for most men, espcially possessive or traditional types of men. The social roles are felt by these women to be far too restrictive in all aspects of intimate relationship.

Another comment about Mars in Air signs: with Mars in Air, the mind rules the sexuality and sex energy. Everything goes through their heads! The *idea* of a particular relationship, its *form*, must appeal to them to get motivated. In fact, they will often reject feelings if the intellect cannot easily categorize what is happening. Even if the feelings are pleasant, the person might repress or reject them unless the mind can somehow process the feelings into familiar categories. This is a good example of the *conservatism* of the Air signs! It shows you one reason why the Earth and the Air signs have the same ancient ruling planets. Both groups of signs have a tendency to become fixated on form, categories, and rigidity of one sort or another. This is why an old Libra often resembles a Taurus and why an old Aquarius often seems similar to a rigid Capricorn!

One final remark must be made, lest our discussing these basic principles lead you to oversimplify your evaluation of someone's Mars or Venus in Air. Remember that the aspects with Venus and Mars, as well as the subtone of each and the house position, also have an effect. For example, if a man with Mars in an Air sign has powerful aspects to Mars from Uranus or Pluto or perhaps Saturn, there is often much more lustiness, passion, and craving for excitement than is ordinary for Mars in Air. Likewise, if the man's Mars has a subtone of Scorpio or Capricorn, there is bound to be a more passionate quality evident in his personality and behavior. Likewise, these same additional factors always tone the natal Venus also. Still, however, the Air element placement itself inevitably must manifest dominantly, even if distorted or modified by aspects or other factors.

MARS & VENUS IN THE EARTH ELEMENT

With Venus and Mars in Earth, it should come as no surprise that *time* is a major consideration and determining factor in their relationships . . . time and patience. They take time to express their feelings and desires; sometimes they take what seems to others to be interminable time! There's often a period of caution and a practicality that predominates over the instincts and over the need for romance and excitement. Strong as the physical instincts are in the Earth element, there is a tremendous caution, self-protectiveness, and practicality that dominates the instincts. Self-control is a theme you find throughout all the activities and motivations of all three Earth signs. And, in fact, not just *self*-control, but also a desire to control everything and everyone else! The Earth signs seem to imagine that through control they can achieve security.

However, once those with this Earth emphasis finally say yes to someone and commit themselves to a relationship, they tend to do so very deeply

and with considerable steadiness of commitment. You then know they are *there* with you, not spaced out in their heads or anxiously awaiting a more exciting opportunity. Then they try to make the relationship *work*! One problem that arises in relating to those with a dominant Earth element is: you never quite know if they are involved with you because they really *care* about you personally or because they have some practical reason for being with you. For instance, are they just buying security? Do you happen to be convenient for them as a stepping stone to their ambitions?

Those with Mars and/or Venus in the Earth signs tend to be dutiful and efficient, although the laziness of Taurus commonly takes precedence over duty and efficiency. They also tend to be proud of sexual *technique*; they often work on technique, trying to become accomplished at it, trying to stay in control even of passion. Mars and Venus in Earth signs are very basic and down to earth. Even Virgo is quite a sensual sign; it's not particularly sexual, but they are sensual, very physically oriented. So many people with strong Virgo get into the healing arts, nutritional studies, nursing, physical therapy, and massage. The Earth signs want to take care of human needs and instincts efficiently and impersonally. Sex, love, and intimate relationships are tied in with basic needs and duties. This approach leads sometimes to their being rather mechanical and downright boring. Spontaneity and imagination are not their greatest strengths.

Those with Venus in Earth signs seek shelter, structure, and emotional security in relationships, and this can lead to excessive traditionalism, conservatism of attitudes, and rigidity that sometimes finally produces deep loneliness. Instead of producing a solid, grounded emotional base, the Earth element sometimes takes over and makes the person totally inflexible. The physical presence of the beloved is felt to indicate that everything in the relationship is OK. The Earthy person tends to believe in forms as an ultimate reality, even if they are in essence false, hypocritical, and deceptive. If you want to make an impression on a partner who has a lot of Earth emphasis, whether Venus, Mars, Sun, or Moon, you may well find that the only thing that really gets through to him or her is your physically leaving for a while. That is the only thing real to many of them and accomplishes much more than months of discussion trying to convince them that a problem exists.

Here's a quote from a woman with Mars in Taurus, taken from a recent interview: in explaining how she likes to be treated by men, she said, "Be substantial with me. Be physical with me. Want my body, not just me!" This is an excellent contrast to the Mars or Venus in Air that we just talked about. The Air person would never say this, right? The Air person would say, "Get to know me personally . . . my body can come later!" Physicality,

form, appearance, and dress are all extremely important to the Earthy people. In other words, exterior appearances matter a great deal, especially when Venus is in Earth.

Because of their extraordinary conservatism in relationships, those with Earth emphasis (again, especially so with Venus in Earth signs) deny themselves many possibilities in human relationships. They are so traditional and people have to fit their categories so specifically that many possibilities of new experience with people are neglected or dismissed as impossible or impractical. This is true for many people, not just those with Venus in Earth; but I feel that it is more common and inhibiting to those of the Earth attunement. The Earth types tend to be quite formal, and it is beyond their imagination that people with different attunements might have less rigid approaches to life and relationship. Nor can they imagine that there would be much satisfaction from any kind of relationship other than a traditional, conservative arrangement of well-defined duties, rights, and lifestyle.

MARS & VENUS IN THE FIRE ELEMENT

Venus and Mars in the Fire element are direct but rather impersonal. Love, relationships, romance, and sex are tied in with release of abundant energy and a confirmation of their identity. They tend to be quite self-centered, in relationships and in sex; they tend to be very much on a narrow track. It's hard for them to come down to other people's level to relate to others as mere human beings. Those with these placements often have relationship problems because they are too impersonal; they have difficulty adapting themselves to others and meeting others on their own level, on a simple, person-to-person level. This is especially true of Venus in the Fire signs.

There is some very good material on the Fire element, a very unique treatment of this element's qualities, in Liz Greene's book *Relating*. I cannot repeat all of it here, but—in general—the Fire element has much to do with style and fantasy. Those with Venus and/or Mars in Fire want the lover or spouse to fit whatever dynamic image intrigues and excites them; they want to pull the person into their own personal fantasy world and dramatic vision of life. Fire is always bigger than life; it's never quite enough for them just to *be* contentedly. Aries always has to go on to something new; Sagittarius has to expand continually, even if they make less and less sense in their generalizations; and Leo has to express themselves so broadly and to dramatize themselves so exaggeratedly that they sometimes find that their audience has given up on them and left!

Another way of saying this is that those with Venus and/or Mars in Fire want to pull their lover into the flaming dance of unreflective energy that they consider to be life. There is a dance of life that Fiery people feel within themselves, and that is what they want everyone else to feel and share as well. It is as if they are saying to you, "Come on! Live! Come along with me, join my fantasy, merge with my enthusiasm, and be part of something big! Join my big dream. You're never going to have me unless you join in with my wild vision of life and its magic." And, if you are not so inclined, if you prefer to maintain your own identity and your own private grounding in reality, you may not blend with them very well; you may in fact simply exclaim, "Oh my God, what obnoxious, selfish people!" and leave. You really won't have much choice: merge into their dance or forget it. You can't fight them and ever hope to win. The Fiery people don't extend themselves to you; you have to adapt to them.

The Fire element is a strong element and brings with it a strong ego. The image of self that they project to others is very important to them; their style is very important to them. (I might add that Fire by nature projects light; those with strong Fire in their charts cannot help but project some kind of image. At best, it is light and bright and positive and encouraging and inspiring. At worst, the person thinks he or she is the brightest light on God's earth.) Here's a quote from one interview with a man who was describing women with Venus in Fire:

> With Fiery women, you have to become part of their dreamworld "up there" in their imagination, or else nothing can happen in the relationship. It is as if they are always waiting for a dream man to come along and fulfill their magic image. You have to fulfill or have to pretend to fulfill *their* dreams. Your own dreams don't really seem to matter to them. But as long as you can pretend, those with Fiery Venus are rather easily fooled. They are not the most realistic people in the world.

I might mention one thing about Mars in Fire that appears significant. In men, Mars in Fire usually manifests as definite action in their own lives. In women, the Mars energy is often projected and also often powerfully activates the imagination. It is as if the Mars energy flows into the imagination and activates all sorts of projections, images, and fantasies. This is also true for men with Mars in a Fire sign, but more often a good percentage of their Mars energy also flows into physical activity and dynamic, overt action. This is of course not a sharp differentiation; you will find your local sports teams filled with women who have Mars in Fire signs. But there is the tendency toward a highly charged imagination, and a tendency toward dynamic projections into the future!

For those with Venus and Mars in Fire, there is a connection between sex and high-spirited laughter, joyous exuberance, and feeling appreciated through being shown a good time. One woman interviewed who had a Fire sign Mars said, "Laughing a lot and having a good time makes me more seductible." The Fire placements manifest as a genuine enthusiasm for sex, but—for many—only when it is morally permissible and when they are getting sufficient respect from the other person. Remember, their self-image has to remain intact and needs to be polished by other people's attention! But this is the Fire element, and there is also a quality of sexual impatience and a tendency toward ordering others around that quite often elicits considerable resentment and sometimes rejection from their partners. If you simply keep some of these key principles in mind, you'll find yourselves tuning in on clients' intimate problems and needs so well that you'll often scare them to death! Thank you for coming.

6—Light & Shadow

Liz Greene

I would like you all to try a small exercise. Spend a few moments thinking about the kind of individual who most irritates you. This might be a general type of person or a particular person of your acquaintance who annoys you. Just bear this in mind for a moment—what is it about that individual which you find so difficult?

I would also like you to consider those people of your own sex whom you might tend to idealise. If this is a general type, then bear that in mind. If it's a particular individual, then try to get a sense of what it is that fascinates you, what qualities this person has which you find so wonderful.

Thirdly, have a little reflection about any particular racial or collective group against which you have any sort of prejudice, or about which you have any preconceived opinions which come up whenever you get into a conversation about it. Also, you might consider any collective group that you tend to idealise or romanticise, which seems to you absolutely wonderful or heroic and worth dedicating one's life to. Think about that for a moment.

Finally, consider your politics. Is there a particular political viewpoint or ideology that you absolutely loathe, so that whenever you meet that viewpoint in a group or in a conversation you get raging angry and compelled to argue? Also, is there a particular political or ideological bias that you idealise, which you feel is the one and only truth which will save the world? I would like you to remember what you have come up with as we get into this morning's talk.

The theme of this talk is what aspects of the personality are in the light and what aspects are in the shadow. The points I have asked you to consider are very connected with this theme. Since no one is going to demand answers from you, you can be honest with yourself. You won't have to provide written evidence of your own reflections.

I would like to begin by talking about Jung's concept of the shadow. Like a lot of other psychological terms, this one is beginning to find its way into common language, at least among astrological and psychological groups. I find it highly amusing that among astrologers one can now go around saying, "Well, I know that I'm a bit depressed, but it's because I'm having my Saturn return." Once upon a time we had to say that it was because of the flu, or something one ate, or marital squabbles. You can even pretend you're terribly esoteric by using alchemical symbolism, and explaining that you're

depressed because you're in the middle of a *nigredo*. And you can talk about the shadow in the same way—"Well, sorry, that wasn't me, it was my shadow." Although this is a good way of fobbing off responsibility for dealing with one's psychic stuff, nevertheless it's probably important that we can begin to think in this way at all and look at things in these terms.

When Jung writes about the shadow, he makes it very clear that he doesn't mean one's faults. The issue of light and shadow doesn't deal with those personal areas where I know that I'm not quite as wonderful as I ought to be or where I am fully aware of my problem. It's easy to say, "Oh, I'm too sensitive," or, "I know I have a rather sharp tongue." We can comfortably enumerate these little flaws, and they aren't really a big issue. They are not really the shadow in the sense Jung means it. Because one can be conscious of these little personality flaws and can talk about them freely; even if there is a sort of light embarrassment about it, there is no deep dilemma. There is more a kind of surface apology—"Well, sorry, I'm just like that." These are things that we more or less accept about ourselves. But Jung writes about the shadow as a profound moral dilemma. What belongs to the shadow cannot be seen, which is why it doesn't deal with those faults we can enumerate. A moral dilemma is not a comfortable owning of surface idiosyncrasies. It can provoke profound self-disgust. An experience of the shadow can often feel like what one defines as evil or repellent or loathsome. The shadow may involve aspects of ourselves which we absolutely do not wish to own. We wish nothing at all to do with them because the owning of them is the carrying of a species of cross. The shadow is not to be taken lightly, which I don't mean as a pun. I don't think it's very easy to be glib or funny about it. Usually it is a pretty painful issue.

Why a person who is trying to be good or decent should have such a thing trailing behind him is really a metaphysical question. Why should there be such psychic qualities in each individual, that are so totally unpalatable to everything the person stands for? Why does a person repress the shadow with such force, and suffer so much if he is forced to acknowledge it? I don't think it is possible to answer these things without becoming terribly theoretical and philosophical. It is simply like that. The mystery of the shadow side of the personality is given great importance in fairy tales, and although fairy tales never attempt to answer metaphysical questions, they are often very wise about the meaning of things. So I would like to touch on some pertinent points about the figure of the shadow as it appears in folklore and fairy tales. The best person to read on this theme is Marie-Louise von Franz, who has written a book on the shadow in fairy tale motifs. I will be borrowing a lot from her work.

There are many different faces to the shadow, and one of the faces which appears with great regularity in fairy tales is that of the deformed creature. Very often we meet this creature as a dwarf, such as Rumplestiltskin. Sometimes it is a creature that once was human but has been transformed into a frog or a beast. There is something very grotesque about this kind of image. It's stunted, crippled, warped, debased. It's usually very ugly and often malicious, and it generally appears at that juncture in the fairy tale where everything has come to a halt and there is a stagnation or a plateau. This grotesque figure comes in and upsets or obstructs everything, by throwing a curse or stealing a child or playing a trick or offering to make a deadly deal. Often the creature steals children, or makes a deal with the parent to obtain the life of the child.

To give you some idea of this, there is a group of tales which always begin with a character, such as a miller or a farmer or a merchant. The miller or the merchant has suddenly lost all his money, and one day in the woods he meets one of these stunted or malevolent figures like a dwarf or a goblin. The dwarf comes up and says, "I hear you have no money," and the miller says, "Well, yes, I'm actually quite desperate." The dwarf then says, "I'll tell you what, if you give me the thing that stands behind your mill at this moment, then I will give you all the gold you want." Or he says, "Promise me the thing that brushes up against your legs when you first get home, and I will make you rich."

The miller or merchant always falls into this blindly, and thinks to himself, "Oh, that can't be anything very important. The only thing behind my mill is my old apple tree." Or he decides that the only possible thing that could brush up against his legs is his old dog. So the miller always makes the deal with the malevolent dwarf and goes home and discovers, to his horror, that it is his beautiful daughter who was standing behind the mill, or his young son who brushes against his legs when he gets home. This is the place where the shadow creeps in and appeals to the person's desperation when he feels he has lost his wealth or value. The shadow says, "I can get you what you want, don't worry. But in exchange I want the life of your child, your true potential, your highest values." The entire action of the fairy tale always depends on this critical interaction. There would be no story without it. The shadow figure serves the function of forcing the characters to develop, because now they have to get out of the mess they have made in some new way that hasn't been tried before. Something is always redeemed at the end of the story which leads to a higher or better state than what was there at the beginning, before the miller loses his wealth.

Another face that the shadow wears in fairy tales besides this ugly or

deformed one is that of the witch or sorcerer. Often the issue with these figures is power. This tells you something else about the shadow. The dwarf tells you one thing about it, which is that it comes in the shape of the distorted or crippled or ugly part of oneself. The witch and the sorcerer tell you that the shadow is concerned with power of a particular kind. I think it's a generalisation to say that the shadow is always concerned with power, but often this is its issue, and it will enter in through any chink in the armour, any area of self-doubt or damage or inadequacy.

Alfred Adler was very concerned with this problem of power. He wrote about his concept of the inferiority complex and the will to power which was its compensation. He seems never to have really been very interested in any other dynamic of the psyche except this one, but he is awfully relevant on this particular point. He seems to be talking about a very intimate portrait of the shadow. Where one feels infantile and powerless, impotent and worthless, that is where the damaged child creeps away rejected and forlorn and comes back again with a very dangerous friend.

This friend is often very big and powerful, and dressed in the garb of the witch or the sorcerer. This friend says to the frightened child, "Don't worry, I'll take care of you. I will make sure that no one ever hurts you again. I will control everyone and make certain that they can't touch you." A typical figure of this kind is the wicked queen in *Snow White*, who looks in the mirror and demands that she remain the fairest one of all. She cannot tolerate competition or relationship with any other woman. This is a shadow figure. These figures in fairy tales paralyze the hero or heroine, and hold him or her in bondage. If you are caught in such a shadow, it stops any creative flow in your life because you are so busy defending yourself and controlling everybody else. Because of this paralysis, there must always be a prince or princess in the story who passes a test or undergoes a task to perform the act of redemption. The shadow invokes the redeemer. So once again these figures are responsible for the whole dynamic in the story. Without them, there would be no development.

Another face of the shadow is that of the rough companion. The rough companion trots along beside the hero or heroine and often appears in the garb of a beggar. Sometimes he is someone brutish. Nevertheless, although he is coarse and crude and uncivilised, at the critical moment it is he who knows a way to get over the bridge or through the woods or a spell to counteract the witch. Sometimes he is a helpful animal like a dog or a frog or a shaggy pony. This too tells us something about the shadow, that it is often instinctual and uncivilised and crude. But it knows nature's way and is very wise when civilised methods fail, although it is unpresentable at a dinner party.

One of the most interesting things you can do with a horoscope is to look at it from the point of view of what is in the dark and what is in the light. I've touched on this theme quite a bit already in connection with relationships, but I would like to work with the shadow figure in particular today because the shadow usually wears the mask of one's own sex. I don't think this is a hard-and-fast rule, but in general the problem of the shadow isn't one of sexual attraction or repulsion. More often it deals with the dilemma of accepting one's own sexuality, one's masculinity or one's femininity. It would seem that anything in a horoscope can drop into the shadow. Any point in the chart can be appropriated by that figure. Earlier I spoke about missing elements. These missing elements not only have to do with the kind of people we fall in love with. They are also bound up with the dark side of the soul. Planetary aspects also can have as much to do with the shadow as with the sort of people that fascinate you among the opposite sex. Points in the chart such as the descendant and the IC also have a great deal to do with what falls into shadow in the personality.

I will mention something about the IC first because it's a point that is often overlooked in the horoscope. The midheaven or MC seems most of the time to be connected with how we wish to appear in the eyes of the collective. The opposite point, the IC, seems relevant in terms of what we don't want the collective to see. The sign which is at the very base of the chart is the area of darkness, the place of the sun's lowest ebb, and it is one of the points of greatest vulnerability through which the shadow enters.

If you bear in mind the questions I asked at the beginning, about the kind of people and groups which irritate or antagonise you, and the kind of people and groups which you idealise, consider what sign is placed at the IC in the birth horoscope and what its particular qualities are. Likewise you might consider what sign falls at the descendant. There is something very queer about the relationship of what we love and what we hate. They are often the same thing in slightly different form. If you take those two images of what you idealise and what you despise and stand those images side by side, you may find that the same root exists beneath them both. It's the same figure, but it wears a different garb.

For example, if you have Taurus on the ascendant and are typical of the sign, you may despise people who are not overt and out in the open. Taurus often dislikes those who seem to be secretive or manipulative, who aren't straightforward, or who complicate things and create crises when there could be peace and quiet. But at the same time, Taurus is fascinated with people who have a mystery about them, who are not easy to read and who seem to have insights into human nature in a magical way. It's the same figure. But if

you don't like it, then it's evil or slippery or vicious, and if you do like it, then it's deep and profound and strong. Both sides are wrapped up in the Scorpio descendant.

If you have an Aquarian midheaven, then you are likely to present to the world the tolerant, humanitarian face of Aquarius with its wonderful reasonableness and fairness and concern with other people's rights. You may loathe and despise those self-centered people who aggrandise themselves at the expense of the group, and who draw too much attention to themselves in social situations. You might be profoundly annoyed at the exhibitionist who puts himself before others, because you believe that everyone is special and entitled to the same rights and benefits. Yet you might have a tremendous admiration for the creative person, the artist who can ignore everybody and lock himself in his room for five years and produce a great painting or a magnificient novel. To create like that one must, of course, be megomaniacal enough to believe that his vision is important enough to be seen or read by everybody. But Aquarius frequently idealises the artist, while failing to recognise that every artist must of necessity be egotistical and ruthless about other people's demands and rights. Once again it is the same figure, but seen in opposite ways.

Another example might be a Gemini ascendant, which is cool and rational and clever and never takes anything all that seriously. Gemini loves to play with words and ideas, which are like the balls which the juggler juggles. Information interests Gemini, who is the reporter and observer of life. Gemini will always remember the little anecdote or notice the little idiosyncrasy about another person which everyone else misses. But if you have a Gemini ascendant then it's all likely to be terribly interesting but none of it will passionately concern you. Passion and intensity may be annoying and even frightening. You may really dislike the fanatic, the proselytizer who believes in something with fervent emotion but who can't be bothered with facts. Or you may despise people who wear their hearts on their sleeves, who throw themselves about, showing wild emotion, whether it's emotion about a person or a philosophy. Someone who is very committed to a religion or a philosophy can really anger Gemini—the one who comes up to you on the street and says, "You should join Scientology," or, "Are you saved?", or whatever. Gemini recoils from this because he's much too intellectually sophisticated to believe there's only one truth. Yet you may secretly admire the person who is able to have real spiritual vision and real commitment, who can throw himself into life with passion. You may idealise the person who has imagination and intuition, and never realise that the same fire inspires both these figures.

If you identify very strongly with a particular set of qualities in your own nature, then when the opposite surfaces or appears in someone else, then the result is often repugnance. It's frequently a deep moral repugnance, a real distaste of what that other person stands for. It isn't just a casual disinterest or dislike. The shadow arouses anger far out of proportion to the situation. You don't just ignore the fanatic with the leaflets on the street corner. You want to beat in his head. Why should there be this kind of anger and repulsion? If you penetrate at all deeply into the feelings around a confrontation with the shadow, you will see that the shadow is experienced as a terrible threat. It is a kind of death to allow the shadow any recognition or acceptance. If you are prepared to permit even an inch of tolerance or compassion or value, then the whole edifice of the ego is threatened. Of course the more rigid and entrenched you are in particular attitudes and a particular self-image, the more threatening the shadow becomes. And it's particularly painful because sometimes you must recognise it yet still make the moral choice of not acting it out.

Some time ago I did a chart for an Aquarian woman with Capricorn on the ascendant. She had a number of very strong Saturn contacts in her horoscope, most of them trines and sextiles, and it was terribly important to her to be self-sufficient. She was proud of her capability and her strength. She had raised two children to adulthood in a loveless marriage with a very weak and unsupportive husband, and had carved a successful career for herself in banking. The one thing she could never admit to anyone was a feeling of helplessness or neediness or dependency. She preferred to suffer in stern silence rather than demonstrate any kind of need that might make her vulnerable to another person. She needed an unsupportive husband because a supportive one would have forced her to confront her own shadow. When we began to talk about these issues she told me a dream that had recurred two or three times which disturbed her. There was a particular woman who worked in her office that she disliked terribly. She dreamed that she was in her home and this woman knocked at the door and asked to be let in. She became very angry and slammed the door in the other woman's face.

I asked her to tell me about the other woman. My client said, "Oh, I can't bear her. I find her absolutely hateful." I said, "Well, what is it about her that you hate?" She went on to tell me that this woman, who was about twenty years younger than my client, was "one of those silly little receptionists." It seemed that the younger woman was easily hurt and cried a lot, and played very helpless around all the men in the office. She was always asking for assistance and pretended that she didn't know how to do things even when she did know, so that other people had to help her. My client kept

using the most charged adjectives—the young woman was slimy, deceitful, horrible, disgusting. One of the ways in which you can easily see this dynamic of shadow projection is in the adjectives, which go right over the top. My client couldn't just say, "I disapprove of this woman." She went on and on for some time.

Then I said, "Do you suppose this woman's behaviour might have something to do with you?" and she snapped, "Certainly not!" At that point in the chart reading she did precisely what she had done in the dream. She slammed the door to keep the shadow out. After a while I changed the subject. That is a shadow figure, and my client reacted to it in a very typical way.

You see that the issue of the shadow isn't a question of admitting faults. It's a question of being shaken right down to your foundations by realising that you are not as you appear—not only to others, but also to yourself. The shadow reminds you that what you value the most may be badly shaken if you let it in. My client with her strongly Saturnian personality had built up her whole life and self-image around proud self-sufficiency. The shadow kept knocking at the door, and she kept refusing to allow it entry. The repugnance usually hides a very deep fear, a fear of being annihilated as the person you know yourself to be.

I think that the older you get, the harder it is to face this threat of having everything you have built in your life destroyed. Of course it doesn't have to mean destruction, but that is the fear. The more crystallised the personality becomes, the stronger the ego gets, the harder you have fought to get things you want, then the more difficult the whole issue becomes. If you have exercised self-restraint and self-denial in order to achieve some value or ideal, then the more painful the confrontation is, because letting the shadow in may mean that the whole house of cards comes tumbling down.

So you can see why there is fear and repulsion. It isn't just an idle dislike. It's a threat to established values. The more lopsided we are, the harder we fight to keep that figure out. Even if my client had acknowledged that her horrible colleague was actually an image of something in herself, she would not have thanked me for pointing it out to her.

There is a custom in some primitive cultures that you must never step on another person's shadow. This is literal—you must never tread on the shadow that person casts behind or in front of him. There seems to be a great deal of psychological wisdom in that, because what your best friend won't tell you he quite rightly won't tell you to preserve the friendship. If someone decides in the spirit of clinical truthfulness to tell you bluntly all about your shadow, you will probably wind up hating him for a long time to come. There is no way to listen to someone touching this sensitive unconscious spot without suffering a pretty strong reaction.

Audience: But then how did you introduce the subject of the shadow to your Aquarian client?

Liz: In that particular instance I didn't say, "Oh, you pretend to be really hard and self-sufficient, but you're really desperate and long to be able to collapse and be helpless for a change." I talked about the sense of responsibility and self-control in a more complimentary way, and then suggested that perhaps she was a little too hard on herself sometimes and needed to be able to ask other people for their help occasionally. She was very bitter about this, because she claimed no one was willing to give her any help anyway and so what was the point of asking? It was at this juncture that she mentioned the dream, as if to say, "See how hard I've worked all my life, and then I have to put up with these horrible people who get away with something for nothing." I took her mentioning of the dream as a kind of unconscious request for insight.

Audience: I suppose that having the dream in the first place was a kind of message.

Liz: Yes, I would take it that way. If a figure like this appears in a recurrent dream, then it's trying to get into consciousness. The fact that this figure knocks on the door speaks for itself. Dreams always precede what we're aware of. So if a figure emerged in a dream and the person recoils from it, one may have to leave it alone for a while until the person is more ready to consider it.

Audience: Have you noticed that possibly if a person has a house strongly accentuated in the horoscope, in other words, say, the first house, that this would give him a sort of Aries quality, and that the shadow might for that person be tied up with the qualities of the natural sign associated with the house opposite?

Liz: Yes, it could appear in that way. There's no way that you can take a chart and say, "The shadow belongs to A, B, and C." It might certainly take the shape of an empty house which is opposite a stellium. It might also take the shape of the sign opposite your sun-sign.

Audience: In the case of your client, the shadow sounds like the sign on the descendant.

Liz: Yes, you're quite right. My client had Capricorn rising, and her shadow-figure certainly has qualities that are typically Cancerian.

Audience: Could you tell me what the timing would be on something that a dream is saying? Could the dream be a long time before things start to show in the person's life?

Liz: It could be a very long time before, or it could be two days. One just doesn't know. There are childhood dreams which map out the entire life pattern sometimes. You can't really determine something like that except with hindsight. The only clue you can get is if the dream makes the timing clear. Sometimes dream images come up where timing is made explicit. Someone brought me a dream recently where she had given birth to a premature baby with very peculiar hair, the hair represented all kinds of things to the dreamer which she felt she was struggling to find. The baby in the dream was born after four months of pregnancy, and needed a lot of looking after until it was of normal size. So it had five months to go before it was a normal baby. That might be an explicit suggestion of time from the unconscious. On the other hand, it might not be. The dream might just be saying that something was emerging a little too soon which needed careful handling. You never really know.

Audience: Do you find that this kind of thing comes up with certain transits?

Liz: Yes. I wanted to talk about that. Saturn and Pluto seem to be the most unusual planets turning up by progression and transit when there are issues of the shadow to deal with. The particular woman I was talking about is in the middle of her second Saturn return. So it is very appropriate that the shadow figure should emerge at such a time. Saturn obviously has a great deal to do with the shadow. The sign in which Saturn is placed, and the house in which he's located, and the aspects he makes, all might have something to say about the shadow. But it isn't the only thing in the chart which needs to be considered.

I think we have to be very careful not to take this too literally and go straight for a certain point in the chart and say, "Aha! That's the shadow!" One of the problems with this dark side of the personality is that as soon as you begin to shed some light on it, you discover an even deeper darkness. It doesn't stop. It's not a process where once you've caught the fellow he then goes away. All that happens is that he deepens and brings up more collective features. Wherever you have the light of consciousness, there is always going to be an area in shadow. When you begin to work with the more personal aspects of the shadow, the whole personality is enlarged. But then the shadow gets deeper, and you start encountering more archetypal aspects. You begin

to hit figures such as those I mentioned earlier, like the terrible gorgon who castrates, and the psychopath who has no feeling for anybody. These are much more archetypal figures.

Even the ascendant can have a connection with the shadow. The ascendant is very often a point in the horoscope which the person doesn't like at all. I have met a great many people who, when you tell them the sign on the ascendant, reply, "Oh, no! I thought I was a Gemini ascendant. I don't want to have Taurus rising, it's so boring." Or they say, "Oh, how horrible. I wish I didn't have Cancer on the ascendant, I really can't bear Cancers, my mother is one." Or they tell me I must have done my calculation wrong, because that sign sounds so utterly unlike them, it can't possibly be right. I have heard this most frequently with Capricorn and Scorpio on the ascendant, because these signs have a rather bad press. Very often the ascendant seems to behave as an autonomous figure. You see this particularly when the rest of the chart is very different in flavour, say, a chart with mostly air and fire and then Capricorn or Taurus on the ascendant. If your chart is very weak in a certain element and then that element appears on the ascendant, you can be pretty sure that the shadow will have some of the characteristics of that sign. And you find that other people born under that sign tend to turn up in your life with more than ordinary frequency.

In the end, the problem with the shadow is to actually relate to it, not just intellectually conceive of it. That is the most difficult thing in the world to do, because it poses a moral problem. Part of this moral problem is whether or not one lives out those shadow qualities. This is one of the worst dilemmas in analytic work, for both the analyst and the analysand. When the shadow formulates and begins to come into consciousness, the person is saddled with the burden of ambivalence. If he has been living a very conventional and proper life and the shadow appears as a Dionysian tramp with a bottle in a brown paper bag and a pack of pornographic postcards and a dose of the clap, what is the poor individual going to do with him? Does he destroy everything in his life and run away to become the shadow? If he has any feelings at all it's going to distress him terribly, because there isn't such a thing as a right decision. Should he try to find some way of living that figure out on a more symbolic level? Should he just accept that the shadow is there, repress it firmly and get on with his former life?

With this kind of dilemma there doesn't seem to be any formula or answer that works in a general way. It's part of the reason why judgment is so irrelevant in this sphere. One person may find it necessary to act out the shadow, because his life has been so starved of real vitality and the shadow is the one with all the energy. This may cost a very high price because it could mean the destruction of a lot of things to which the person has been attached.

But he may feel it's worth the cost, because the life he has been living previously has, in a sense, been a lie. But someone else may find it more appropriate to contain the shadow and try to gain some of the qualities inwardly within the boundaries of the ego's values. It's hard to say which of these is the more painful, because they are both very difficult. And for a third person the shadow may represent such primitive values that it may be appropriate to sacrifice its desires. This is, of course, more of a spiritual path. The shadow of a saint is not going to be very pretty, and part of the spiritual journey is to face it and then deny it. There is just no way to know the right manner of working with the shadow until the time comes. And even then there is never a right answer to the question.

One of the issues that I feel is most critical about the figure of the shadow is that it's quite irresistable to get some insight and then say, "Alright, I've got a glimpse of it. Now I have to find a way to transform it." This is a pretty inevitable reaction to anything that we find ugly or maimed or tainted. It's especially typical of a more idealistic temperament, such as you find with a very airy chart. As long as one takes that stance toward the shadow, the shadow fights back. As long as we see it as ugly, it gets even uglier. As long as we see it as the enemy, it declares war on us.

What kind of leap is required to be able to accept the fact that the shadow might never change? There is another book to which I would like to refer you, which is by James Hillman, called *The Dream and the Underworld*. Although I think James Hillman enjoys taking the position opposite everybody else's just to shake things up, he makes some very valuable points. In this book he is concerned with those ugly and crippled figures that emerge out of the underworld of the psyche, which are a perfectly horrible experience for the analysand. He attacks the typical stance of the psychotherapist toward these figures, which is that they must be healed and made normal. Of course they resist any such efforts, and Hillman suggests that this resistance might be perfectly valid, that there may be a psychic necessity for pathology. One can spend years and years in analysis in the hope that the shadow will suddenly transform and become white and shining, and often it just doesn't. The wound simply never heals. This book is a kind of tourist's guide to the geography of the shadow.

Hillman uses a lot of mythical material. He writes about the underworld region of Tartaros, where you find figures like Sisyphus rolling his rock up the hill forever. Sisyphus is an image of something which never changes, but just goes around and around and always returns to the same wound.

Audience: This sounds a little like what you were saying about Pluto.

Liz: It is a lot like Pluto. It touches on an issue I was talking about with regard to Pluto—that if you want to work creatively with this side of life, I think you have to be prepared to accept the possibility that it will never get "better" in the ordinary sense. The moment you can get near this kind of acceptance, it opens up the possibility of finding some meaning and genuine relationship with the shadow. But if you keep trying to cure it, then you have guaranteed its eternal enmity.

I feel that some of what is required is the willingness to experience real self-disgust. And who wants that? Which of us would actually try to cultivate such a quality? It certainly doesn't sound like a typical goal of self-exploration. Who wants to believe that there is some part of the personality which is lame and which will never be made well? Of course the hysteric cultivates nothing but this, and runs around pointing it out to everyone else—"Look how awful and horrible I am, how can you bear to be near me?"—and so on. But that isn't really what I mean by genuine self-disgust. That isn't disgust at all. There's an enormous satisfaction in it. But if you have a certain sense of your own validity, and then come up against the crippled shadow, your own integrity will make it difficult to justify it. Any relationship you go into, any intimacy with another person, exposes you to the risk that sooner or later that shadow figure will make itself known. And if it won't change, then you can never be really complacent about that relationship. How many of us are really prepared to take such a risk? So you see why Jung makes such a point of talking about a moral dilemma of the highest order when he writes about the shadow. It is a challenge to the entire personality.

Now I would like to talk a bit about identification with the shadow. This means that you see yourself as this figure, and fall into it. Much of the time, this occurs in the form of moods. It's one of the main components in a great many depressions. One tumbles down into the arms of the shadow and goes around depressed because one feels crippled or loathsome or ugly. This can often be a very productive and important experience, especially if it happens to someone who blames everybody else for everything bad that happens to him in life. This is a characteristic reaction to a Saturn transit or progression —we discover something nasty in the basement and for a while it's shattering.

But there are people in whom identification with the shadow is a more or less permanent state. If it's a particularly black shadow, then the individual may become one of the outcasts of society. He is the one who takes on the collective shadow. You often find these people carrying the blackness in a family, and they are the scapegoats or symptom-bearers. They act out all the

evil for the family, and the rest of the family all collude with it because then everybody feels better. For perhaps very mysterious reasons they identify with not only their own darkness, but also the archetypal shadow. So society sees them as evil, and they see themselves as evil. They willingly carry our evil for us, and we are therefore very afraid of them.

Audience: That seems to have happened to a lot of Viet Nam veterans. Everyone blames them for what happened in Viet Nam.

Liz: Yes, that would be a good example. Another example is someone like Peter Sutcliffe. Do you all know who he is? Sorry, he was called the Yorkshire Ripper. Britain has fewer mass murderers than America does, and when one turns up he makes the headlines for months. This particular man managed to elude capture for a very long time. His speciality was murdering women. Some of them were prostitutes, and others were presumably women he thought were prostitutes. When he was eventually caught and brought to trial, an enormous dilemma arose around the question of whether he was bad or mad. On the one hand you had a large section of the public saying, "This man is evil, he must be punished with life imprisonment." If there were still a death sentence in Britain, which there isn't, the call would have been to hang him. For these people there was no question about Peter Sutcliffe. He was evil, and therefore deserved annihilation or the next best available thing.

On the other side of the fence another large section of the public, including a good many psychiatrists and social workers, said, "This man is sick. He behaved in this way because he had a terrible childhood. His wife drove him into it." They then dredged up the observation that his wife was schizophrenic and had made his life intolerable. They talked about his awful childhood. They suggested that Peter Sutcliffe was not responsible for his actions, and should receive a judgment of diminished responsibility in court because he was a sick man and society owed him the duty of caring for him and trying to heal him.

These are the two viewpoints that came out about this case. The trial became a paradigm of a very deep moral dilemma which I think pertains very much to our issue of the shadow. The question inevitably arises of whether this dark side of the personality is evil, or is damaged because your mother rejected you and your father beat you and your childhood was unhappy and deprived. According to which side of the fence you take, your attitude toward the shadow will alter accordingly. I don't know what the answer is. I can see the truth in both viewpoints. I know that my own reactions to Peter Sutcliffe were ambivalent, and I was very grateful that I

was not in any way expected to make a judgment on such a problem because I would have been extremely uncomfortable with any judgment either way. I suspect that the shadow is both evil and damaged, but you could as easily say that it's the evilness of it that attracts rejection and consequent damage as you could say that the damage generates the evil. This raises also the entire problem of what constitutes evil for us. Where does it come from? Is it an independent force, or a reaction to something? Is there truly an archetypal devil, or is the devil the product of human misery born in people who have been twisted too far out of shape to be able to bear it? If a person is twisted that much he may identify with the dark and with the urge for power and destruction. Those urges are present in all of us. But why some people fall into them and others do not is a great mystery.

Audience: What does Peter Sutcliffe's chart look like?

Liz: I'm afraid I don't know his chart.

Audience: What was the result of the trial?

Liz: The result of the trial was that they decided he was bad rather than mad. So he received life imprisonment. The trial was very confusing. Peter Sutcliffe claimed that he heard voices that commanded him to kill prostitutes. This was challenged, and the psychiatrist who had initially felt he should be allowed diminished responsibility because of the voices then admitted that he felt he had been fooled. It seemed Peter Sutcliffe had been watching his wife's schizophrenic behaviour very carefully, because she heard voices. So he learned very quickly that if he claimed to hear voices also, he would get a much shorter sentence and psychiatric treatment in a much nicer prison. The entire judgment hinged around the problem or whether or not he had committed his crimes voluntarily and with consciousness. That is an incredibly tricky problem. Evidently if you hear voices then you're definitely mad, but if you don't hear them then it isn't so easy to decide.

There are also figures of great light as well as figures of great darkness which can be related to the shadow. That may sound paradoxical, but the shadow can contain divine qualities and is not necessarily evil. What is in shadow in the psyche is what is beyond the circle of conscious perception. So if you have very little self-esteem and tend to see yourself as a waste of time, a general failure in life, like the Elephant Man who doesn't expect very

much because he knows he's grotesque, then the shadow may appear as a redeemer, a superman. It may be nothing less than a Christ figure. That figure may emerge in one's dreams as an aspect of the personal shadow, in the form of a person whom we idealise. I think the distinctions between what we despise and what we idealise are very blurred. If a collective is very low in self-esteem, then the shadow may emerge in the collective as a kind of saviour. This was the case with Germany after the First World War. She was beaten and flattened and denigrated. It was inevitable that the longing for a saviour would erupt from the collective in that state. It sounds dreadfully heretical, but I think it is relevant to suggest that not only the devil is an archetypal shadow figure, but so is Christ.

A recurrent question that arises with these figures is what you actually do with them. I would like you to bear in mind something that I mentioned in another talk—these images from the psyche tend to seek incarnation or concrete expression in life. One of the best ways of working with these internal images is to paint them. This may sound terribly simplistic to you, but in fact painting an image like this is really a very magical process, particularly if a figure appears in a dream which is frightening or disturbing. And shadow figures are often nightmarish. It's very productive to sit down with some large pieces of paper and some good, bright colours, oil crayons or poster paints, and try to let the image portray itself. It's actually better if you aren't an artist, because then you won't be self-conscious about producing something to hang in the Metropolitan Museum of Art.

One of the important things about images such as these is that they are living, and behave like other living things. If you give them value and attention, they respond. Because they are living energies, they react to one's interest. If you are interested enough to take an hour out of the day and give as much energy to an inner psychic being as you would ordinarily give to something external and concrete, then very often changes begin to happen. Clay is another good medium to work with. The unconscious begins to describe itself in ways which you don't anticipate. Little things slip into the drawing, sometimes quite compulsively. If you keep working on it without trying to judge or analyse it, but just allow it to portray itself spontaneously, something may happen which is hard to describe but which feels like a tremendous release of energy. This is the beginning of allowing the figure into consciousness. Frequently, if you work on drawings such as these, the image appears slightly differently in the next few dreams. It might be a bit less frightening, and more approachable. Perhaps initially it's a terrifying figure which chases you or threatens you. If you have taken the time to formulate it in a creative way, very often in the next dream it may still be unpleasant and nasty and say vicious things to you, but it might talk to you instead of

just trying to kill you. Images have great power to contain and transform energy. All that one can do is trust that process and keep working at it. Another good method of formulation is to write a story about the figure, but you have to be very careful to keep the intellect from censoring things.

Audience: What if the force is invisible? I've had that experience. The feeling is terrifying, but there was no visible image.

Liz: If there is no definite figure, there are other things which can still be expressed creatively. You can still get a smell of the thing, or find a colour which by itself expresses some of its feeling. You may do nothing except draw a grey cloud; but if you sit with a few crayons and play around with the grey cloud, then you might find that something starts shaping in the middle. It doesn't matter whether there is a recognisable human figure. I worked for a long time with someone who used to just paint entire pieces of paper black. One day he started thinning out the black paint and clouds began to form. I think you must take the stance of a child toward these things, because otherwise it just sounds ridiculous. But a child, or the child in all of us, can enter into this magical world and take it seriously. The most enormous changes can happen within the person if he will just allow the unconscious to work upon the ego in this way.

Another way of working deals with the body. This is an entirely different approach to the realm of the shadow. You can try to get a sense of where energy is blocked or accumulating in different parts of the body. For many people, images are less accessible than bodily sensations. There is, of course, a whole movement in psychotherapy which deals with releasing psychic energy that has become trapped in the body. Maybe the shadow lives in your stomach, and you have met it as your familiar indigestion or cramp. Or perhaps it lives in your head, and you meet it as a migraine headache. Or maybe it manifests as your backache or the spots that break out on your face whenever you're in a situation which constellates the shadow.

Audience: Do you think doodles might be useful in this respect?

Liz: Probably, but I somehow feel that it isn't the same as allowing an image to paint itself. If you want to get acquainted with some part of yourself that's hidden, then I think you must invite it to dinner and go the whole way. The only problem with this area of work that involves fantasy images is that it isn't always the best thing to try to do on your own. Sometimes one needs a guide, because although you are telling yourself how silly it is,

you can become very frightened by the power of the images and feelings that arise out of a painting session such as I have been describing.

Audience: Wouldn't having a dialogue with the figure be a good way of controlling it?

Liz: I don't think the point is to control it. But yes, having an imaginary dialogue is often fruitful. If it gets uncomfortable you can stop it immediately. But you can get some clues from the questions I asked at the beginning. You can get an image of the sort of person you despise and can actually try talking to that figure in fantasy and ask it things like, "Who are you? Have I offended you? What do you feel about me?" and so on.

Audience: It sounds as if the shadow is very similar to the animus and anima.

Liz: I think using these terms involves a separation of psychic material into artificial compartments. This is very useful, but in practise there is much more of a blurred boundary between these different figures than the terms would suggest. For the purposes of trying to gain insight into them and integrate them into our lives, we draw distinctions which in practise don't exist so clearly. The figure of the shadow tends to belong to one's own sex because it's an aspect of one's own masculine or feminine personality, and it's closer to consciousness. The transexual figure is further from consciousness and feels much less personal. Very often they carry the same qualities in a slightly different way. They certainly blur into each other.

For example, you might consider the sort of man who is very refined. You see this quite a lot in an airy chart, where there is an emphasis in Gemini or Aquarius or Libra. The masculine principle expressing through this kind of chart is happiest with intellectual expression, and the issues of being civilised and refined and clear and rational are very important to such a person. Often there's a dislike of aggression, on principle. And the shadow side of this kind of man is often the "jock." You can hear such a man being very disparaging about the more basic expressions of masculinity. He would never congregate in a pub with the boys, or play rugby, or engage in the sort of coarse conversations which are expected whenever a group of men get together. He would feel that this sort of thing is beneath him. He often abhors violence. He may be a pacifist and an enthusiastic philosopher. He would never strike a woman or treat her with overt disrespect. Obviously I'm describing a caricature, but often people are caricatures. And with this type, the shadow will frequently turn up in dreams as a thug, or a big, hairy gorilla, or somebody very brutish and macho and crude.

You can see the same thing in reverse. There is the classic situation of the very macho man who has a horror of anything that might be construed as effeminate. He will never be seen shedding a tear or showing sentiment of any kind. He has to be on top in every conceivable way, and the idea of needing a woman is intolerable to him. He must always be in control. He's tough and pragmatic and competent. And the shadow will often emerge as a highly spiritualised figure, which is somewhat androgynous. For this sort of man, coming to terms with such a shadow figure is often quite a difficult process. But if one can do it, one has a much broader spectrum of life that one can live. One can be comfortable with many different aspects of the masculine, instead of having to hang on desparately to just one.

D. H. Lawrence once made the very pertinent remark that women were either wives or mistresses. He seems to have had insight into a fundamental shadow problem in women. If a woman identifies completely with being the wife and mother, then the shadow will often formulate as a whore. The more respectable the woman is, and the more devoted and selfless and dedicated to her family she becomes, the more promiscuous and rebellious the shadow is going to be. You can also see it the other way around. The very liberated and independent woman may have a shadow which is terribly conventional. You can often meet the career woman who loathes the housewife and heaps nothing but scorn on the mother who stays home and cares for her children. That, to her, is weak and despicable and undeveloped. And the shadow is often something straight out of a midwestern American town, with all of its bigotry and conservatism—and all of its richness and stability and strength, if she could only approach that figure more tolerantly and find out what it might have to offer.

In many ways the transexual figure is a deeper one, and a person is inclined to fall in love with that image because it offers a possibility of greater wholeness. But very often the shadow and the love-object share the same qualities. That highly spiritualised, refined, ethical man that I just described may have a very primitive shadow, and he may also have a tendency to fall in love with very primitive women. But when he encounters those qualities in his own sex, he will hate them. With the women, he is attracted, and you get that curious dichotomy of idealising and loathing the same thing. If those qualities appear in the guise of the opposite sex, you may fall in love with them; whereas if they're in the guise of your own sex, you may recoil from them.

It's very interesting to work with the horoscope with these things in mind. You can look at points like the IC and the descendant and Saturn, and also squares and oppositions where the planet at one end of the aspect

describes qualities or drives that are unacceptable to the ego. It's much more productive to try to get an image for these astrological placements, and paint them, than to analyse them and find keywords to describe them. You might find a figure in a fairy tale that reminds you in some way of these qualities, or a mythic figure, or some character in a film or a television programme. But I feel it's important to work with images, rather than concepts. It will not only help you inwardly, but it will also teach you things about astrology that you can't learn from a textbook or a lecture.

I would like now to touch on the issue of the collective shadow, because this concerns the question I asked at the beginning about what kind of racial and ideological prejudices we carry. I am struck over and over again by the fact that when we believe we're being most objective about our political views and religious philosophies, that is when we are really being most personal and when the personal shadow appears with great regularity. If you are caught in a party conflict, you can see this dynamic at work with great clarity. For example, there is the old issue of the communist and the fascist, and their eternal hatred of each other. What makes it begin to look like something other than politics is when you put away your copy of *Mein Kampf* or *Das Kapital,* and try to get an image of what you think one of those disgusting left-wing or right-wing people looks like. You might discover some remarkable things about yourself and why, ultimately, you need to have opinions about political issues and strong convictions and powerful urges to change the world. I'm not suggesting that we should have no concern at all for the world. But discovering one's own psychology in the midst of what looked like an objective political view tends to make one slightly less certain about the absolute rightness of one's argument. While that may not destroy your effectiveness or your dedication to promoting change in society, it may make you a little more tolerant. If you become a little more tolerant, then the view you propound might become a bit more realistic and more possible for you and others to live out in actual life, which is perhaps an improvement on preaching wildly something that no person can live because it's so inaccessible and theoretical and unrooted in human reality.

The issue of racial prejudice is an exceedingly interesting one as well. We don't like to believe that we have prejudices, yet I suspect that no person is free of them, because no person is without a shadow. Those prejudices may not lie in the area you think they lie in. The racial issues may be much less obvious, and one doesn't even know when it's going to come up until all of a sudden a situation triggers it. So, what is your image of the particular group that you fear or dislike so much? Once again, you might discover something

interesting about yourself. One of the things which has fascinated me for a long time is the way in which black figures appear in white people's dreams and white figures appear in black people's dreams. I think what we do is look at the physical characteristics of a person or racial group and then project onto it a psychic image. In other words, we turn physical people into symbols which have something to do with us. You have the same kind of thing going on between the Jew and the Catholic, and between the Jew and the German. You can even see it in the way we project the light on the figure of the Indian guru. I have often asked people what their associations are when an Indian guru or an ashram appears in a dream, and so often they tell me they think all Indians are mystical and spiritually enlightened. Obviously one cannot make such a pronouncement about all Indians, any more than one can make it about any collective. But the guru is an image, a symbol, of a quality of spirituality that might be unconscious in the person who has dreamed it.

It seems as though we look at the physical qualities of our fellow men and translate these into something symbolic, something psychic. If there is something "dark" in a psychological sense with which you are trying to come to terms, then a person who is physically dark is going to provide you with a hook. The trouble is that "dark" can mean many different things according to the individual, and none of those meanings might have anything to do with the actual black person who is the hook. If there is an issue of "light," then we tend to translate that into a physical object. It opens up an area where I don't think in the end we can free the personal situation from the collective one. We all have our secret fantasies about collective groups. Although it's fairly unlikely that anybody at this conference, given the sort of studies we are concerned with, is likely to be rushing around joining the Ku Klux Klan or the National Front, nevertheless these figures appear in the dreams of the most liberal-minded of individuals, and it can be a bit of a shock to find a Nazi or a Klansman in your own psyche when you thought you were so enlightened. We all dream about Ronald Reagan and Brezhnev and Margaret Thatcher and the Ayatollah. But these aren't just collective figures. They also have something to do with you, if they appear in your dream.

The boundaries between personal and collective are very vague indeed. It is just possible that if one can work with the personal side of it, which in the end is the only thing truly available to us, then in the end that little personal contribution might affect the larger collective in ways that are unseen.

Another interesting area where you can see this is in our reaction to great collective crises. In this context I want to mention the conjunction of Saturn and Pluto, which was last in effect between the end of 1946 and 1948.

These two planets were conjuncting in Leo. Because I feel that Pluto has some connection with the collective shadow, the group born under the Saturn-Pluto conjunction interests me. There is also a square aspect that occurred between Saturn and Pluto when Saturn was in Taurus, and an opposition that occurred around 1930 when Saturn was in Capricorn. There was an earlier Saturn-Pluto conjunction that occurred during the First World War. These two planets touch each other with regularity during the course of a century. In fact they are coming up to conjunct at the end of 1982.

Saturn seems to me to represent, among other things, the boundary line of the ego. It marks where I end and you begin. It's my sense of separateness, my structure, my ring of defenses. To have Saturn connected with Pluto, or any of the other outer planets for that matter, means that something in the collective is invading and breaking through my boundary line. If Saturn touches these planets, there is a kind of permeability to movements and currents operating deep in the collective unconscious. If Pluto is involved, then the thing with which one is connected is the collective darkness. I don't think it's accidental that the Saturn-Pluto conjunction has occurred during or just after the two great wars that we've had in this century. The first conjunction occurred right in the middle of the First World War, and the second came right on the heels of the Second World War. I won't make any comment about the fact that there is a third conjunction in 1982 and 1983.* But I have a feeling that in some way what we call "war" is an eruption of the collective shadow. I'm pretty certain that the last war had a great deal to do with that kind of eruption of aggression and violence. If you want to get a sense of how this relates to you personally, consider your own reactions when something like *Holocaust* appears on television. Where in oneself are the Nazi and the Jew?

Audience: I was wondering about Hitler, and how we set ourselves apart from him. Maybe most of us don't come to terms with the personal shadow, so it then becomes collective. Maybe in a sense we're all responsible for Hitler.

*This lecture was given in San Francisco in July 1981. At the time that I am now editing the transcript, which is May 1982, Great Britain and Argentina are at war in the South Atlantic. It has already progressed beyond local boundaries: America is supplying Britain with missiles and ammunition, and Russia is supplying Argentina with intelligence information. There are rumours that Peru, South Africa and Libya may be providing Argentina with arms and missiles, and there are Soviet spy ships all over the South Atlantic. The Saturn-Pluto conjunction is running true to form.

Liz: Yes, I am inclined to agree with you. I've encountered many dreams in people I work with where the figure of Hitler appears, and this happens with both men and women. I always ask what the person's associations are to Hitler, because it varies from one person to another. But the figure usually refers to something tyrannical and dictatorial in the individual. Very often the issue of Hitler hating the Jews is relevant, because the Jew is often a symbolic figure to many people. The blonde Aryan superman hunting the dark scapegoat concerns the person's inner problem.

One of the things I've found with the Saturn-Pluto conjunction is that the people who were born under it seem to carry a quality of having been through the war. It is hard to describe, but I have found some highly paranoid traits with Saturn-Pluto, particularly paranoia about crowds and masses of people. Whenever I have run a group, the Saturn-Pluto people tend to hang about in the back. They don't wish to belong to any group. They don't trust groups and they are suspicious of leaders, especially leaders who demand any sort of obedience.

I have also met many dream images in Saturn-Pluto people which have an eerie resemblance to the Holocaust. Dreams of persecution are common, and so are dreams of being either pursued by an angry collective, or being part of a collective pursuing a scapegoat. I have even been told dreams of being trapped in the gas chambers. I am not inclined to rush immediately to reincarnation as an explanation for this, because I think approaching it psychologically is more fruitful in the end. What happens in the outer world serves us as a symbolic image of what happens in the inner world. The vivid and terrible images of the last war are not only historical. They describe the mythic drama of an inner war. If you have a Saturn-Pluto conjunction, it's as though that war is occurring internally.

Audience: What about the opposition?

Liz: It's very similar. It has the same flavour, and the dream motifs are also similar.

Audience: Do you think there is some special work for Saturn-Pluto people?

Liz: I think there is a responsibility of some kind if you are born with these aspects. I think this applies with Saturn and any outer planet. What it means to me is that you have a gift—that you can potentially channel or mediate powerful images from the collective psyche and give them form. Saturn is the form-builder. I think it's about giving creative form to the

race shadow. Maybe it also means that you are trying to perform alchemy on a chunk of the collective which does not look initially very pretty, and that it would be better if you recognised it.

Audience: And the square?

Liz: Any contact of Saturn and Pluto touches on these issues. Obviously a lot of people have those contacts. I'm focusing on the conjunction because it's the most obvious. But I have seen that paranoia about the crowd in all the Saturn-Pluto aspects, along with a horror of being controlled by anything or anybody. Claustrophobia is a common symptom that I've met with these aspects—literal claustrophobia, the horror of being confined in a small space with a lot of people.

Audience: How do you think one might work with these aspects in a chart?

Liz: The way I would personally see it is that the energies which we symbolise astrologically by planets and signs and aspects are the stuff of which we are made. Alchemy would have called it the *prima materia,* the basic substance with which the work begins. A horoscope to me is a pictorial map of the chunk of basic substance that is, as it were, handed to you at birth with a little note that says, "Do what you can with this." If you get a chunk which contains Saturn-Pluto, then you're not only given a personal issue of power and aggression and primitive passion to work with, but you're also given a sensitivity to a great collective problem with the same ingredients. That personal shadow figure in yourself which we've been talking about may have resonances with some of the collective shadow figures that history has spewed out—in particular the tyrant. And if that's the case, then this is the thing you must work with internally, to find a way to shape and channel that tremendous force. At the same time, you're contributing something to a collective where the gods, at the moment of your birth, were having a bit of a heavy time with primordial passions. There are some planetary contacts which are easier than others, and I think we would be fools if we didn't admit it.

Audience: Do you think that a Saturn-Pluto aspect transiting across something in the birth chart means the person must become involved in major historical events?

Liz: I don't know. I don't think a transit can pull anything out of a chart that doesn't have that propensity inherent in it in the first place. Not

everyone is drawn toward becoming involved with external events in that way. What I think is likely is that the conjunction reflects a dilemma of power and a problem of the redemption of the beast. If it hits your chart, then that dilemma and that problem are going to come up in your own life according to your own special way of experiencing things. Whether it has bearing historically or not, I don't know.

Audience: What about the trine and sextile?

Liz: It's the same pair of planets. I think that a trine means the feeling tone is less offensive to the person than a square. The beast is perhaps a little less terrifying, or one is less inclined to repress and condemn it out of hand. There is more possibility of a natural outlet for those forces. If you have an inner planet which is making a trine or sextile to the conjunction or square or opposition of Saturn and Pluto, then there is a relatively accessible area of life through which the primitive can be channelled. It's easier to work with that figure.

Audience: I think that when Pluto, which is a very strong planet, conjuncts Saturn, which is also a very strong planet, the result will be something tremendous. But there is no way out, is there? If you do go into the way you are, and look the thing in the face, then there is a tremendous energy which is going to go out into the collective which is even more than the two planets at the beginning.

Liz: I'm having trouble understanding what you mean.

Audience: When you're making a step in a good direction, then you're releasing energy, and that energy is more powerful than the energy of the two planets at the beginning.

Liz: Yes, I see what you mean. I'm sure you're right. I can only comment on how that might work in the individual, because I can't measure the collective. But I have seen Saturn-Pluto give the most tremendous inner reserves of strength and depth if the person really confronts his beast.

Audience: If a person is born with a Saturn-Pluto aspect, do you feel, as I do, that at the time when there is a transiting Saturn-Pluto aspect they are brought into a particular social relevance?

Liz: The psychological issues in the individual are brought into relevance at the same time that the same issue is going on the collective. If there is a

war going on externally, the Saturn-Pluto person will be made very aware of his own internal war at the same time, even if he isn't actively involved with the outer one.

Audience: Even if the present transiting Saturn-Pluto conjunction doesn't aspect anything in your birth chart?

Liz: Yes, I think so. At least that is what I have observed. By the way, I should say that I don't see this issue of Pluto and the collective shadow as bad or evil. The way I understand Plutonian energy is that it is archaic, primitive. It is raw nature, pre-civilisation.

I have been getting remarks made to me during the breaks between talks that suggest some of you feel the whole issue of the shadow is terribly pessimistic. I suppose to some of you it is, but the shadow is a part of life and I think we must look at any increase in understanding of life as creative.

I suppose I also am in accord with the Jungian view about the layers of history we carry in ourselves. If you take a twentieth-century person and peel away the top inch of rational consciousness, you will find a medieval person, and the medieval mind's world-view is very different from ours. To medieval man the universe was wonderful and awesome—one huge interconnected living thing. Hence you get those strange accounts of hierarchies of angels and laws of correspondences. These underpin modern astrology, although we've largely forgotten its heritage. You can read people like Paracelsus writing about Mars and iron and the colour red and blood and oak trees all being part of the same substance.

So if you strip away twentieth-century consciousness you find medieval consciousness. If you strip away medieval consciousness, you find the ancient Greek with his rich pantheon of pagan gods. If you peel away the Greek, with this kind of mythic imagination and that brilliant childlike inquiry about the universe that eventually became science, then you'll find the primitive. And the primitive mentality is thoroughly animistic. There are spirits in stones and demons in rivers and ancestral ghosts in trees, and the earth is peopled with great primordial powers before which man's little ego consciousness is very, very frail. It's like a tiny little candle in a large dark room. One must work terribly hard to keep the light burning, and one must propitiate the terrifying powers of nature, of which the greatest are procreation and death. It's at that most basic, most primordial level that I see Pluto. It's not an evil force, but something utterly uncivilised. It's no more or less evil than nature herself.

When that force erupts in our twentieth-century Western World, as I feel it did during the last war, and as I think it does in individual cases of

psychotic breakdown, then it doesn't look very nice. But this is largely because of the arena in which it erupts, and because of the complete absence of understanding of it. We just can't believe such passions could still exist in us. We have become horribly arrogant with our development of consciousness. If you try to look with more symbolic eyes at Germany and her position in the last war, and you take a look at German history, you find that she is the one nation in Europe that was never Romanised. Germany was pagan, and worshipped Wotan, who is at best a mad, chaotic god. Then she was abruptly Christianised, in a great hurry, without those centuries of slow Roman processing. Every other country in Europe had a gradual development from the early pagan gods to the Christian era. I imagine Germany as a collective psyche with a kind of vacuum in the centre, and into that vacuum Wotan began to seep from below. The Christianisation of Germany was never very effective. All the really powerful, chaotic, heretical sects during the Middle Ages tended to erupt in Germany, like the flagellants. There were a number of mystical, violent cults and cult leaders who emerged out of Germany and threatened the fabric of the Church. I think Wotan was trying to seep through even then. I would recommend that you read Jung's essay on Wotan, because the eruption of Germany in this century was certainly a revival of a powerful pagan spirit.

If you consider the inner content of the last war as a pagan and primitive energy bursting out through an apparently civilised veneer, then you will begin to realise that these forces can burst out anywhere. The only difference between Germany and the other western nations during the war was that the other countries had an extra layer of Romanised skin which enabled them to keep some hold on the primitive. But even among the "good" countries the same antisemitism and savagery kept bursting through. Everyone is terribly embarrassed about it all now, and it is played down. Anti-Jewish feeling in England is not discussed now, although it was pretty strong during the war. But we can very conveniently place the collective shadow on Germany historically, because it makes us feel better.

I am inclined to feel that it isn't really an issue of evil, but an issue of lopsidedness and dissociation.

Audience: That would mean that God really isn't on anyone's side—He's playing the whole.

Liz: I am inclined to sympathise with both Greek philosophy and Renaissance Neoplatonism. I think there are many different gods, or aspects of one central thing, and I think different gods take different sides. Homer had a great deal to say about this when he wrote about the war between

the Greeks and the Trojans in the *Illiad*. Some of the gods sided with Greece and some with Troy, and they fought each other on the battlefield among the human soldiers and also fought each other through ploys and tricks on Olympus. They are all gods, but they quarrel among themselves. That's what a horoscope tells you—squares and oppositions reflect the gods quarreling, and we get caught in the middle.

I feel this way of looking at things is very valuable, and if it makes you angry and uncomfortable, then it's all the more valuable. I am afraid that working with any sense of responsibility on one's own personal issues, not to mention a client's issues, may mean giving up the luxury of believing you can always see the right thing. In the end, there does seem to be a quality of conscience embedded very deep in us. But to be able to live with your own uncertainty is, I think, the most precious gift you can give a client—particularly with the issue of the shadow. You can afford to be very tolerant with a client whose dark side is nothing like your own, because then you can be relatively objective and view the whole thing with compassion. You can talk about ways that the person might get on better terms with what he despises in himself. But if his shadow is anything like yours, then God help you, because there is no way you can respond with anything except your own feelings. All of a sudden you're engaged with that client, and you can't be aloof and superior and objective anymore. You're not the omniscient astrologer sitting in his chair with a horoscope before you. That client will make you uncomfortable, and that is a marvellous thing, because then you actually have to bring yourself into the horoscope reading. If you can live with some uncertainty and some confusion about what you believe to be the nature of the world and the rightness or wrongness of your own beliefs, then you might just possibly refrain a little bit from trying to direct your client—consciously or unconsciously—into the type of transformation that you believe to be appropriate for him. I don't think we ever get free of this problem, no matter how many years we work at it. I'm certainly not free of it. I don't know anyone who is. I know no analyst who is free of it, which is why analysts accept the responsibility of having to stay in their own analysis for many years.

Audience: Does Pluto in Leo alter the meaning in any way?

Liz: I think a planet tries to find expression through the vehicle of the sign in which it's placed. If Pluto has something to do with the most basic, archaic impulses in us, then he will try to find a place in the individual's consciousness when he is in Leo. He will try to become creative in individ-

uals. I see Pluto in part as a kind of collective matriarch, a collective primitive. I suspect that Uranus is a bit more like the collective Renaissance or Greek philosopher who tries to find out how the universe is governed. He's the spirit of questioning, who attempts to understand the mind of the gods. Plato thought the divine Ideas were the innate structure upon which the manifest universe was hung. If you have a Saturn-Uranus contact, then it is that figure which is constellated. Ideas, of course, can be destructive as easily as they can be creative. I don't think there is any question of Uranus being "better" than Pluto. But I think we tend to like him better in the twentieth century.

I associate Neptune with the figure of the divine victim and the divine redeemer. I mentioned this mystical longing earlier, the longing of the race for its spiritual home. It's a yearning to be reunited with the thing out of which one came, whether you see it as God or mother's womb. That longing can disintegrate the personality as easily as it can vivify it. If you have a Saturn-Neptune contact, then it is this figure of the mystic which is constellated.

It's interesting to see what people do with these kinds of Saturn aspects, because some people side with Saturn against the outer planet and other people side with the outer planet against Saturn. The shadow will pick up one or the other. There are Saturn-Uranus people, for example, who identify very strongly with the Uranian side. They are the bearers of new ideas for the collective. They are the ones who want to change society, and what they hate most is that Saturnian force of tradition. Saturn is the inflexible structure that is based on what has been tried and proven through experience, and has no room for risky change. Saturn-Uranus may hate this in the world, and so the ideology becomes coloured by it. But the inflexibility and rigidity become part of the shadow, and you find that the more extremely iconoclastic the views are, the more rigid the person is who propounds them.

Likewise Saturn-Neptune people may side strongly with Neptune. I have noticed that a lot of people born under this conjunction have withdrawn from society to go into communes which they hope will provide the alternative utopia that can open up the spiritual side of man. What they hate is materialism, and they may despise the man who puts energy into making money so that he can buy a house and a car for himself. This is what is despised, but it becomes part of the shadow, and I have never met any groups with as many money problems and manipulativeness with money as the spiritual groups who think money is a dirty thing. Then there are those who stand on the other side and identify with Saturn. They are the ones who will condemn the Neptunian visionaries and call

them all drug addicts and dropouts, which is the way Saturn sees Neptune.

Audience: Do you think Saturn-Neptune requires some mundane service to the community?

Liz: Not really. I don't think Neptune is concerned with mundane service. Neptune is about a giving up of one's sense of separateness. It's an inner, intangible thing, and when you try to convert it into good works it becomes fanatical. One of the places in which you can see Neptune is in a church service, if the person is really deeply involved with it. There is a tremendous feeling of being lifted up and out of yourself that comes from a group singing or praying or meditating. One loses the sense of isolation and loneliness. At a very elementary level you can also see it at a football match, where the individual disappears into the crowd. There is simply a mass of people, all screaming their heads off in the hopes that a particular side will win. You can also see Neptune in fashions. Why is it that everyone suddenly starts wearing the same thing? We don't question this. A style appears, and we go out and buy that garment. It's a merging into some kind of collective emotional pool, which gives a feeling of belonging. The letting go of Neptune is not really about practical service. It's a feeling of unity with a greater whole. If you have Saturn contacting Neptune, then you must find a way of including this longing in your own life. Neptune can be both sublime and ridiculous, but its end objective is the same either way.

Audience: What about the group born under Pluto conjunct Uranus?

Liz: There seems to be tremendous energy and also tremendous violence in that group. When transiting Saturn went through Virgo and passed over that conjunction, a good many of this group erupted. Suddenly in England the news was full of them. Punk rock burst on the scene, and a lot of new violence broke out—people were being beaten up on buses and subways by fourteen- and fifteen-year-olds in gangs. That generation group was activated not only by Saturn transiting in conjunction, but also by Neptune transiting in square. The theme on their lips was very much the destruction of existing society. I can see that there is a very positive potential in all that, and I don't doubt that a good many social changes will be inaugurated by them eventually, but I fear the changes are likely to be less than peaceful and gradual because Uranus-Pluto is a very violent conjunction. Saturn-Neptune is much more mystical and visionary.

Audience: Do you think we have any choice about how we react to these collective movements? Or are we all fated by those generation trends?

Liz: That's very difficult for me to answer. A good many determining factors lie in one's upbringing and in what the parents stand for. The parents are very bound up with the personal shadow, and problems with the parents also mean there is much less conscious choice, because we tend to see the world as if it was peopled with mother and father unless we have some awareness of the nature of our parental ties. The country you live in, and the collective standards you've imbibed with mother's milk also bear great weight. You can't separate yourself from the collective and walk away from it. In some way, you must come to terms not only with the world you live in, but also with the currents and trends that are happening during your lifetime. But I think we have choices about how we live these things individually, and the more one knows about the secret pressures and influences in unresolved unconscious conflicts, the more choice one has.

Audience: Don't you feel that we are always given what we can carry and no more?

Liz: Well, I'm not sure about that. It's a nice philosophy. But there are situations where the collective is stronger and tramples the individual. I have a feeling that some of us are given more than we can carry. In some theoretically perfect universe I am sure we are given exactly what we can work with, but I am struck by the casualties in life. There are individuals who seem to carry madness for the rest of us. This is Ronnie Laing's view of schizophrenia. The schizophrenic is really the great Christ-figure of our time, because he is living out the collective's psychic dissociation. I am afraid I can't really agree with you, except in a theoretical cosmos. I can talk about choice, but I am only too aware of the monumental effort involved in getting even a small sense of freedom about very personal issues. I think many of us are given more than we can bear.

Audience: What is the light side of the shadow?

Liz: I think the mythic figure which represents this best is the figure of the redeemer. If you explore any of the great redeemer figures, such as Christ or Mithras or Dionysus, you will see that the redeemer transforms the world through his suffering. In a strange way it is the suffering, crippled side of the personality which is both the dark shadow that won't change

and also the redeemer that transforms one's life and alters one's values. The redeemer can get the hidden treasure or win the princess or slay the dragon because he's marked in some way—he's abnormal. The shadow is both the awful thing that needs redemption, and the suffering redeemer who can provide it.

If a person projects this outside, then he believes that someone else can redeem him. This is one of the most frequent and most mysterious happenings in psychotherapy. The analyst or therapist catches the entire projection of the shadow, which means that he is both the horrible, threatening thing and also the thing which will save and redeem. The discovery that both extremes are one's own is a shock, but it's the beginning of healing within the person.

I will give you a dream as an example of this. The man who had this dream has the sun in Scorpio with Mercury and Venus also in Scorpio, and all of them square to Pluto in the twelfth house. I worked with him for quite some time, and as you might expect, his early dream material was very violent and bloody. He was very frightened of his own cruelty and anger, not only because he found it terrifying in itself, but also because he had had a very violent father through whom he had experienced these things early in life. He was very aware of his own damage, and saw himself as a terribly injured person with little hope of change or happiness. At a certain point in our work he had the following dream, which made an enormous difference to him.

He was in a car which was his own, but he wasn't driving. He was in the middle, and on one side sat his father. On the other side, at the wheel, was an old man. He didn't know the old man, but he knew that the old man was magical and very wise and a healer. He suddenly realised as they drove along that something was going on between his father and the old man. In some way, although they didn't speak, the old man was healing his father. The dreamer had nothing to do with this process, and couldn't control it or interfere with it, but it was happening in his car. One of the things that struck him was that his father and the old man resembled each other.

I think this dream speaks for itself. The two older men resemble each other, yet one of them is the terrible violent father and the other is the "wise old man" that Jung is always writing about. I am not being a proper Jungian by referring to the old man as part of the shadow, but it's obvious from the dream that the two figures are two halves of the same thing. The old man is the one who understands the meaning and purpose of the problem, and has the patience and wisdom and compassion to redeem it. The dreamer isn't in

control. Something is happening in him, in his car, but it goes on without his interference, and it involves a healing of the violent anger in himself.

Often these redeeming figures appear in the middle of a particularly horrible period in one's life. They leave a feeling behind them of hope, even though the person may be deeply depressed at the time. Somehow the suffering has a meaning.

I think collective religions pick up this figure and project the image of the redeemer onto an historical personage. That doesn't mean the historical personage isn't also the redeemer. I don't know, because I'm not a theologian. But psychologically, the figure of the redeemer is an inner figure. If you experience it through Mary or the Buddha or Krishna or Christ or your analyst or even your astrologer, you have exteriorised it. That is not to say that you should abandon your religion. But both God and the Devil have their echoes within.

7—Methods of Chart Synthesis
Stephen Arroyo

Chart synthesis is the topic of this talk, and—as the description states—I'm going to present a few methods that I have found particularly valuable for understanding the chart as a whole and for integrating the different parts of the chart. In other words, I'll talk about some synthesizing methods that I have found to be especially useful. That does not mean that I am dismissing all other methods and procedures that I'm not mentioning; I'm merely emphasizing the positive, with particular stress on some extraordinarily simple methods of viewing the chart as a dynamic whole.

A few philosophical comments seem to be in order, for one cannot ever have the capacity for viewing the chart and the person broadly and inclusively without an overall philosophical openness. In other words, how can you see the big picture of a person's life and nature without being open to bigness, to the vastness of life, or—you might say—to Jupiter? With Mercury conjunct Jupiter in my chart, I can't get away from philosophy, from the philosophical implications of ideas, from the ultimate meaning of ideas and methods and theories. I am thus rather selective in the astrological theories, ideas, and techniques that I personally use and recommend. As Dane Rudhyar (who, with Sagittarius rising, is "ruled by" Jupiter) has especially emphasized for many years, you have to have a clear philosophy and a clear sense of purpose to understand and practice astrology at its best. If you don't have that, then obviously it's very hard to differentiate between ideas, theories, and techniques. You then have no grounding, and you easily get thrown off on innumerable tangents.

First of all, I have to emphasize that there is no substitute for an intuitive grasp of the *whole* chart, which is to say, an intuitive grasp of the *whole person*. This can only develop over time, from a great deal of experience with lots of people and lots of charts. No matter how many methods or measurements you use, this intuitive apprehension of the totality of a chart and person can come only from time and experience. Some people are born with the ability to develop that capacity comparatively quickly; that I will not deny. Others require many years of patient practice *and personal development* before—often quite suddenly—a wholistic vision falls into place. But, no matter what kind of person you are, no picky analytical focus on specific, isolated chart factors can replace or equal a comprehension of the totality of an individual's nature and energy pattern. And this total comprehension

can usually only happen *in person* with a client, unless one is very, very psychic. And even if you are sufficiently psychic to tune in on a person whom you have never seen, just through the chart (as in the mail-order "readings" that many people do), you have to be willing to put out a tremendous amount of psychic energy to do it. You pay a heavy price when you do that; it is often very draining. You see, I am not saying that it is impossible to achieve this total, synthesized comprehension of a person and his/her chart at a distance. But I am saying that it is much more difficult, much more draining, much more dangerous, and often more misleading and inaccurate; and very few people can really do it well and with consistent accuracy. Many people involved with astrology are at least somewhat psychically sensitive, but why drain yourself? What are you trying to achieve? Why not have the person physically present whenever possible so that he or she can contribute to the energy required through a genuine, detailed dialogue?

So, now that the limitations of specific methods have been clearly stated, I also must acknowledge that some methods of chart synthesis *can help us* to see this wholeness and unity; and this is what I want to look at today. I simply cannot emphasize enough, however, that as long as one piles up analysis upon analysis, trying to guess all kinds of petty details about life, and neglects the intuitive faculty, one cannot synthesize. It would be more valuable and useful to pay attention to the roots and sap of the tree of life than spending all your time trying to count and classify every leaf on that tree, which is a job that can't ever be finished. New leaves endlessly burst forth; you can't keep up with them! But if you understand the tree's basic energies, nutritional needs, flow of the sap, and root structure, the leaves will take care of themselves; the leaves will be healthy if the roots and sap are healthy.

This is why I always emphasize the four elements, which constitute the energies of life, the sap of the tree. But the human mind is such that it can put together an infinite number of cute little tricks to entertain itself and that enable the mind to congratulate itself on how clever it is. Cleverness, however, has nothing to do with understanding or with seeing the big picture of life. Note on the archetypal level how Gemini is always opposite Sagittarius: cleverness with no context in contrast to large-scale overview systems of meaning and belief. If you are just playing with cleverness and analysis, with mental dissection of a chart, there is of course no end to the resulting methods, facts, correlations, and pseudo-facts, as we can all see from the directionless, chaotic proliferation of "new techniques" in astrology in recent years. But pursuing that limited approach will never lead *by itself* to understanding or even to *useful* discoveries.

As long as one continues to attribute to astrology more than it can be and do, one cannot synthesize. Liz Greene also said something like this in

one of her talks. As long as one continues to attribute to astrology a wider scope of applicability than it can usefully fulfill, we are leading ourselves to misunderstanding, we are misleading our clients by promising more than we can fulfill, and we are doing a disservice to astrology's true greatness and strengths. If we look for everything in the chart, we can never synthesize. If we try to account for everything through astrological details, we forget to look to life itself for revelation and inspiration. We simply have to acknowledge that astrology has its limits, just like any tool, any invention, any system of thought.

EMPHASIZING INNER EXPERIENCE LEADS TO REAL SYNTHESIS

Let me tell you one thing that happened to me a couple of years ago. It's a good example of how real chart synthesis can only come if you emphasize the inner, experiential dimensions of life. In other words, if you're focusing on events or abstract, disconnected details of life, no matter how technically competent you may be or how intelligent or theoretically brilliant or verbally clever you may be, you will often go wrong. You will so often take the wrong road in your interpretation if you do not have the constant reality test of repeatedly relating the symbols to the individual's intentions, feelings, needs, fears, and ideals—in other words, to the person's inner life and inner experience. If you lack this reality test, you will make all sorts of assumptions about the person's life and values and preferences that will turn out to be wrong.

A couple of years ago, I was facing a lot of important decisions, such as: Should I move? Should I hire help? Should I go into a business partnership? What about my creative work? And so on. I had met one astrologer, whose name I won't tell you because the work he did for me turned out to be totally irrelevant and incorrect, who had impressed me as being quite intelligent and capable. I figured that consulting another person could give me a better perspective on things. You know, a good doctor will always have his children and himself examined by another doctor, just so an objective evaluation is possible. This astrologer has a very good reputation, is very intelligent; and he is technically very capable, as well as being extremely thorough and systematic in his work. This is why I chose him, although I didn't know him personally; I simply had gained a good impression of him in various ways and from speaking with others who valued his work. Also, I didn't have anyone nearby whose work I particularly trusted, except for those I personally knew too well.

METHODS OF CHART SYNTHESIS

So, in spite of the fact that he lived across the country and so would not be accessible for a personal consultation, I wrote to him and asked him to do a complete analysis of the next year or two, based on my chart, its progressions, transits, etc. I did this open-mindedly but also as a sort of experiment, since I have always had strong reservations about by-mail interpretations. However, since I knew he did mail-order work, since I knew of nobody more likely to do an accurate job, and since I was asking for an interpretation of trends, cycles, and timing rather than for in-depth psychological counseling, I decided it would be worth doing. So, I said to him, "I don't want any favors. I'll pay your regular fees. I just want you to work hard at doing this well because I have many extremely important decisions to make quite soon. I'm not testing your knowledge. I just want another perspective."

So, he did an incredibly thorough job and even sent me all his preliminary notes that went into the final typed material. All the transits were listed in order, very systematically. To be fair to him, I feel that the results of his work would have probably been fairly good had a personal consultation been possible. So, anyway, when the material arrived, I was actually quite excited; I hadn't had "a horoscope" done by anyone else in years! I read it, and it sounded really impressive: reasonable, intelligent, and practical. I could see right away that he had made a number of wrong assumptions because he had never talked with me nor asked me many questions to clarify my deeper values, long-term plans, motivations, and ideals. He *had*, however, initially asked me to send him in writing a great deal of detailed information: questions, choices, and so on, which I had done in detail.

Among the wrong assumptions were some rather important ones. For example, he assumed that my values were those of this culture. He assumed that I therefore shared a typical materialistic approach to life and to all business decisions, and that I would therefore naturally want to expand constantly, which is the typical American way. In fact, one of my main values was and is keeping my life fairly simple; simplicity of lifestyle has to be weighed against money and worldly "success." There were also some other wrong assumptions, for example, about how I might connect "spiritual" ideals with my work, something which he viewed in a totally different way than I do. So, these wrong assumptions led to wrong conclusions. The majority of the material dealt with the future and its trends and potentials. So, I decided to put it away for a long time and simply let the future unfold.

Then, just a few months ago, after a lot of time has passed, I read the entire thing again very closely. It was almost one hundred percent wrong. Almost everything was wrong because he was totally emphasizing the outer world of events rather than the inner workings of my life. He was out on the

periphery of life trying to guess details rather than probing toward the center of life from whence all motivations and actions come. I could see exactly why he came to the conclusions he did, because all the research was listed, including some of the rationale and all the specific aspects. But none of it manifested in the way he expected. And I'm not criticizing him personally, because he does a very traditional kind of astrology in a very capable, intelligent way. But, because he didn't talk with me, asking such things as, "What direction are you going in?" "What is really important to you now?" "How do you see your options in your own mind?"... because he never asked those questions to tune in on *my* reality, he immediately assumed, "Well, you naturally want to be a big success like everyone else. If you are successful and can be a big shot, you'll be happy; so that must be what you want." This experience, needless to say, was very instructive to me, and in fact a bit shocking. But it was the last straw for me in defining my attitude toward "readings" for people you don't know and can't see in person. If you *have* had personal contact with a client, it then *may* be more possible to do simple, *general* outlines of trends for them at a later time even if you can't then talk in person. But even to do this well requires an unusually firm and subtle mastery of *language* so that you can give the right impressions complete with all their subtleties. How many astrologers can do this? So, how can any astrologer or astrological counselor really create a synthesis that matches the client's reality? Only by tuning in on the client's inner experience—his or her intimate view of his or her life. That is the client's reality, not what other people may see.

SIMPLICITY—A GUIDELINE FOR ASTROLOGICAL WORK

A guiding aesthetic for astrology, something necessary since astrology is an art as well as a science, should be simplicity. I cannot go into all the philosophical reasons behind the importance of the principle of simplicity in this talk, but—just to emphasize that this principle is fundamental *as a foundation for science as well as for art*—let me briefly quote L. L. Whyte, from his excellent book *Accent on Form*:

> The task of science is not merely to identify the changing structural pattern in everything, but *to see it as simple*. Science starts with the assumption which is always present, though it may be unconscious, may be forgotten, or may sometimes even be denied: *There exists a simple order in nature; a simple way of representing experience is possible; the task of science is to discover it.*

METHODS OF CHART SYNTHESIS

This same idea is stated in the famous saying called "Occam's Razor," formulated in the fourteenth century by William of Occam:

"Multiplicity ought not to be posited without necessity."

In other words, why do we unnecessarily dream up large amounts of theory and data if we don't need it? This saying means: keep it as simple as possible; simplest is best, if it will do the job. We should aim for the procedure, theory, method, or technique requiring the fewest extra assumptions, modifications, and complex details required to do the job.

But do we do this in astrology? Perhaps we should take the advice of William of Occam. It seems today that so many astrologers are evidently trying to make things as complex as possible, just for the sake of demonstrating pseudo-cleverness, without any clearly defined goal or direction. There is something about the nature of the mind that loves to create problems. It might be called a mental disease of the Western world, that we develop the intellect in such narrow ways, isolated from the rest of our being. No longer can we accept simple things in a simple way, without processing them through our over-energized computer-mind. Essentially, in the West we've been trained to take great pride and great pleasure in creating problems and then solving them, or pretending to solve them. And yet, are those supposed solutions of any use? In so many cases, they are a lot of baloney—purely abstract speculation or a series of meaningless classifications with meaningless labels attached to them. As one of my teachers, Dr. Randolph Stone, used to say, "The mind loves foolishness!" Some of the most "intelligent" people, who are always coming up with very clever answers to everything, are—as you can easily observe—among the most miserable people on earth, totally stuck in their minds. This kind of person feels very frustrated then, when he or she cannot solve the problem that he or she created!

By now, you may be wondering what all these philosophical remarks have to do with "chart synthesis." Well, let's face it; you can't have "synthesis" merely through analysis. *Analysis is dissecting,* breaking up the whole. In the practice of astrology, you have to use analysis somewhat, but—to arrive at a final synthesis—that analysis has to be based upon and have a background of a holistic, synthetic vision. And a true synthesis can come only through a higher, broader perspective; then you can see more of the whole. And so, all of this Jupiterian philosophy (the opposite principle to Mercurian analysis) is an attempt to take us all to a higher level of understanding from where a vaster, more inclusive vision will be possible.

To me, a birth chart is very much like a piece of music. There are themes that run through any chart, some more defined than others. Sometimes there

are minor themes, indicated by only one or two factors. And there are major themes, indicated by three, four, or five factors. In her excellent textbook *Astrology: The Divine Science,* the late Marcia Moore mentions what she refers to as The Law of Three. She said that anything important in the chart, that is a truly dominant theme in your life, will be shown in the chart in three different ways. Let's say that one of your dominant themes is an unyielding willfulness. Perhaps you'll have Mars conjunct Uranus, and a strong Taurus emphasis, both added to a major factor in Leo. So, in trying to apprehend the wholeness of a person through the tool of astrology, one ought to focus most of all on the major themes in the chart *because they reflect the major themes in the person's life.* So many of the unnecessarily complex astrological methods now being dabbled in will not reveal any major new theme than the traditional methods, *properly understood,* clearly point out.

The following quotation nicely describes the current situation in astrology that robs us of the simplicity that we need for deep, reflective understanding. This was written by Douglas Donleavy when he was the editor of "Transit," the newsletter of the British Astrological Association.

[In the last] ten years a trend has begun to manifest in astrology that seems likely to accelerate alarmingly in the next ten. Once upon a time, astrology knew only 7 heavenly bodies. As recently as 1971 there were only 10, although they were becoming mutually related in increasingly complicated and indirect ways. Since then we have added 2 planetoids (Chiron and Charon), 4 senior asteroids (Ceres, Juno, Pallas, Vesta), 1 fictional moon (Lilith), 6 junior asteriods (Sappho, Hidalgo, Eros, Toro, Icarus and the other Lilith) plus who knows how many transplutonian planets, arabic parts, occultations, imaginary moons of imaginary planets, stars fixed in anything but interpretation and dear old "sensitive points". Coming soon no doubt will be shadow suns, the Galactic Planes, meaningful meteorites and bewitching black holes. It seems every new body possesses a special significance not quite like any older body but not all that different either. Already there can be few readers whose 10 natal planets are unaspected by some real or imaginary lump of rock for which an ephemeris exists. In another 10 years we might have as many heavenly bodies as there are astrologers and clients. Every chart will have its own unique ruling pebble. How much easier it will be to identify with than the complex and ambiguous stresses of a conventional chart. Astrology will simplify into long distance psychometry, aspects will be a separate specialist field of study and chart interpretation will have more to do with reading encyclopædias than with interpreting poems.

There are some otherwise excellent and perceptive astrologers whose motto seems to be—if it moves, interpret it. Whence comes this ever more frantic attempt to ensoul newly discovered or newly imagined planetoidlets? I doubt if it is adequately explained by reaction to the advent of computing facilities or any similar "appliance of

science". I think it may be a symptom of increasing frustration with the fact that the Self of a person evades the astrologer, so that there is a certain suspicion abroad that the chart only shows the archetypal masks of Self and the games played between such masks. If the chart is a less than comprehensive map of the person, perhaps out there somewhere is the rock or angle that will fill in the gaps? When this messianic discovery occurs, perhaps it will relieve us of our burdens of insecurity and uncertainty.

I prefer to think that encoded into all horoscopes is the message that a life cannot ever be wholly interpreted, insured or analysed against uncertainty and insecurity. If so, then the more serious challenge is to live with and transcend insecurity, not to try in vain to evade it by projecting it onto new particles of rock.

I maintain that, rather than helping us to achieve chart synthesis and thus a *meaningful* evaluation of the person's major life themes, putting too many factors in a chart makes it harder to discriminate between the significant themes and the peripheral details. Since one can rationalize almost anything through a birth chart, and the more so the more points and methods and minor planets one uses, my view is that one should use a minimum of *major, reliable* factors in order to see a client and his or her situation clearly. Otherwise, you'll project confusion, not order, to the client.

Just as air traffic controllers at an airport have difficulty distinguishing airplanes from other static on the radar screen and in distinguishing which is the closest approaching plane if there are too many in the sky at the same time, so astrologers using too many celestial factors will find it increasingly difficult to discriminate between the significant and the insignificant and so will more and more be inclined to impart confusion, illusion, and inaccurate observations to clients who are searching for clarity. People don't go to astrologers to find confusion or to collect a million petty details and speculations; they go to find some clarity and direction in their lives. Even if they want a prediction from you, that is their way of asking for clarity.

You have all heard of the microcosm/macrocosm idea: namely, how a person's nature (the microcosm) is reflected in the solar system or even in the entire universe (the macrocosm), and likewise, how the entire universe is within each individual human being. This is exemplified in the famous saying of Jesus: "The Kingdom of Heaven is within you." Well, along these lines, we know that modern, materialistic science is in love with the infinite details of creation that are revealed by a microscope. The microscope helps us understand the physical reality of the microcosm and the immediate environment. Astrology, on the other hand, can be viewed as a *macroscope* in that it is especially useful for viewing and understanding the big picture, life's totality instead of petty details. If we use this microscope/macroscope analogy to understand astrological practice, what do we find?

Just as with a microscope, all practitioners of astrology use a variety of lenses. Depending on the individual's special field of study, i.e., what he has to see, he chooses certain lenses over others, which is to say that he gravitates toward different methods and systems. Hence, we might see all the varied methods, procedures, approaches, techniques, and viewpoints merely as different lenses for the astrological macroscope. We all use certain lenses, and if you find that a lens consistently helps you see the level of reality you want to see, then undoubtedly you begin to value it and keep using it. However, you won't know if a particular lens works if you keep changing lenses so fast that you never have time to clean, polish, and focus even one lens! Some lenses are finely ground; they're very fine and enable you to get a very sharp focus and amazing clarity by using them. Other lenses are extremely coarse, and you can hardly see anything with them, or you can only see vague outlines, or perhaps you can only see certain sizes of objects.

It seems to me that there are two main points implicit in this analogy. One is that we are foolish if we don't prefer the most finely polished lenses we can find. And it seems to me that the very basic fundamentals of astrology are extremely polished, finely ground lenses: the signs, planets, the primary meanings of the houses, the major aspects, and so on. Thousands and thousands of astrologers have used those factors for who knows how long. And, through observation and trial and error, they have repeatedly polished those lenses, to the point that we can rely on the clarity and sharpness that those lenses can reveal. And, while I'm not saying that many of the new techniques floating around are bad or wrong or provide inaccurate results, I have to say that they should be regarded as coarse lenses. They are simply not yet finely polished. Of course, if you want to experiment with a coarse lens and continue to polish it more and more, fine; but do so privately! When a client comes to you, it is your responsibility to use the best, sharpest lens you have, not the one you're still grinding.

The other point of this analogy is that an astrologer should, therefore, polish one lens continually for many years before he switches to another one. Use one system and stick to it for a while; use just the basics; use one house system for a long time, unless it begins to seem wrong for your work, in which case you should change it and then use the new system for a long time. But you have to polish that lens, because *astrology is a way of seeing* ... that's why it depends so much on the individual practitioner and his or her personality and level of consciousness.

Once you have finely polished a few lenses over a number of years, then —just like someone in a laboratory with an elaborate microscopic system— you will have a number of finely polished lenses in a rack, ready for your use at the appropriate time. But you will then know how appropriate each

lens is for any given purpose. So, this kind of familiarity with a variety of lenses is not a bad thing to aspire to; but certainly, in the first few years of astrological study, all you want to use is one lens that works well for basic purposes—one lens that is finely polished and through which you can get a clear vision of reality. Unfortunately, nowadays there are many people who have a whole rack of dozens of lenses but lack the knowledge of how to use any of them well. This is happening throughout the healing arts field; many people dabble in dozens of theories and techniques but master none of them.

So, what you want is quality, not quantity. If you have a big rack full of dozens of different lenses, it won't mean anything if all of them are coarse or covered with dirt and dust from lack of use! You have to master one way of seeing things first, and when you've done that, then you know not only what it can do but what its limits are. And then you'll know whether adding another lens is really necessary for your particular purposes. You have to know what your tools, your lenses are appropriate for, what kinds of analysis, what kinds of understanding, what levels of reality they focus on. In other words, it is useful and advisable to *define the parameters and scope within which your particular lenses are most effective and focus most sharply and clearly.* Defining this helps you to discriminate and helps your client to know if you are the kind of consultant he or she wants to see.

To reiterate, especially in the early years of astrological study, it seems to me best—and I know that some of you teachers have found this—to use *the minimum number of major reliable factors required to enable you to see a client and his or her situation clearly.* And then . . . go on from there. I've had people tell me recently that there are teachers in this area whose beginning classes go into progressions in the third meeting! Can you believe that? The students come out of the beginning class totally confused, and so astrology will appear to most of them totally confusing or not worth pursuing for the rest of their lives. Instead of a way of clarification, it becomes a way of confusion, and it's all the teachers' fault.

One might ask, how can one possibly cover even all the basics, let alone all those extra things, in one consultation? Well, you can't. This is why I repeatedly emphasize that the astrological counselor, instead of getting lost in meaningless, self-indulgent analysis, the only purpose of which is self-aggrandizement, should focus on what is important in the person's nature and life and on what kind of person he or she is. That is the real road to "chart synthesis." The birth chart is really synthesized and fully realized within the individual person and the fabric of his or her life. Even if you're doing a consultation by long-distance telephone, get some feedback first. Ask them what they want, what they're confused about, what do they see as their options, what major decisions are demanding attention?

We all know that a lot of astrologers are giving astrology a bad name. *If astrologers focus on trivia, they are actually trivializing astrology!* If someone does not know any astrology but is just beginning to open up to the possibility that it may hold value for him, and he goes to an astrologer who—instead of talking with him about himself and his life—rattles on about dozens of "parts," planets, and asteroids that he's never heard of, what kind of reputation is astrology getting? I'm very conscious of the reputation of astrology as a field of study and as a profession, and we should not trivialize such a great study and science. *The real chart synthesis revolves around tuning in on the major life themes of the person,* and this is not just a prejudice of mine but seems to be validated by what we know about reincarnation and how the memory works from lifetime to lifetime.

Those of you who have studied past life regression or the past life readings of proven accurate psychics like Edgar Cayce will remember that, when people see back into past lives, they don't remember the details in many cases. But they always remember the significant themes of the past life, the major soul-crunching conflicts, the agonizing dilemmas, the uplifting experiences of spiritual inspiration. What makes a lasting impression on the psyche, therefore, are not the trivial details of life and the meaningless, transitory events, but the experiences that go really deep. Once these crucial philosophical considerations are applied, then true chart synthesis may be attained. And only then can we speak about specific methods and techniques of synthesizing the chart.

SPECIFIC CHART SYNTHESIS METHODS

There are any number of synthesis techniques that one can use. I'll mention a few rather briefly. For a person like me who sees everything in terms of energies, perhaps the most useful idea is Dr. William Davidson's definition of the Sun, Moon, and Ascendant in energy terms. These ideas are found in his excellent book, *Lectures on Medical Astrology.* He says the Sun is your *Voltage,* your basic power and life force attunement. The Moon he calls your *Amperage,* the rate of flow of the energy and the strength of the current. Just as the Moon reflects the solar light to the earth, so the Moon in your chart reflects (and affects) the rate of flow and the strength of current that your solar voltage has in your body and through your life. Finally, he says that the Ascendant is the *Conductivity* or *Resistance,* how readily and in what way the life force can flow through the person and into the world. These correlations alone enable one to begin synthesizing the chart's primary energies.

THE ASCENDANT & RELATED FACTORS

It's a very ancient tradition that the Fire signs rising have the greatest vitality and therefore throw off sickness most effectively. Their conductivity is greatest, fantastic for energy flow; the resistance of the Fire signs is very low. With Leo, the fixed Fire sign, there is some resistance, but not a whole lot. It's a sign that just beams energy outward. (This conductivity idea, incidentally, is very important in the practice of various energy-oriented healing arts.)

We're going to mention a number of things about the Ascendant, but I and many other people have long wondered why there is so little good material in print on the Ascendant, when all astrologers have been saying for so long that the Ascendant is so crucially important. This was mind-boggling to me for years, and now I've concluded that it's because nobody can describe it. The Ascendant is so subtle, so essential, and so dynamic that it's very hard to describe, except in very traditional terms. In fact, this lack of available reference material motivated me to start another one of the research projects I have going which won't be finished for years. I've started to compile notes on the different Ascendants, each one of them having twelve variations, depending on where the Ascendant's ruling planet is: Virgo rising with Mercury in Aries, Virgo rising with Mercury in Taurus, Virgo rising with Mercury in Gemini, and so forth. I think this will be a very nice study, probably finished by the time of the next Jupiter-Saturn conjunction! That should give me enough time.

Back to the specific Ascendants in energy terms, the Air signs rising have very high conductivity; their resistance is also low, except perhaps Aquarius in some cases—their rigid minds at times inhibit the energy flow. With the Water signs rising, the conductivity is not the greatest, and their resistance tends to be high, especially with Scorpio rising where you often find a certain sluggishness. The Earth signs rising have the least conductivity and the most resistance to energy flow; they're all gross matter. Virgo rising has the most conductivity of all the Earth signs, because they're Mercurian and their nervous systems conduct energy quite well. A person can have tremendous vitality shown by the Sun and Moon signs; but a Taurus rising especially, and a Capricorn rising in some cases, can stifle the energy or resist its flow in a significant and often problematical way. This is an example of the beginnings of chart synthesis; you've got to see how the energies flow through the whole person and thus through the whole chart. The chart reflects the unique dance of cosmic energy which the individual person is. But, in any effort at synthesis, one has to emphasize the Ascendant and see how it aids or inhibits the person in expressing the other energies shown in the chart.

When considering the Ascendant, you not only have to look also at the sign and house position of the planet that rules the Ascendant (what has been called for many decades "the Ruler of the Chart" or the chart's "Ruling Planet") but at the aspects to the Ascendant as well. The aspects to the Ascendant are rarely mentioned in textbooks of astrology, although a few books give a token acknowledgment along the lines of, "Yes, aspects to the Ascendant are very important." But comments like that make me suspicious that the author doesn't really know what he's talking about. I personally think this is another example of a factor being so dynamic, so absolutely essential in the person's make-up, that people have a hard time seeing it or describing it. It is another case of our not being able to see a most obvious major factor. Another reason that aspects to the Ascendant are not emphasized more is that they can't reliably be determined in any charts but those based on accurate birth times. Hence, they are harder to study in a systematic way. And also, until the last few decades, the vast majority of people were born at home, and the birth times were often not recorded at all or only with estimates at a later time. So, entire generations of astrologers had to emphasize in their studies those factors that they could rely on.

So, when considering aspects to the Ascendant, you have to look first at how accurate the birth time is likely to be; what is the source of the birth time and how reliably has the supposed Ascendant itself been working? How is the Ascendant reacting to transits and progressions? Since so many birth times are recorded five or ten minutes off from the actual birth time, my approach is to give the Ascendant a wide orb in judging aspects to it. This accounts for minor errors in birth time, but it also acknowledges that the Ascendant is a great dynamic point in the chart, with a wide aura, so to speak. It's the most dynamic point in the chart that is not a planet, and *any* planet aspecting the Ascendant makes a big, big impact on the person's whole life and colors a person's attitude toward everything and their entire way of expressing themselves in the world.

The planet that is aspected with the Ascendant by any thirty-degree multiple angle inevitably tones and adds its quality to your entire consciousness. It is something that you have within you automatically, ready to express; it is not something you have to learn, although you may have to learn—over time—to be *conscious* of it and to consciously *acknowledge* it as a major part of you. That planet's function and dimension of experience are at your disposal from an early age; it's an intimate, essential part of you. If I may venture a controversial statement, the *planet* closely aspecting the Ascendant may just be more powerful in many people than whatever the Ascending *sign* is. This will not always be true, but—if you look at it—you may well find it so in many cases. And I might therefore also say that com-

bining the Ascendant's sign, its ruling planet, and any planet aspecting the Ascendant is a major step toward chart synthesis, and a major challenge for the astrologer. This kind of merging of those factors can open many doors to an understanding of the person's essential nature and what he or she is trying to express or be, whether consciously or unconsciously.

The Ascendant is very much how you contact the outer world. There are a lot of ways of defining it. One way that is especially useful is to call the Ascendant *"the Image of the Personality."* It's the *image* of one's personality (or at least it contributes to that image in a major way—the ruling planet's position and aspects to the Ascendant also color this image); but it is not the personality itself—it's only one tiny part of the entire personality. It fools a lot of people. I'm sure many of you are aware of people who see you in a certain way; and when they describe how they see you, you can't believe it since it's so unlike how you feel yourself to be. They are often seeing that personality *image.*

It's not that the Ascendant always describes the physical appearance either, as some traditions indicate. Sometimes it does, very precisely; but so does the Moon sign, so does the Ruling Planet's sign, and so does the Sun sign in many, many cases. The Ascendant does describe the appearance at times, but so many factors can affect the appearance. A planet in the first house, especially one conjunct the Ascendant, can also affect the appearance markedly. But the Ascendant is always the image of your personality in a broader sense than appearance or physical form. There's something about you that the ascending sign describes, what kind of energy is projected from you, which is then modulated by the Ruling Planet's sign, the aspects, and the other various factors.

If your Ascendant is one of those which has both an ancient ruler and a modern ruler, such as Scorpio, Pisces, and Aquarius, you should look at the *house* positions of both of them, for both will be at least somewhat emphasized in the person's life. However, look especially to the ancient ruler's *sign position* because that sign will always be much stronger than the sign of the modern ruler, assuming other emphases are not present. In other words, if you have Scorpio rising, your Mars sign is generally much more important in your personal make-up than your Pluto sign, unless another major factor is in the Pluto sign. You know, with the Pluto in Leo generation, not every one of them with Scorpio rising is particularly Leonine in their individual nature and personality! But in every case, their Mars sign is especially powerful; that energy flows assertively through them in every case; that energy is projected with special emphasis in every one of them.

This is one other area in which I am more and more getting back to very ancient ideas. You know, I am one of those who has to make his own mis-

takes, who has to experiment with life, who cannot accept what has previously passed for truth simply on the authority of one person or tradition. But in many areas I find myself pulled back through my observations and experience to many older ideas in astrology—not because I've always been wedded to them out of love for tradition, but because of definite values I'm finding in them. So I am getting pulled more and more toward some of the older ideas of rulerships and dispositors. So many other people seem to be rejecting those very concepts! So many people I see are going into all sorts of pseudo-scientific stuff while here's Stephen going back into the "Dark Ages"! But I have no control over it; I just have to follow where my own personal need for truth leads me. I have to follow what is working. In some circles now, it is fashionable to dismiss rulerships, to dismiss houses, to dismiss exhaltations as if they are saying, "Oh, those old-fashioned astrologers, how could they have known much before our wonderful modern age? We're much smarter than they were, much more sophisticated. And, after all, we have computers!" All I can say is, what arrogance! Wisdom remains rare today just as it has always been. As for computers improving astrological understanding, remember that if you put garbage in, you get garbage out.

So, as I said, you always look at the so-called Ruler of the Chart, its sign and its house. The house position invariably shows a field of experience where a lot of your life energy and effort manifests. Also, while mentioning aspects to the Ascendant, I should emphasize that a *conjunction* to the Ascendant or to the Descendant is a tremendously powerful aspect. In many cases, that planet may be the most powerful planet in your chart. Sometimes a planet closely aspecting the Ascendant will dominate your whole life. For example, I have seen some people who are very artistic and mystically inclined who have said to me, "I have an unaspected Neptune." And you look at the chart and see that Neptune is exactly square the Ascendant or exactly trine the Ascendant. If you are one of those who draws in the lines on a chart for major aspects, I strongly recommend that you do so also for aspects to the Ascendant.

One other major issue related to the Ascendant is: How well is the Ascendant integrated with the rest of the chart? In other words, does the Ascendant represent something that is true for most of the rest of the person's nature, or is it a shield, or is it a powerful image that is otherwise mostly empty? Is this image true of the inner person? Or is it primarily covering up many other aspects of his or her nature? The Ascendant will also show you the first impression you get of another person. But is your impression applicable to the person's total nature, or is it merely an image with no depth behind it? One of the best examples of this is Cancer rising. You know that Cancer, along with Leo, is known for often being involved in acting, the

drama field. Well, so often those with Cancer rising will seem much more sympathetic and sensitive than they are, especially so if their other major factors are in Air and Fire. How integrated the Ascendant is with the rest of the nature does depend in large measure on the harmony of the Ascendant's element with the elements of the other major chart factors.

What I am trying to emphasize is that the Ascendant can be mainly an image, or it can be a kind of gate, a door to the person's whole being. You simply have to look at the entire chart to see if the person has the ability and capacity and determination or talent to actualize what the Ascendant promises. Can you mobilize the rest of your chart, the rest of your energy to flow through that channel that the Ascendant symbolizes? The Ascendant is a gate through which a lot of your self has to flow. Can you project or express your self or most of your self through that particular gate? If not, can you adjust your life or lifestyle in some way to enable you to do so more easily?

PERCEIVING CHART SYNTHESIS THROUGH HOUSE PLACEMENTS

Perceiving the chart as a whole, in other words synthesizing the chart's many factors, requires you to have a sense of the various types of houses so that you can quickly combine the various house emphases. Let's just briefly go through them. If there's an emphasis on the water houses, you know that the person is very much motivated by *yearnings,* very deep, unconscious needs and yearnings, so deep that it may be difficult for the person to know what's going on. No matter where the planets are in the signs, an emphasis on the fourth, eighth, and/or twelfth houses invariably shows the intrusion of many unconscious factors into the person's life. The person may be very spiritual or quite psychic, or there could simply be a dominant vulnerability and constant yearning for security and safety.

If there is an emphasis on the earth houses (the second, sixth, and tenth), you know the person's going to focus a great deal on *needs*: how can I make money, how can I assure I'll have a job, how can I prepare myself to fit into the world, how can I be useful? Even if a person has no planets in Earth signs, if the earth houses are packed with planets, you know that he'll never be able to get very far away from practical concerns. They simply have to put a lot of energy in that direction: being useful, and practical accomplishment. Otherwise, they won't feel alive.

If the air houses are emphasized (the third, seventh, and eleventh), you have someone who is very focused on *concepts* throughout his or her life. Even if they have little or no emphasis on Air signs, they'll nevertheless pour

their energy into thought, communication, ideas, dealing with other people, and picking and choosing between the endless concepts that fill the air. I'm sure many of you have noticed the correlations between the signs and the houses; they are quite astounding at times. For example, if someone has a major emphasis on the third house, especially if the Sun is there (and Mercury there makes it even more evident), you'll see a tremendous curiosity and a constant desire to learn, even when no planets are in Gemini. They can be authentically interested in an amazing variety of things. Sometimes they also write or they keep a journal. The correlations between signs and houses are also extremely important in medical astrology; the houses very often correspond to the parts of the body usually associated in tradition with the corresponding signs. There is so much blatant proof of the houses being a valid concept that I personally cannot at all agree with those who would abandon the houses simply because they are not physically measurable.

If the fire houses are emphasized (the first, fifth, and ninth), even if there are no major planets in Fire signs, there is a marked future-oriented quality to the person's life. The person is motivated by *inspirations* and *aspirations*. There is an entire section on these houses in my book *Astrology, Karma & Transformation,* so there's no need to repeat all that information here. Suffice it to say that there is something magical about the fire house triangle, and I believe it is related to the fact that—in the natural chart—the fire houses are all either conjunct or trine the Ascendant. The fire houses have to do with the person's overall attitude toward life itself, and planets therein affect that attitude.

I might also mention, while on the subject of the houses in seeing the chart as a whole, that the houses involved in major aspects should always be looked at. I especially find major life dilemmas and areas of special development and continuous major activity indicated by the opposite houses activated both by opposition aspects and by the lunar nodal axis. Sometimes you can tune in rather quickly on a client's major conflicts just by looking at those opposite houses. I should venture the idea, however, that the houses wherein the lunar nodes are placed are not necessarily that *important* to the person if there are no natal planets there. The person may in fact be quite active in those areas of life, but how important to him personally an area of life is seems to depend more on the planetary placements. That's where the most immediate energy flow is, and thus where the most conscious effort takes place.

FACTORS TONING EACH PLANETARY PRINCIPLE

Each planet has a principle and represents a specific dimension of experience, and that dimension of experience is toned or colored by a myriad

METHODS OF CHART SYNTHESIS 179

of factors. In other words, how will each dimension of experience (shown by the planets) be toned or colored in your life? When you begin to examine all the factors toning each planet, many things begin to add up, so many in fact that you have to use considerable psychic energy to begin to *feel* them all at once. The analytical mind simply can't cope with such a variety and quantity of variables all at once, each of them having an effect in a slightly different degree. These factors all affect a particular planet and thus constitute the major tones or colorations of a certain dimension of experience:

> 1) The planet's Sign. This is the basic energy wave and attunement of the planet in a particular chart, and it is symbolic of a dominant mode of expression of that planetary principle. Other factors modulate this basic wave.
>
> 2) The planet's Subtone. This is the *Sign* position of the planet's dispositor, utilizing the ancient rulers only (e.g., a person who has Moon in Virgo and Mercury in Sagittarius is a person who has a Virgo Moon with a Sagittarian Subtone).
>
> 3) The planet's close aspects. The major aspects, including all thirty-degree multiple angles, all noticeably color a planet's expression.
>
> 4) The planet's House position. For example, if a person's Venus is in the third house, it is similar to having a Mercury aspect to Venus, i.e., a Mercurian tone is added to the basic Venus attunement.

One could go on adding various minor factors, but that would unnecessarily complicate what is already a very complex picture. Eventually, one would wind up having every planet toned by every other astrological influence! You look at the major, reliable factors, especially those that repeat.

As an example, let's consider a specific chart.* With the Moon in Sagittarius, you will get a dominant Sagittarian reaction to all kinds of things and situations. The Moon principle is reaction—how do you react instinctively, spontaneously to anything? No matter what other factors are toning this Moon, you're always going to have some of that Sagittarian reaction. But all sorts of other factors will modulate that reaction, will color that basically Sagittarian mode of expression. Simultaneously, with the Sun in an exact square to the Moon, the Pisces Sun is getting cautious and bewildered at the Sagittarian expression; the Sun says, "Just wait a second here! I'm in control!" And then Mars in Aquarius, sextiling the Moon closely, says, "Yeah, let's do it. I like this kind of action." And this person has Jupiter in Virgo, so the Moon's subtone is Virgo. So, while all these other things are going on, Jupiter in Virgo is analyzing and trying to figure out why part of the self is so unwarrantedly optimistic; Virgo *is* square Sagittarius. And then, when you add the close Uranus aspect to the Moon and the Moon's second

*A diagram on the blackboard was used at this time to illustrate this point.

house location, you have even more factors involved, *all* of which color the Moon's reactions.

It is astounding how complex human beings are. If you talk about "chart interpretation," where is the end of it? Each planet is so unbelievably complex and interwoven with others in so many ways. So, eventually, you have to achieve "chart synthesis"; you don't have any option if you're going to do good astrology. That's why I said earlier that you really need to focus on what is important for the person. If you try to do a "complete reading," there is no end to it; it's just an absolute impossibility. How can a mere human being with limited intelligence sum up such a complex, infinite creation as a human being?

I'm sure many of you have had the following realization, especially those of you who have been into astrology for perhaps ten years or more. Maybe once you thought you understood your chart, and then—as you change and grow and gain self-knowledge, and as new parts of yourself start coming alive and old parts of yourself subside—your chart comes alive again, and with a new mystery about it. You say to yourself, "Ohhh, *that's* what that is! That's what my chart's been showing me but which I couldn't see until now." A really good example is Neptune. Look at the house your natal Neptune is in . . . ah ha . . . you once thought you knew something there, right? You may have once thought that you had figured out Neptune in your life. But isn't Neptune the planet of deception, self-deception, and illusion? You know, you're always learning something, and you're perhaps amazed now at how little you know and how little you knew before. And yet, in the past you might have prided yourself on being so great in that area of your life shown by Neptune's house position. You may have thought you were so good at something or so clear about something or so idealistic about something; but now, in so many cases, you can look back and see that you really had no idea what was happening at all.

RULES FOR APPLYING & INTERPRETING SUBTONES

We only have time to summarize some of the key applications and rules for using what I have come to call *subtones*. I explained the basic definition of "subtones" earlier, and I also mentioned that I am engaged in a long-term research project on subtones which I plan to publish in a book eventually.* So, since there is enough material on subtones to fill an entire book, it's obvious that we can only touch the surface of this subject in this lecture.

*This forthcoming book is tentatively titled *The Sun, Moon & Ascendant Subtones: A Method of Individualizing the Birth Chart.*

I'd like to introduce the subject of subtones with a famous quotation from T. S. Eliot's *The Four Quartets,* often regarded as one of the major poems of this century. What he says is applicable to subtones and their profound simplicity, as well as to the common experience we just mentioned—the fact that you once thought you knew yourself somewhat and knew therefore what your birth chart meant; and then later, in shock and amazement, you exclaim, "Oh my God! I haven't seen what's right in front of me all these years!"

> And the end of all our exploring
> Will be to arrive where we started
> And know the place for the first time.

I read this to caution you not to underestimate such a simple idea as subtones. Some of you may be asking yourselves, "Why is he spoon-feeding us this simple, basic stuff?" Well, maybe after all our exploring of diverse and far-fetched astrological notions, we should come back to where we started ... the absolute basics of astrology. And, if we can open our eyes anew, perhaps we will know the place for the first time.

Here is a way of writing a planet's major tone (its sign and house), along with its subtone. If this person's natal Moon is in Sagittarius in the second house, and his Jupiter is in Virgo in the tenth house, you have this equation:

$$\text{MOON } \frac{\text{Sag/2nd}}{\text{Virgo/10th}}$$

In other words, you have a second house Sagittarian Moon, with a Virgo subtone; and, since the Moon's dispositor Jupiter is in the tenth house, there is also a tenth house connotation to the subtone. So here, this factor alone reveals someone who could easily be an academic or something professorial as a career and livelihood. It's someone who likes to say what he believes, maybe a preacher; but there's also a scholarly, analytical streak shown by the Virgo subtone, and maybe an interest in health. Well, this person is a professor and also a teacher of various therapeutic and health subjects as well. He's also taught comparative religion and world mysticism. Since his Sun is in Pisces, Virgo is also the subtone of his Sun. Remember, we use the ancient ruler of Pisces in determining the Sun's subtone—hence, Jupiter. In other words, his tenth house Virgo Jupiter is the dispositor of both his Sun and Moon. He is extremely Virgoan, and yet—since Jupiter is his only Virgo planet—most astrologers, if doing an interpretation of his chart in the abstract, would not particularly emphasize the importance of Virgo qualities in him. He's even a bachelor at the age of 40! You would write the equation for his Sun like this:

$$\text{SUN } \frac{\text{Pisces/4th}}{\text{Virgo/10th}}$$

How else has this strong Jupiter manifested in his life? He is very religious, although in a non-traditional way. He's very optimistic, at least in his obvious moods. There has been a great deal of travel in his life, shown also by the Sun's and the Moon's signs and subtones all being mutables. He has lived in many different states and spent years in a foreign country as well.

I mentioned that you trace a planet's dispositor to find its subtone, but only using the ancient ruler. If you have a Mercury in Scorpio, for example, the sign where you have Mars is Mercury's subtone. Another point to emphasize is that you mainly look at the Sun, Moon, and Ascendant subtones as the most dominant factors; and then, secondarily, you look at the Mercury, Venus, and Mars subtones. The subtones of Jupiter, Saturn, and the outer three planets are ignored for all practical purposes. Let's use an example from someone here. O.K., what's your Sun sign and the house position of your Sun?

Audience: Taurus Sun in the second house.

So Venus rules your Sun sign. Now, where's your Venus?

Audience: Venus in the first house in Aries.

O.K., so you'd write it like this:

$$\text{SUN } \frac{\text{Taurus/2nd}}{\text{Aries/1st}}$$

So your Sun has an undercurrent of Aries, in the rather assertive first house at that. So you'd be a very forceful Taurus, a much more dynamic Taurus than the archetypal lazy Taurus. Now where is your Moon?

Audience: Pisces in the twelfth.

Now with subtones you ignore the outer three planets because you want to know about *personal* motivations now, not generational. So, where's your Jupiter?

Audience: Jupiter's in the seventh, in Virgo.

$$\text{MOON } \frac{\text{Pisces/12th}}{\text{Virgo/7th}}$$

So your Moon then is a Pisces Moon in the twelfth house, but it has a Virgo subtone. So, unlike many people with Pisces Moon, there is an undercurrent

of discrimination here, which probably is very useful! All kinds of emotional reactions, while being Piscean, would also be subjected to analysis. You might even be a bit picky about your own emotions, and—with Pisces and Virgo both coloring your Moon, and hence your self-image—you would no doubt have a strong tendency toward working on self-improvement, in matters of health and in other spheres. Now, where's your Mercury?

Audience: Aries, in the first house.

Mercury's in Aries in the first. So then where is Mars?

Audience: Also in Aries, in the first house.

O.K., so now this is an especially strong emphasis here, because the primary tone and the subtone are identical. You'd write it like this:

$$\text{MERCURY} \; \frac{\text{Aries/1st}}{\text{Aries/1st}}$$

So here we have a tremendously assertive Mercury, not only in Aries but also in the first house, and those factors repeat as the subtone. I mentioned earlier about The Law of Three, wherein any factor that repeats three times is undoubtedly a major factor in a chart. Well, along the same lines, repetition when doing subtones is always indicative of an emphatic factor in your life, a major energy attunement and dominant life theme. Although not all planets that have the same subtone as primary tone are "dignified" planets—witness the Aries Mercury example we just did; Mercury is not dignified in Aries— *all* dignified planets, that is, planets in their own sign, have the same subtone as primary tone. For example, this lady has Mars in Aries; it's "dignified." It has no subtone, so to speak, because the ruler of Aries is *in Aries*. And since her Mars is also in the first house, we have an example of the pure Mars achetype. Every dignified planet is a rather pure example, a pure expression, of the planet's basic qualities and function; for it has only one dominant tone from the zodiacal signs, and that sign is absolutely sympathetic to its own nature. The house position and aspects of course also tone its expression, but the sign and element attunement invariably remain powerful in the personality.

If you run through your subtones, just the subtones of your Sun, Moon, Ascendant, Mercury, Venus, and Mars, you'll sometimes start seeing a sign *or an element* emphasized by repetition in the subtones that really makes sense but which wasn't so obviously powerful previously. When something starts repeating in the subtones that you previously didn't think was particularly strong in your whole personality, you'll usually identify with it immediately. For example, if you have only Venus in Gemini but you have

Sun and Mercury and Mars in Taurus and then also Moon and Ascendant in Libra, you'll begin to see why Gemini is so strong a quality in your nature; after all, Gemini would then be the subtone of five major factors! The subtone idea also provides a good understanding of the ancient concept of "mutual reception," when two planets are in each other's signs. Hence, they each have the other's natural sign as a subtone; their energy expression constantly reinforces each other.

In some charts, when you trace the subtones, you only find the chart's obviously dominant signs repeating as subtones. In those cases, each particular planet's primary tone and subtone can be looked at, but the overview of the entire chart will not be helped much in cases like this; for the subtones will basically be the same as the natal chart's obvious primary tones. It is the *new* information or theme to which your attention is drawn that validates the process of finding the subtones in every chart you do.

The concept of subtones will sometimes be useful also in understanding relationships. Sometimes a subtone or two subtones of a person you know will harmonize especially well with your chart. Or your subtones may harmonize especially well with the other person's primary tones. Two years ago, when beginning to experiment with the subtone idea, I did the subtones for the two people that I was working with all the time. Both of them, although they had different Moon signs from Aquarius, had an Aquarius subtone to their Moons. Well, Aquarius is my Moon sign, and we were extraordinarily comfortable working together, especially when we all needed to act crazy. Subtones often clarify patterns of attraction between people as well. So you see, the idea of subtones has many practical applications; it aids *understanding*. It's not simply another flamboyant technique with dozens of ramifications but all of which are useless.

Subtones illuminate certain things; they show basically another level of the obvious. *Doing subtones is just an exercise in making yourself pay attention to the fundamentals from a slightly different point of view.* It gives a more individualized picture of the person's nature. It shows another level of motivation; the subtones reveal subconscious motivations and predispositions that are not always apparent just from the obvious placements of the planets themselves. *Subtone analysis is a refinement of basic interpretation; it reveals a pattern of attunement modifying the primary pattern.* It is especially useful for understanding deeper motivations and needs which are not obvious to you or which are bothering a client who is not fully aware of them. My feeling is that using the subtones, and that includes seeing whether any of the four elements is repeatedly emphasized in the subtone pattern, gives a more useful and valid understanding of people's nature and psychology than most of the tangential secondary techniques being experimented with these days.

METHODS OF CHART SYNTHESIS

If this is true—and I know it is sure to be contradicted by many people—but if such a simple procedure is true and so revealing, why is that? I maintain it is so because the elements, and thus the signs as expressions of the elemental energies, are *primary*. They *are* life energy. Hence, the signs are *fundamental patterns of life energy*. And, as Dr. Randolph Stone wrote, the planets symbolize *modes of energy exchange between the individual and the universal storehouse*. So, the elements and signs are the *what* of life energy; the planets are the *how* . . . how the life energy is regulated and flows.

A HOLISTIC APPROACH TO TRANSITS

A proliferation of books on transits that attempt to reduce each transit's meaning to a neat paragraph of explicit predictability has had the side effect of encouraging many people—especially beginning students of astrology—to try to interpret various transits in an isolated way, apart from the context of the whole chart. Thus, I feel it is worthwhile to counter that tendency with a few observations and facts that are pertinent to understanding transits.

First, we have to acknowledge that astrology, as expressed in books, lectures, or in consultation dialogues, is using *words* to try to get near *life*. At most, using the right words with the right understanding might *approach* life's meaning; it will never capture it. Life cannot be encapsulated in neat little paragraphs of so many words. Likewise, in the majority of cases I've seen, the paragraphs that purport to explain the meaning of a given transit usually fall far short of describing the reality of the person's experience. Most books miss the essential reality, and one of the main reasons—other than the fact that words can never capture reality—is that they so rarely stay close to the fundamental principles symbolized by the planets involved in the transit. That is why I wrote the chapter on transits in *Astrology, Karma & Transformation,* because I felt the need to define the absolutely basic principles involved in *any* transit, mainly by specifying key words that seemed sufficiently descriptive and—at the same time—precise.

I am not going to repeat those principles or key words here, but I do want to present a couple of ideas to encourage you to see the whole pattern of energy revealed by transits in the context of the whole life pattern. One preliminary idea might be stated as a procedural guideline, to quote from Charles Carter:

> Planets tend to operate in terms of their radical positions rather than their progressed places; and this is true, in my experience, in all systems.

—Symbolic Directions in Modern Astrology (1947)

In other words, we need to keep the focus on the *natal* planet that is being transited, for that planet symbolizes our inborn attunement to an entire dimension of experience which will go through many changes of expression over a lifetime but will remain essentially the same as a dominant part of ourselves. For example, all transits to natal Venus are similar in that they will all invariably affect our Venus function and the Venus dimension of experience. All transits to Venus will have an effect on one or, probably, more of the following: love, values, tastes, relationships, financial situation, social needs and social ease, sense of contentment, and so on. In a way, it doesn't matter which transiting planet brings Venus to your attention, so long as it is brought to your attention periodically. *How* exactly it is brought to your attention is quite secondary, although you may much *prefer* to have it brought to your attention in a Jupiterian rather than a Saturnian way! But it is *Venus in your natal chart* that defines how well or easily you express Venus or fulfill Venus, how important Venus is to you, what houses and signs are involved, and so on.

Another fact that is never emphasized enough is that transits to the *natal Sun* are infinitely important. Transits to the Sun affect everything, every dimension of your life, because the Sun is your life energy and basic consciousness. Just as the Sun is the center of our solar system, and the planets in the solar system—to a large extent—reflect that solar energy, so the planets in astrology *distribute* the core solar energy. Hence, although a transit to Mars or Mercury or Venus will not always deeply affect your whole self or your sense of identity and confidence and well-being (it depends on how strong those planets are for you), a transit to your natal Sun will *always* affect the confidence and identity and sense of well-being; it will always affect your entire self, and thus, secondarily, your Mercury, Mars, Venus, and so on. When the life force is diminished or energetically expanded, the same happens to your entire self! A good example of this is how, when Saturn squares the natal Sun by transit, the person's happiness (Venus), sexual energy (Mars), and mental vitality (Mercury) all usually decline or diminish, at least to some extent, although one's concentration (Saturn!) may be improved in spite of the lower level of energy. But a Saturn square to Venus or Mars or Mercury will have a far narrower range of impact in your life; your overall sense of confidence and well-being (Sun) may be in quite good shape in spite of the Saturn square to the other personal planets.

The other concept I wanted to emphasize, as an effective way of helping you *think holistically* when viewing transits, is the analogy of the solar system to a huge generator. There seems to be considerable validity to this analogy, and it explains some of the observable facts of astrological "influence" that are usually inexplicable through the basic concepts of physical science alone.

Numerous people, both scientists and psychics, have hypothesized similar ideas to explain how the solar system works. For example, John Nelson, who worked with planetary angles at RCA, Inc. for over twenty-five years while he was engaged in long-range radio-weather forecasts, said the following:

> Mercury and Pluto, which are both small planets, have a profound effect in relation to magnetic storms... no two combinations of planets are alike—consequently, there are new things to learn almost every day.... These relationships cannot repeat exactly in thousands and thousands of years when four, five, or six planets are involved.
> I have no solid theory to explain what I have observed, but the similarity between an electric generator with its carefully placed magnets and the Sun with its ever-changing planets is intriguing. In the generator, the magnets are fixed and produce a constant electrical current. If we consider the planets as magnets and the Sun as the armature, we have a considerable similarity to the generator. However, in this case, the "magnets" are *moving*. For this reason, the electromagnetic stability of the solar system varies widely.
>
> —Quoted from Joseph F. Goodavage's *Our Threatened Planet*, pp. 138–140

One can also use this analogy, especially Nelson's explanation of the almost infinite variety of combinations between planets, to show the following: why astrology is so difficult to "prove" to the skeptics; why it must be regarded as a science that deals with so many variables that it requires an experienced *artist* to use and "interpret" the variables effectively; and why consistent prediction of definite events is so rarely possible (in spite of the claims or images put forth by some practitioners of astrology). Obviously, any moment in time is accompanied by not just one transit, but by many simultaneously; and the infinite resultant combinations are the substance that needs to be *explored experientially* in a consultative dialogue. Who is equipped to guess the possible meaning and manifestation of a certain set of transits with no context or reference point, when the planets' current combinations in the sky are virtually unique, let alone the fact that those combinations also have to be related to the natal chart's unique pattern of planets? Establishing this relationship multiplies the number of possible combinations so tremendously that it is no wonder that the practice of astrology demands so much from its responsible practitioners and that so many would-be practitioners attempt to formulate short-cuts in order to avoid the demanding challenge of high quality astrological work.

A description of the solar system that is remarkably similar to that of Nelson is found in the views of Aron Abrahamsen, a psychic with an ex-

tremely good record of accuracy. The following is a quotation from Jeffrey Goodman's book, *We Are the Earthquake Generation*:

> In the readings we did together, he [Abrahamsen] presented a way of viewing the universe and our solar system quite different from professional astronomers, who believe that the laws of gravity are the most important way to understand the movements of the planets. Abrahamsen said that the laws of magnetism are even more important. He pictured the solar system as a giant electromagnetic field, in which lines of magnetic force stretch out between the sun and the planets. He said that the planetary system is carefully balanced and each planet acts like a magnetic gyrocompass, where the sudden deviation of one planet almost immediately and very directly affects all the other planets through this magnetic field. Thus, according to Abrahamsen, small planets, which have small gravitational effects, could nevertheless have large (magnetically derived) effects on the other planets when they were located at pivotal positions (p. 189).

Please note the statement that a "deviation of one planet almost immediately and very directly affects all the other planets through this magnetic field." Not only does this view of the solar system allow us to do away with rigid space and time concepts as limitations to planetary "influence," just as astrology implicitly postulates, but it also helps to explain how the small planets Neptune and Pluto have been correlated with such immense "effects" in astrology. Obviously, in this conception of the solar system, the physical size of a planet is no guideline to how powerful an effect it will have.

Perhaps the most important thing about viewing the entire solar system as an immense *field of energy* is that it enables us to place many astrological phenomena in a context that is both reasonable and usefully accurate. For example, when the entire solar system is seen to consist of a huge energy field—one whole, integrated, constantly-changing field of which we are a part—it is then no longer seen as a random assemblage of discrete "planetary energies," the descriptions of which can be easily packaged in neat little boxes. This approach also shows why a consideration of the "chart as a whole" is necessary and significant, but it acknowledges how difficult it is to *see the whole pattern* and to interpret all the ever-changing factors in the heavens that may relate to a particular person at a given moment in time. Hence, it makes the astrologer more cautious, realistic, and—we might hope—more humble.

And, specifically in relation to the subject of transits, it is quite possible that the power and reliability of transits can be better understood and even somewhat explained by this electromagnetic field concept. If in fact we are born with, so to speak, the solar system at that moment imprinted upon and impregnating our entire being, and if that particular energy pattern is

fundamentally ours throughout life but subject to changes and fluctuations (many of which correlate with transiting planets in the sky), then we can easily imagine how transits might throw our entire energy field into a different pattern—possibly through this "magnetic" effect. The transits, in other words, temporarily alter, and even distort significantly in some cases, your inborn energy field and thus...your consciousness! How long this alteration or distortion will last depends upon many factors. In some cases, the alteration (or transformation!) appears to remain permanently, with a new attunement and an entirely new pattern-of-the-whole emerging, based upon the old pattern but yet fundamentally different in the way the energies are expressed. In most cases, the alteration or distortion will be relatively short-lived, and the original energy pattern will re-assert and re-establish itself over a period of time.

Certain types of healing and therapy, such as Polarity Therapy, can also aid one in re-establishing the basic pattern in a healthy way once a particular transit or transit pattern has passed, while accepting and acknowledging any transformations that may have occurred. However, you can't fight the solar system! When even one new factor begins to affect your energy field, remember that the *entire* field is thrown into a different pattern. We have to learn how to live with that pattern, how to adjust. The planets keep moving in their orbits. Life's changes keep coming and will never stop. We are put through innumerable alterations and transformations, most of which we cannot change, affect, or avoid. But our *attitude* is something that we can change to some extent, and that leads me to my closing quotation, one from a great spiritual teacher that applies to all of life and—specifically—provides a guideline for using any astrological method that projects into the future:

> Dread of a coming misery renders us more miserable than the actual misery, which perhaps may come or may not. In fact, we cause more pain to ourselves brooding over our imaginary troubles instead of girding up our loins and facing them bravely when they come. One half of our misery will immediately leave us if we turn to God for help.

8—Jupiter & Saturn
Liz Greene

This afternoon I shall attempt to talk about Jupiter and Saturn, as their current conjunction is the umbrella under which this entire conference has taken place. I would like to begin with the mythological associations to these two planets, and end with the more personal. William Butler Yeats once wrote:

> *If Jupiter and Saturn meet,*
> *O what a crop of mummy wheat!*

Now, Yeats is referring to something rather obscure, because mummy wheat is not your average garden variety of wheat. Yeats had a very profound knowledge of astrology, and he associated the Jupiter-Saturn conjunction with ancient lost wisdom. His son had the conjunction in his birth chart, and Yeats felt this meant a deep concern for hidden knowledge and the secret philosophical roots of things. Mummy wheat is connected with the Egyptian god Osiris, who is sometimes portrayed, during the time of his mummification before resurrection, as a dead body with shoots of wheat growing out of it. The wheat is the first sign of new life during the time when the spirit lies entombed and the cycle of death and rebirth is not yet completed. The image of the wheat growing out of the mummy is the transient state between the death of something old and the birth of something new.

In medieval and Renaissance astrology, the Jupiter-Saturn conjunction is always considered to herald a change in rulership—the death of a king and an interregnum of chaos and the emergence of a new king. Great difficulties in the environment were always predicted, but the main theme is the image of the old king dying and the new king being born. You can go all the way back to Greek myth and find the same theme. In Greek these two gods are called Kronos and Zeus.

Kronos is the old king, the earthy Titan, ruler of the gods. He's ancient and he's jealous of his throne, and he's very paranoid. He represents a structure that has existed from time immemorial, which has been built on power and aggression. After all, he becomes king of the gods by overthrowing his own father Ouranos and castrating him. A prophecy or oracle has been given to Kronos that says that one day a son of his will overthrow him in turn. In order to prevent this new thing from emerging and taking away his power, he

eats his own children. The only problem is that one of them escapes. That is Zeus. Zeus avoids being eaten through the help of his mother, Rhea, and hides in a cave. So again you have the image of waiting, mummification prior to change. Rhea gives Kronos a stone wrapped in a baby's blanket to eat instead of Zeus. He's sleepy and stupid with the meal he's just devoured, and doesn't recognise the difference between a child and a rock. In the course of time, which in the gods' terms is obviously not the same as ours, he throws up the entire meal because the stone is causing him indigestion. Right at this moment of vulnerability, Zeus emerges from his cave and leads a rebellion. He overthrows his father and banishes him to the underworld, and becomes king of the gods. So once again you have the image of something old dying, and an interim period of chaos and confusion and the apparent supremacy of the old principle which seems to have succeeded in repressing any new life that might attempt to emerge.

I have been watching this conjunction of Jupiter and Saturn transiting over the charts of people who have Neptune in the first decanate of Libra, because personal observations of actual people's experiences are ultimately all we have to base our understanding on. The backdrop of mythology is meant to amplify these observations, rather than explain anything. I started noticing something rather curious about this transit of Jupiter and Saturn in Libra conjuncting the natal Neptune in many people's charts. The first thing that struck me was that several people mentioned dreams in which their fathers had died. I found this with my analysands and also with astrological clients. I started testing this, because I thought, aha, this has something to do with the death of the father. So I began to ask about this issue of an old principle dying, and I collected more and more dreams of this kind. Sometimes the actual father died. Occasionally it was the mother in the dream, but usually the father.

If you take this kind of dream image on a symbolic level rather than a literal one, which is obviously the case because not all these people lost their actual fathers, then you have to ask what father means. Who is this old man who appears in the dream who is at long last being overthrown? What kind of psychic principle does he represent? I think one of the facets of this principle concerns entrenched attitudes and opinions. Particularly for women, the old king is often the tyrant inside which rules her through her opinions about herself. He decides for her who she ought to be and what kind of life she ought to live and what she ought to look like and what she ought to think and what men and women ought to be. The operative word is "ought." This is a voice which I think many of you might recognise within yourselves—a rigid, opinionated, critical voice which knows much better than you what kind of person you ought to be developing into. The old man knows all the

answers to life, and constantly reminds you that you're failing to live up to his expectations. He very often disguises himself as a spiritual conviction or intellectual concept of perfection that you think you ought to be striving to meet. That concept of perfection is usually masculine, because the old man is an old man. He's also the voice of duty, which says, "You must not be selfish or emotional or self-indulgent. You must be dedicated to my truths, but never to your own nature."

The old man is a representative of a negative patriarchy. He isn't a creative masculine principle, but a negative one, who rules by belittling. In medieval times they referred to Saturn or Kronos as Rex Mundi, which means the Lord of the World. To the Albigensians, the Lord of the World was a god, but he wasn't the same god as the Lord of Heaven. He was the god who created form, and to them he was the devil. In the dualist religions like Catharism and Manicheeism, you gave the devil his due, because you acknowledged that there were two equally matched gods, one of them ruler of spirit and one of them ruler of matter.

Rex Mundi is the Lord of the World, who says, "These are your boundaries. These are your limitations. You cannot extend beyond them. This is your earthly fate. You cannot be greater than this. Man is only a poor mortal creature who in the end must die." In himself, he's a necessary principle. But when he rules, then it means he destroys everything else, he eats all the new potentials in the personality. If this figure dies in a person's dream, then it's quite understandable that there is going to be a period of depression and chaos. In historical terms, an interregnum is always accompanied by revolutions and riots and conspiracies and general chaos, because all the social groups which have been repressed for so long just go berserk. Armies go berserk, and every organisation and structure feels as though it's disintegrating, because the thing which restrained them has broken down.

If you translate that into what happens inside a person, then you must consider what will happen if the thing which has always formed the restraining and ruling principle is removed. Depression and disillusionment and volatile emotional states and confusion are pretty typical. Questions like, "Who am I? What am I doing? What do I actually want? Where am I going?" are likely to emerge, along with feelings of despair. You can also see great panic both in the individual and in the collective, if the old man dies. If a ruler of a country dies, people rush about wondering what will become of the country. The dominant feeling is panic. Who will provide the structure and the sense of safety? Even if the ruler is a hated one, the reaction is the same. I think all of you will remember what it was like here when John Kennedy was shot.

So an old ruling principle dies. But what is the new thing that emerges? I

haven't talked very much about Zeus yet. I think one of the figures which Jung mentions who is connected with the young Zeus is the figure of the *puer aeternus*. That means the eternal youth. He is a figure of potentiality. He also represents aspiration, and we've met him already several times during this conference in the form of the young and beautiful god. So the *puer* inherits the throne after the interregnum, and he has not yet proven himself, so consequently he's not yet very trustworthy. Often in myths the *puer* is injured or lamed or endangered in childhood, so he begins with a handicap which makes him seem weak. All he has is his hope and his optimism. So the feelings of optimism and of new possibilities are accompanied by great fear, because in a kingdom when the old king dies and the young king takes the throne, everyone is very frightened. He might be weak and ineffectual. He might not live to fulfill his potential. So there is terrific ambivalence around the event. Along with the hope that things will finally become better and more creative, there is also the fear that the new potential will be cut off before it has a chance or turn out to be a disappointment. That ambivalence is characteristic of the inner state of a person going through this transit.

There is another dimension to what I have seen in my clients, and I think this probably comes as much from Neptune in Libra as it does from the Jupiter-Saturn conjunction. One of the things that has struck me about the generation who have Neptune in Libra is that they carry around an extraordinary vision of perfect relationship. They believe in a perfect world, and a perfect philosophy about a perfect life. But most of all Neptune in Libra seems to be concerned with the ideal relationship, and nothing short of a divine union seems to be expected from human encounters. I think this is characteristic of an entire generation of people, because Neptune stays in one sign for about fourteen years. That is the romantic fantasy of an entire chunk of humanity. While Jupiter and Saturn have been transiting over Neptune, I have watched the collapse of that fantasy taking place in many of my clients. This doesn't necessarily mean that relationships break up. But the fantasy collapses. Something has died. The old man is buried at last. The perfect father-lover who will come and take care of us and will be devoted to us forever and ever no longer holds any truth for the person. There will never be anyone who can make everything perfect and wonderful and prove that life is fair. The perfect father dies, so the sense of disillusionment is very great.

I have noticed that the sense of disillusionment is very great with some people, especially if that fantasy has been the mainstay of a person's life. If it's the only thing you've had, the thing you've pinned all your hopes on and used to justify all your failures and disappointments, then the sense of

disillusionment is crushing. I think there is a large group of people encountering very deep changes in their ethics about love and relationship. But there is also the birth of a great new possibility, which allows people to be human rather than gods. A new figure emerges which is no longer the perfect father in heaven, but is much more creative and compassionate. The old king has no compassion—he demands obedience. It's almost as though an old image of marriage itself is collapsing. Something much freer and more human is replacing the implacable rules.

For a man, the image of the perfect father demands that the man himself be perfect, or he won't earn the father's love and support. He must be spiritually evolved, and he must have no flaws that might make him unacceptable before the face of God. In his dealings with women the onus for perfection is placed on the woman, but it's really the old man's demand on him. So all that he feels to be dark and sinful and tainted in himself he blames on the feminine. If you value perfection above everything else, how in the world can you possibly live with another person? Whatever that person is or says or does, he or she will inevitably be imperfect, which in turn reflects your own imperfection back to yourself. So any relationship is doomed to disillusionment by this fantasy of Neptune in Libra, whether you are a woman seeking the perfect father-god or a man seeking it. Life itself will always disappoint you in the end, and leave you with a sense of failure, which is the eating of the children, the killing of hope and potential.

Now, the new king, which I have connected with the figure of the *puer*, has a very bad press in some analytic writings and a very good press in others. But if you just take him as an image of new potential without moralising about him, what kind of change does he bring? If a woman has let go of the perfect father-god and has begun to allow in this new figure that has enormous creative potential but cannot be used as a container for life support and structure, then obviously she must find her own way of supporting her life. The *puer* doesn't want to father anybody. So she must use her own values as her structure, rather than those given by the old king. The *puer* is her creative impulse, which needs her to mother and contain it. But it isn't any longer crushed by the old man.

If the old man dies within a man, then what might happen to him? I think again it releases some creative potential which has previously been crushed. This might be a potential for experiencing joy in his own individual nature, rather than having to be approved of all the time by the collective. He might begin to allow himself to be imperfect, which will allow him to be confident enough to create without that terrible fear of punishment. I think the *puer* in his better aspect is also a potential for religious feeling of a

genuine, inner kind. Kronos-Saturn is a paranoid god, who will kill to preserve his throne, and his brand of religion is that of dogma rather than an inner wellspring.

You can see so many men labouring under the rule of the old tyrant, who exist in meaningless jobs that they never really wanted and which weigh upon them like huge stones, but which society demands they uphold because that is what a man is supposed to do. Of course those demands are inside, or the person would never be crushed by them. In the end you can't blame the outer world for the old man. If there is any potential in a man, to be a wanderer or an artist or a visionary or a romantic or just himself, whatever that might be, then it isn't permitted. Kronos-Saturn is always strong and supportive and unchanging and is never allowed to show instability or confusion. He can never be a fool. The *puer*, or Jupiter if you prefer, has a very close relationship with the fool. Some of you may know the card of the Fool in the Tarot deck. He is the same as the Harlequin or Arlecchino in Renaissance theatre, dressed in patchwork garb. The reason the fool can be foolish is because he has nothing to lose, unlike the old man. He is not afraid of the future. In the Tarot deck, he is shown dancing along with his dog at his heels and his sack which contains those few possessions which he can carry with him. He is about to step right off the edge of a cliff with a smile on his face that suggests that he knows he will not be destroyed if he gambles with life. So you can get some inkling from this of what kind of release the new king offers to a person.

There is another facet of the current conjunction which is worth talking about, which is its unique occurrence in an airy sign. Saturn and Jupiter have been conjuncting in earth signs for around a hundred and twenty years. So we must look at what the element of air might mean in collective terms. I think air is connected with our ethical codes, our morals, our ideals—what you might call the civilising instinct. Air is the only truly human element. It is the only element which possesses no animal figures among its symbols. The reflective quality of the human mind is the single most important thing that separates us from the animals. Air allows us to step back and detach and think of someone else's point of view. This detachment allows us to consider society as an organism, and to plan, because I think air also deals with mapping and planning and the quality of foresight. So if the old king is going to die and the new king emerge, this mythic scenario will enact itself in the sphere of our collective ethnics, moral codes, beliefs, and opinions about the nature of society.

Jupiter and Saturn make a pair in the birth chart. Obviously there are a great many interpretations that we can use for them, and I don't think any one of these facets is the only correct one. But one of the many ways that

you can look at them is to see Jupiter as the carrot that dangles in front of the donkey, and Saturn as the stick which beats him from behind. Both planets are concerned with growth and movement and meaning. They are neither wholly personal nor wholly transpersonal. They are the boundary lines between the inner planets which we associate with our individual needs, and the outer planets which are concerned with deep movements in the collective. Jupiter and Saturn underpin one's personal philosophy about life, one's world-view. The realm of philosophy is the borderland between personal and transpersonal. Jupiter and Saturn describe our visions of life and the kinds of ethical structures we use as a basis for decision-making. What kind of god do we believe in? Or that wonderful question that no one will ever be able to answer satisfactorily—what is the meaning of life? There is a joke about that which I might tell at the end of this talk. Anyway, the meaning of life for these two planets is very different. For Saturn, meaning can only be found through work, through suffering, through hard labour, through discipline, through asceticism. Saturn's way is the dark, introspective, bitter road through experience, and realisation only comes in old age when there is enough experience behind you for you to be able to say, "I know this to be true because I have been there."

Jupiter has a very different voice. He says, "I know this to be true because I just know it." Jupiter glimpses a vision of the truth. He doesn't have to wring it out of his own blood. In fact, he prefers to avoid hard experience. He finds his meaning through his intuition, through meditation and looking at horoscopes and reading inspiring literature. He is attracted to religious and philosophical systems that "ring true" for him. Jupiter doesn't like to confuse his truth with facts, unlike Saturn, who doesn't like to confuse his facts with the truth.

In a sense these are the voices of the visionary and the pragmatist, and we all have both of them in us. In some people one is stronger than the other. If a chart is very Jupiterian, with a lot of planets in fiery signs or a lot of ninth house emphasis or a strong Jupiter with many aspects, then that person will not seek meaning through experience because he doesn't have the patience to allow experience to teach him anything. Besides, he doesn't trust experience, because to him the earthly world isn't the real one anyway. It's intuition and revelation which give insight and meaning to that individual. If a chart is more Saturnian, then only experience is trustworthy, and everything else is doubted. You can see this in people with a lot of earth in the chart, or strong Saturn aspects, or many planets in the earthy houses. Only experience teaches and only time can be trusted. Some people grow more slowly in terms of their inner development, in terms of evolving a system of values which they can trust and base their choices on. These are the people

who mature in their forties and fifties. Their gifts and potentials flower late, and they can't be hurried, because they are following Saturn's way rather than Jupiter's. Even though they may try many different things in the interim, ultimately they trust nothing until that thing has been tried and tested.

So what happens if you put these two principles together? Marc Edmund Jones made a reference to Jupiter in square to Saturn as the "last chance lifetime." I have often wondered what he meant by that phrase. Does he mean that you've been grappling with this problem for a whole succession of incarnations and now you get one more shot to try to work it out? Or does he mean that there is a feeling of urgency throughout one's life to somehow understand the meaning of things and formulate a viable philosophy, and that this feeling of urgency presses much more heavily on the person with the Jupiter-Saturn square than on others?

I suspect that it is the latter, or at least that's the interpretation I prefer. Whether he really meant it that way or not is something I'll never find out. But I have seen this urgency in people where there are strong Jupiter-Saturn contacts in the chart. This is what Yeats meant when he spoke of the seeker after ancient wisdom. Whether they conjunct or oppose or square or trine, there is an urgency to understand, to formulate some kind of basis for life that is not purely concrete or instinctual or rooted in personal desires. Jupiter-Saturn is that particular kind of child who has the annoying habit of asking, "Why?" all the time instead of "How?", which is much easier to answer. There is an urgency of philosophical questioning, even if the person doesn't formulate his questioning in typical religious terms.

So if Jupiter and Saturn meet, then I think the collective begins asking questions. Because it's in Libra this time, the questions are going to be particularly about ethical issues, relationship issues, all the other things Libra is involved with. The conjunction began in the autumn of 1980, and began a period which I would interpret in an individual as a time of questioning everything, seeking meaning, feeling disillusioned with old attitudes. There is the hope that some new potential might arise in the future, but there is no trust in it, and that combination produces a sense of overriding urgency. That is the dominant feeling I have so far from this conjunction. It seems to be present in most of my clients. It's certainly present in the collective in England, and it's showing itself particularly in political spheres. Of course the conjunction is not uncommon, because it occurs with fair frequency. Our last one occurred around 1961, so there is roughly a twenty-year cycle with these conjunctions. Each time they come around, I think there is a burst of questioning, and some cherished world-view dies while a new potential emerges.

One of the things which I have found to be terribly important for people going through this transit where it affects their charts, particularly if this involves Neptune, is the necessity of learning to wait. I am thinking again of Yeats and his mummy wheat, and the need to wait and leave things alone. Opportunities seem to spring up like wheat at the beginning of these conjunctions. It seems as if everything will sort itself out and then nothing happens, or things go wrong, or they don't work out in the way one thought they would. Or they take much, much longer than one anticipated. So the issue of being able to wait seems to be an important theme, and the waiting is very painful because Jupiter is such an impatient planet. When you put him together with Saturn, he becomes even more impatient, so at the very moment when one should try to wait quietly, that is the moment when one feels most urgent.

The problem of waiting is one of the themes of alchemy. I think I mentioned that in alchemical symbolism, the base material which is transformed into gold is called Saturn. Jung thought that alchemy was a symbol of an inner psychic process, projected on physical substances. The alchemist was not really concerned with manufacturing ordinary gold. He was concerned with releasing some inner experience which would offer him a sense of eternal life. It's interesting that medieval alchemy emerged from Egypt. In the West, the first we see of alchemy is in conjunction with Egyptian magical embalming ritual, so it's connected with our myth of the mummified Osiris. The themes of alchemy circle around trying to find something which is not corruptible by nature. Nature is cyclical and everything in nature eventually dies. Another way of putting it is that everything in nature is bound by fate, by the fate of the instincts. Alchemy seems to have arisen from an urgent need to find something in man or in life that didn't die, that contained a spark of immortality. That something would transcend fate and corruption and decay.

We look back now on studies like alchemy and laugh and say that alchemy is merely a predecessor to modern chemistry. But it's much subtler than that. The alchemists were trying to extract from ordinary matter something incorruptible that would never tarnish or decay, which they called their gold. But they say over and over again that their gold is not common gold. They seem to have meant something else, but aren't quite clear about what they really did mean. All they are able to say is that it isn't common gold. Alchemical texts constantly refer to Saturn as the basic stuff upon which the work must be performed. It's impossible to know now what they meant by Saturn in actual physical terms. It is thought that Saturn sometimes meant lead, which is of course the traditional Saturnian metal. Sometimes alchemical texts talk about black, poisonous mud. Perhaps some of them tried to use

earth, because they sometimes call the *prima materia* earth. Some of them seem to have thought it was water. Sometimes they just call it matter. Sometimes they refer to faeces. The mind boggles at what the laboratory must have smelled like.

Whatever physical substance they used, they are also talking about the base substance in themselves—their own corruptible flesh, and the ordinary confusions and passions and desires and conflicts of the unconscious psyche. Saturn is portrayed as a sick or tyrannical old man in alchemical illustrations. Sometimes he is shown eating his children. He often has a white beard. In one remarkable illustration which Jung includes in his book, *Psychology and Alchemy,* Saturn is being cooked in a big cauldron that looks a little like a cartoon of a cannibal pot. He's being boiled over a slow fire, and a white bird is rising up out of his head, which is the extraction of the spiritual essence. The fire in a way is Jupiter, because the fire in alchemy represents the heat of one's passionate aspirations and hopes. It's also the heat of desire and passion. This is the impatience and urgency of the *puer*'s vision, which can see what sort of potential that great lump of lead might eventually release.

The *puer* is forever saying, "If I could just get this opportunity right, then everything would be solved. All I need is one more day in the week, and I might finish my book. If I just lived in a quieter place, then I might finish this painting. If I just had a little help, then everything would sort itself out." He is forever trying to break free of confines, so that he doesn't have to wait for anything or work for anything. In the engraving which I just mentioned, the alchemist kneels with a bellows and controls the intensity of the fire and oversees the cooking. So there must be some consciousness which can monitor the combination of the leaping fire of aspiration and the heavy lead of ordinary mortality.

Some of the frustration of the conjunction of Jupiter and Saturn is reflected in alchemy by the images used to describe Saturn as he's being cooked. It's described as a terrible burning, or as a roaring lion with his paws cut off. The alchemists are describing a process of necessary suffering and frustration, which I connect with the sort of feelings an individual feels under a transit of Jupiter and Saturn. Sometimes they portray the *prima materia* as a wolf which must be burned in the fire, or as an old king who cries out in despair to be saved. The old king promises all kinds of things if only someone will spare him from the necessary suffering. But the process must continue despite the difficulty, so the *prima materia* is cooked in a sealed vessel until it turns black and begins to smell.

Alchemy is full of wonderful words to describe different stages of the work. This business of the substance turning black and starting to smell is

called *putrefactio,* which I don't need to translate. The alchemists write about the smell of the grave and the odours of the sepulchre. They also show the picture of the entombed mummy of Osiris. He lies on a slab, and there is apparently no life in him. Everything has finished, and there is no hope any more. It's all very depressing, and one becomes very cynical. All of one's great dreams and ideals have turned out to be quite useless, and one is terribly disillusioned and begins to doubt all of one's former hopes and aspirations. There is then the time of waiting in darkness. Then, just when you have given up on all of it, something starts to emerge. In alchemy this is sometimes portrayed as a white dove, which flies upward out of the charred mass of black stinking stuff. Sometimes it's a little homunculus, which emerges from a pregnant woman. The pregnant woman is another image which appears in dreams with great frequency under this transit of Jupiter and Saturn.

Audience: What astrological connection do you make with the image of the pregnant woman?

Liz: I suppose you could connect it with all sorts of things. I think the most important connection is to what this image actually feels like within the person. What does it feel like if you're psychically, rather than physically, pregnant? I think the sense of preparing for some new potential, and the sacredness of the task, are very much part of it. There is also anxiety, because life will never again be the same, any more than it's the same if you are physically pregnant. It's a great pity that sufficient recognition and ritual are not given either to psychic or physical pregnancy. I think this is reflected very much in the collective. We have a high degree of clinical proficiency with birth, but there is a loss of the religious sense about it. If you have a dream that a child is going to be born, or that you are pregnant, or that there is a pregnant woman with you, I think it is sometimes more relevant to refrain from analysing it to pieces, and rather to think of the myth of the sacred child that is always born in danger in a dark place.

There are a few other relevant bits and pieces I want to mention about Jupiter and Saturn. One of them is the interesting coincidence of an American president dying in office who has been elected under a Jupiter-Saturn conjunction. This has been happening regularly since Abraham Lincoln, and I think all the conjunctions have been in earthy signs. This time the conjunction has fallen in an air sign, and President Reagan got shot but didn't die. There is also the curious example of the Pope, who is a different kind of old king. Once again, there was an assassination attempt, but he didn't die. I

don't know whether this more optimistic note is because air is less concrete than earth and therefore demands less definite concrete expression. These incidents suggest to me that the death of the old king and the interregnum and the birth of the new king may not have to materialise quite so rigidly. Perhaps foolishly, I am inclined to read something very hopeful into this. Perhaps we are just that little bit less fated as a collective. Maybe there is just that little bit more margin of error, whereas fifty or a hundred or five hundred years ago the prophecy of the old king dying had no other possible channel except the literal one.

The issue of the fatedness of the collective is a very curious thing. A nation doesn't seem to be able to resolve a conflict in the same way that an individual can. A nation is made up of individuals, but it is a psychic entity unto itself, and countries have birth charts. A country can't go to see an analyst about a problem in its birth chart. It will react to a heavy transit in a very blind way. I think that the more unconscious the individuals are who make up a nation, then the more fated that nation is in a concrete way. So a conjunction like Jupiter-Saturn transiting across a critical point in a nation's chart will inevitably mean the death of the old ruler, and the interregnum and general mess that precedes the establishment of a new order. Perhaps America loses her presidents because there is a natal Jupiter-Saturn square in her birth chart, which means the nation is very sensitive to those conjunctions of Jupiter and Saturn. But this time the fate has not been enacted concretely all the way through. That suggests to me that there is a little more flexibility in this collective.

Ordinarily I tend to think of America as a very extroverted collective, as compared with a country such as India, which is terribly introverted. There is a tremendous emphasis on external material values in this country. It would tend to act its horoscope out in a very literal, extroverted way. So I take that near miss of the failed assassination attempt as something very hopeful. Perhaps the old king is learning how to die on an inner level, and perhaps the new birth will also be more of an inner birth. It would be quite a change to see a transformation of values and attitudes, rather than the usual economic or political disaster or muddle. So you can see that this myth of the old king expresses itself in the world as well as in individuals, and that there is a possibility of many different levels on which the old king can die.

I can certainly fantasise that I see Jupiter-Saturn changes happening in many areas, although I can always be accused of picking out only those things which I want to see to validate my point. That may be so, but I'll mention them anyway. I associate the Neptune in Libra group with a very strong spiritualising current, which I think has yielded many of the newer

psychological schools that lean toward a transpersonal orientation. I think this generation has firmly established such movements and organisations as Transcendental Meditation and Psychosynthesis, and whatever you may think of these, they are very much part of an aspiration toward validation of the spiritual as well as the biological sides of human nature. Whatever their failings, the people with Neptune in Libra, who also of course have Uranus in Gemini or Cancer and Pluto in Leo in sextile to Neptune, have, I think, brought a new flow of ideas into the collective. And I think now these ideas are being tested and changed and anchored. There has been a rather overwhelming emphasis on light and spirituality and intellect in these movements, which one would expect of Neptune in Libra, and I think this emphasis is being balanced by a more realistic attitude. I can certainly see this among my fellow astrologers, who are recognising more and more the value of one's own experience. This means not just setting oneself up as a counselor, but being counselled oneself, sitting in the client's seat grappling week after week with one's own muck.

I feel this also to be very hopeful, because I have felt for a long time that the aspirant toward a Neptunian vision tends to dissociate himself from life. The very nature of being an astrologer and looking at a horoscope is a detachment from experience, and it's very easy to use such things to avoid taking up what one has to carry inwardly. The mythic background to the astrologer is connected with the figure of the seer and the magician, and this is a very dangerous thing to identify yourself with. No matter how humble you try to make yourself, the client isn't going to hear you, because he's busy projecting the divine oracle on you. No words of yours are going to convince him otherwise, because this projection comes from the unconscious. You can try to be as scientifically clear as you please, and go on and on about astrology not being fortune-telling, but the primitive layer of the psyche will still come to consult the shaman. And the more detached and dissociated you are from your own psychic life, the greater danger you are in from that kind of projection. For Neptune in Libra, spiritual aspiration is enough. I think the Jupiter-Saturn conjunction is battering on the doors of that illusion, and dethroning an old king which badly needs regeneration.

The old king here believes that he is exempt from ordinary mortal suffering because he has spiritual knowledge. Therefore, we should possess no problems and have all the answers. But any psychotherapist worth his salt will tell you that if there is anyone crazier than the patient, it is the psychotherapist himself. If there is any group more ignorant than the person come to consult an astrologer, it is the astrologer himself, who has succeeded in escaping into his symbols as a means of avoiding life. So if the old king of

idealistic perfection is in the process of dying, I can only see that as a wonderful thing, because it might mean that the great Neptunian vision is coupled with some genuine wisdom extracted from experience.

Audience: Can you tell us the joke about the meaning of life?

Liz: Ah, yes, the joke. The joke is about a young man who decides that he must discover the meaning of life. He travels all over the world looking for a wise guru who can tell him the secret. He climbs up to all the hidden Tibetan monasteries and wanders across India asking every holy man for the answer. They all keep referring him on to some other guru who is wiser. Finally he comes to the last guru, because he's run through all the others, and no one has been able to tell him the answer. The last guru lives on the highest Himalayan peak, and the young man has to struggle up the sheer mountain face in howling winds and freezing cold. When he finally reaches the top, and manages to gasp out his question, the old guru doesn't answer him. He just sits in his full lotus posture melting snow. The young man begs and pleads, and threatens suicide, and goes on and on. The guru sends him away for three days to meditate. After three days of agonising meditation in the freezing cold, the young man returns and asks his question again—"What is the meaning of life?"

Finally, the guru says, "Chicken soup." The young man is appalled by this. He is absolutely sure that the guru has told him the truth, but he doesn't understand. So he humbly departs, and decides he has not done enough spiritual preparation to comprehend such a piece of deep wisdom. He spends another ten years travelling around India, fasting and meditating and lying on beds of nails and avoiding women, and trying desperately to understand what the old guru has told him. Finally, after ten years of desperate spiritual striving, he returns to the cave at the top of the highest mountain peak. He finds the old guru still sitting in his full lotus, melting snow. The young man is almost dead by this time from cold and exhaustion and starvation. He says to the guru, "I just don't understand, Master. I've struggled and worked, but I have failed to reach enlightenment. Tell me what you mean when you say that the meaning of life is chicken soup." The guru just looks at him for a while, and then says, very perplexed, "You mean it isn't?"

Audience: You've talked about connecting various astrological signs with mythic figures who represent parts of the psyche. I woke up this morning wondering whether there is some kind of mythic correlation to the four

elements. Is there some kind of archetypal myth of fire, or water, or some deity or spirit associated with them?

Liz: Yes, I think there are stories and figures characteristic of the elements. There are particular animals which seem to represent the elements. I would be very careful with that word "archetypal." In Jung's view, an archetype is an ordering principle. It has no form or image. You can't see an archetype. It's a kind of basic underlying pattern which reveals itself through an image in the individual or the collective psyche based upon the life experience of that individual or collective. Life fills in the empty archetype with a whole chain of images. The four elements are themselves archetypal images of something formless and impossible to define, but which in life we experience as a fourfold structure.

One of the best places to go for images which amplify our astrological symbols is fairy tales. There are many images of the four elements in fairy tales. For example, there are a great number of stories where something is dropped into a pool or a lake, or something is found under the lake or comes up out of it. There are also many tales which involve treasure buried in the earth. There are airy birds which know secrets, and witches and ogres which are transformed by fire. There are fiery and earthy gods in myth, and also gods of air and water, and they all tell us something about the elements. Kronos, for example, is a Titan, which means he is made of earth. There is no dearth of mythic material about the elements. You can even find mythic connections with such things as the moon's nodes. In Indian astrology the moon's nodes are called Rahu and Ketu. Rahu is the demon of the eclipse, and has a gorgon's face, and he—or she—swallows the sun at the time of an eclipse.

No one can teach you how to work with these connections. You must simply go and read fairy tales and myths, and allow your feelings and your imagination to work on them.

Audience: It just occurred to me this morning that a long time ago there used to be a radio programme which began, "Who knows what evil lurks in the heart of men? The Shadow do!"

Audience: You mentioned the attempted assassination of President Reagan and the Pope. Do you think there will be other things like this going on?

Liz: Yes, I have worried about that. Someone, some head of state, is very

likely going to be shot down while this conjunction is going on.* Recently even Queen Elizabeth was shot at. Someone in the crowd fired some shots into the air. Her horse was startled, but she kept very calm and the man was caught. The Royal Family is very vulnerable, as the IRA have already proven with Lord Mountbatton.

Audience: I know you mentioned the *puer aeternus* in connection with Jupiter and Saturn. It's been my observation that the *puer* seems to be emerging with greater and greater force in modern society, especially in the way people dress and in films and things of that sort. I wonder if you have any observations on that.

Liz: My observations are the same as yours. I think the *puer* is emerging more and more strongly. He is a figure of aspiration, and he seems to be manifesting in a whole host of different ways. I think one of his faces is the wanderer, and there is now a familiar figure with a rucksack that you can meet all over the world who I think is embodying the *puer*'s restless searching. I feel all of our new quests for spiritual insight belong to the *puer*. I believe this includes the new rush of interest in astrology and the Tarot and the I Ching and other alternative visions of reality. The *puer* is also very evident in the interest in Jung, because of his so-called mystical bias.

Audience: Also, in San Francisco now, where there are a great many gay people, it seems that the way they dress and act is hopeful of preserving youth as an alternative value. You can go into the gay community and see forty-five-year-old men dressed like children, and they're apparently quite comfortable. It's a social statement that's really emerging in a powerful way. I wonder if you have any astrological observations about it, or about where it's going to go.

Liz: I don't know about any particular astrological configuration that is bringing it up. Obviously it's been happening for quite some time, so we can't pin it on the Jupiter-Saturn conjunction. I am inclined to feel it is connected with the ending of an astrological age, because this is, in its own way, an old king dying. New potentials and new gods and new visions of life tend to erupt with great force at those transition points. Perhaps it's something to do with the generation who have Uranus in Gemini and

*Since this conference in July 1981, and during the continued conjunction of Jupiter and Saturn, President Sadat of Egypt was assassinated, and so was John Lennon.

Neptune in Libra—I don't really know. Also, I don't know where it's going to go. I suppose that if it's enacted on a purely external level, then it means changing morals and religious shifts in orthodox religious structures and so on. I think it also means something new in terms of the individual, a new outlook that is open to the intangible and the irrational. I know what you mean when you talk about fashion. This interests me a great deal, what is considered fashionable or beautiful in the collective. At the moment there is a focus on the slim and youthful body. Once upon a time, the ideal feminine was, shall we say, much more maternal. Enormous breasts were *de rigeur* for a film star. Now there is a much more androgynous and youthful spirit. The slim and healthy body has become terribly important. I don't know where it's going, but I think it is changing values. The *puer* is an embodiment of spirit. He is the son of the Father, and he knows he's divine. He doesn't feel tainted. There has been a very strong religious theme for a long time that human life is basically a process of suffering to purify sins so that one day after death we will be received in God's embrace in a state of bliss. But the *puer* doesn't feel that he's full of sin, because he's not full of body. Perhaps he is heralding a new enjoyment of the spirit in life, without the ethic that life must be terrible and nothing better than a vale of tears.

Audience: Do you think that the Neptune in Libra group would express this differently with Uranus in Cancer instead of Gemini?

Liz: I think the way I have described Neptune in Libra, with its idealism and vision of the perfect relationship and the perfect society, still applies. Uranus spends only seven years in a sign, so it's a kind of mini-group within a larger one. Uranus is much more cerebral, and is concerned with new ideas, new or original ways of expressing the values represented by the sign. I don't think it embodies religious values, so much as the need to break free and find greater scope for expression. Uranus is concerned with improvement and reformation. In Gemini, this will express through ideas of education and all the ways in which we define knowledge. Uranus in Cancer will try to find greater freedom in terms of what is defined as family.

I think that the Uranus in Cancer group is concerned with alternative values about the meaning of roots and family. This means a nation as much as it does mother and father. Uranus asks questions like, "To whom do I owe allegiance? Is a blood-tie really that important? What about a non-genetic family, a family of friends with shared goals?" Family has always been seen as a concrete unit of society, with a husband and a wife

and 3.2 children and a dog. I suspect that Uranus in Cancer represents a generation pushing for other possibilities. The increasing frequency of single-parent families—where the woman wants, rather than has to, raise a child on her own—is relevant. I think gay couples, and single parents adopting children, are other possibilities. I could also mention test-tube babies, and sperm banks, and other situations where the traditional meaning of family is being altered. The possibility of people linked by ideas rather than blood is emerging more and more strongly.

If this placement of Uranus in Cancer is in square to Neptune in Libra, then there is a conflict. The Neptunian vision of perfect spiritual love collides with the need to rebel against the conventional framework in which we have been taught to seek that perfect love. I think the dilemma of this group is concerned with marriage and family, and the possibility of interpreting those basic social units on other, newer levels.

Audience: What about Venus as a symbol of the ideal of beauty and femininity in the collective?

Liz: I am sure that where Venus is placed in a nation's chart says something about that nation's collective ideal of beauty, just as Venus in an individual's chart describes his own personal values of what is beautiful and desirable. You can certainly see the differences by leafing through a few magazines—particularly *Vogue*, which has editions in America, England, France, and Italy. The images of the feminine vary enormously among them, although there is an underlying fashionable theme which may be worldwide for a few years. Having spent time in both America and England, I am personally aware of great differences in these ideals between the two countries. Americans are much more extroverted, and concretise their values much more. I don't know if this is really reflected in the two national horoscopes, but it is very observable to anyone who travels. Until very recently, the ideal of the wife and mother was much more strongly emphasised in America. An unmarried woman had no place at all, except as a failure on the marriage market. But there has always been an acceptable place for the unmarried woman in England and in Europe in general, whether she's a more intellectual type or the continental image of the sophisticated mistress who simply prefers independence, rather than opting for such a life because she can't catch a husband. I think the issue of a woman not wanting children is also less acceptable in America. I suspect this is connected with the country's sun in Cancer. The maternal image is overwhelmingly important here. England has the sun in Capricorn,

and the qualities of manners and class and restraint and dignity are far more important.

Venus isn't just the ideal woman. I think there is also a connection with culture, with refinement and cultural ideals. There too I have perceived a difference. The educational tradition is completely different here. England has always valued the good classical education and the private school—although they are called "public schools" in Britain—and intellectual refinement and articulateness are important. That isn't the case in American education, which has a much more social and physical emphasis. If a country has the sun in Cancer, then all of the myths of the Mother are going to be relevant to that country, whether it sees itself as a protector of underdeveloped nations or as a place where the model of the ideal home and family can be fulfilled. The American Dream is peculiarly Cancerian. Also, Cancer is concerned with the imagination. Cancer is not afraid of the irrational, and is willing to be open to imaginative things. Capricorn is suspicious of the imagination, which is why I think new ideas that emerge in America take about twenty years before they're considered viable in England. Capricorn is a patriarch, and Cancer a matriarch. Britain never saw herself as a protector of underdeveloped countries. She simply acquired an empire instead. And Capricorn is more realistic, and less sentimental. Britain has never pretended that her exploitation of her colonies was anything more or less than exploitation, whereas America calls it protection. When world opinion began to turn against colonialism, Britain was realistic enough to decolonise her empire, without romanticising it. Which you feel is better depends on your personal taste. Instead of mother and home and family and apple pie, you find the stiff upper lip and discipline and class structure and tradition. Britain always has had and always will have a class structure, because Capricorn is a hierarchical sign.

This area of national values is not my specialty, but it interests me a great deal. Unfortunately, I don't know enough about national charts. It's an open field for some very good research.

Audience: Would you comment on Israel's chart?

Liz: I'd rather not. The subject of Israel has a tendency to start arguments. I don't really want to talk about politics. I prefer to stay on the subject of psychology.

Other Books by These Authors

By Liz Greene

Saturn: A New Look at an Old Devil
Relating: An Astrological Guide to Living with Others on a Small Planet
The Outer Planets & Their Cycles: The Astrology of the Collective
Looking at Astrology (Full-color, illustrated children's book)
Looking at the Mind (Children's book)
The Dreamer in the Vine (A novel about Nostradamus)
The Astrology of Fate

By Stephen Arroyo

Astrology, Psychology & the Four Elements: An Energy Approach to Astrology & Its Use in the Counseling Arts
Astrology, Karma & Transformation: The Inner Dimensions of the Birth Chart
Relationships & Life Cycles: Modern Dimensions of Astrology
The Practice & Profession of Astrology: Astrological Counseling in Modern Society

List of titles continued on next page.

*The above books may be ordered from CRCS Publications.

CRCS PUBLICATIONS

CRCS PUBLICATIONS publishes high quality books that focus upon the modernization and reformulation of astrology. We specialize in pioneering works dealing with astrological psychology and the synthesis of astrology with counseling and the healing arts. CRCS books utilize the insights of astrology in a practical, constructive way as a tool for self-knowledge and increased awareness.

ASTROLOGY, PSYCHOLOGY & THE FOUR ELEMENTS: An Energy Approach to Astrology & Its Use in the Counseling Arts by Stephen Arroyo
.. $7.95 Paperback; $14.95 Hardcover
An international best-seller, this book deals with the relation of astrology to modern psychology and with the use of astrology as a practical method of understanding one's attunement to universal forces. Clearly shows how to approach astrology with a real understanding of the energies involved. Awarded the British Astrological Assn's. Astrology Prize. A classic translated into 8 languages!

ASTROLOGY AND THE MODERN PSYCHE: An Astrologer Looks at Depth Psychology by Dane Rudhyar .. 182 pages, Paperback $5.95
Deals with Depth-Psychology's pioneers with special emphasis on Jung's concepts related to astrology. Chapters on: Psychodrama, Psychosynthesis, Sex Factors in Personality, the Astrologer's Role as Consultant.

ASTROLOGY, KARMA, & TRANSFORMATION: The Inner Dimensions of the Birth-Chart by Stephen Arroyo 264 pages, $9.95 Paperback; $17.95 Deluxe Sewn Hardcover
An insightful book on the use of astrology as a tool for spiritual and psychological growth, seen in the light of the theory of karma and the urge toward self-transformation. International best-seller.

CYCLES OF BECOMING: The Planetary Pattern of Growth by Alexander Ruperti
.. 6 x 9 Paperback, 274 pages, $9.95
The first complete treatment of transits from a humanistic and holistic perspective. All important planetary cycles are correlated with the essential phases of psychological development. A pioneering work!

AN ASTROLOGICAL GUIDE TO SELF-AWARENESS by Donna Cunningham, M.S.W.
.. 210 pages, Paperback $6.95
Written in a lively style by a social worker who uses astrology in counseling, this book includes chapters on transits, houses, interpreting aspects, etc. A popular book translated into 3 languages.

RELATIONSHIPS & LIFE CYCLES: Modern Dimensions of Astrology by Stephen Arroyo
.. 228 pages, Paperback $7.95
A collection of articles and workshops on: natal chart indicators of one's capacity and need for relationship; techniques of chart comparison; using transits practically; counseling; and the use of the houses in chart comparison.

REINCARNATION THROUGH THE ZODIAC by Joan Hodgson Paperback $4.95
A study of the signs of the zodiac from a spiritual perspective, based upon the development of different phases of consciousness through reincarnation. First published in England as *Wisdom in the Stars*.

LOOKING AT ASTROLOGY by Liz Greene 8½ x 11, $5.95
A beautiful, full-color children's book for ages 6-13. Illustrated by the author, this is the best explanation of astrology for children and was highly recommended by *School Library Journal*. It emphasizes a healthy self-acceptance and a realistic understanding of others. A beautiful gift for children or for your local library.

STAR SIGNS FOR LOVERS by Liz Greene Special Hardcover Value, $7.95
A lively, entertaining, and original discussion of many aspects of the relationship potential of the zodiacal signs. Includes the "shadow" side of the personality, many mythological references, etc.

A SPIRITUAL APPROACH TO ASTROLOGY by Myrna Lofthus ... Paperback $12.50
A complete astrology textbook from a karmic viewpoint, with an especially valuable 130-page section on karmic interpretations of all aspects, including the Ascendant & M.C. A huge 444-page, highly original work.

THE ASTROLOGER'S GUIDE TO COUNSELING: Astrology's Role in the Helping Professions by Bernard Rosenblum, M.D. Paperback $7.95
Establishes astrological counseling as a valid, valuable, and legitimate helping profession, which can also be beneficially used in conjunction with other therapeutic and healing arts.

THE JUPITER/SATURN CONFERENCE LECTURES *(Lectures on Modern Astrology Series)* by Stephen Arroyo & Liz Greene Paperback $8.95
Transcribed from lectures given under the 1981 Jupiter/Saturn Conjunction, talks included deal with myth, chart synthesis, relationships, & Jungian psychology related to astrology.

THE OUTER PLANETS & THEIR CYCLES: The Astrology of the Collective *(Lectures on Modern Astrology Series)* by Liz Greene Paperback $7.95
Deals with the individual's attunement to the outer planets as well as with significant historical and generational trends that correlate to these planetary cycles.

CHILD SIGNS: Understanding Your Child Through Astrology by Dodie & Allan Edmands 150 pages, 12 photos of children Paperback $6.95
An in-depth treatment of a child's developmental psychology from an astrological viewpoint. Recommended by *Library Journal*, this book helps parents understand and appreciate their children more fully. Nice gift!

DYNAMICS OF ASPECT ANALYSIS: New Perceptions in Astrology by Bil Tierney. Groundbreaking new work! 288 pages, Paperback $8.95
The most in-depth treatment of aspects and aspect patterns available, including both major and minor configurations. Also includes retrogrades, unaspected planets & more!

THE PRACTICE & PROFESSION OF ASTROLOGY: Astrological Counseling in Modern Society by Stephen Arroyo Forthcoming, available 1984

For more complete information on our books, a complete booklist, or to order any of the above publications, WRITE TO:

CRCS PUBLICATIONS
Post Office Box 20850
Reno, Nevada 89515-U.S.A.